IMAGINARY ANIMALS

IMAGINARY ANIMALS

THE MONSTROUS, THE WONDROUS
AND THE HUMAN

BORIA SAX

REAKTION BOOKS

To the dragons!

Published by Reaktion Books Ltd
33 Great Sutton Street
London EC1V 0DX, UK
www.reaktionbooks.co.uk

First published 2013

Copyright © Boria Sax 2013

All rights reserved
No part of this publication may be reproduced, stored in a retrieval system, or transmitted, in any form or by any means, electronic, mechanical, photocopying, recording or otherwise, without the prior permission of the publishers.

Printed and bound in China by C&C Offset Printing Co., Ltd

A catalogue record for this book is available from the British Library.

ISBN 978 1 78023 173 0

CONTENTS

1 The True Unicorn 7
2 Animal Encounters 23
3 What is an 'Imaginary Animal'? 37
4 Every Real Animal is Imaginary 53
5 Every Imaginary Animal is Real 79
6 Monsters 95
7 Wonders 131
8 Creatures of Water 163
9 Creatures of Fire and Air 187
10 Creatures of Earth 209
11 Shape-shifters 221
12 Mechanical Animals 237
Conclusion 249

References 257
Further Reading 267
Acknowledgements 269
Photo Acknowledgements 271
Index 273

Creatures of fable from F. J. Bertuch, *Bilderbuch für Kinder* (1801). Some popular mythical creatures: 1, roc bird; 2, cockatrice; 3, phoenix; 4, unicorn; 5, tatary lamb; 6, dragon.

ONE

THE TRUE UNICORN

> Now I will believe
> That there are unicorns; that in Arabia
> There is one tree, the phoenix' throne, one phoenix
> At this hour reigning there
>
> Shakespeare, *The Tempest* (III, iii)

BY THE START of the seventeenth century, the existence of the unicorn was widely doubted among educated people. The Reverend Edward Topsell, in his *History of Four-footed Beasts and Serpents and Insects* (1658), had this to say about the sceptics:

> of the true unicorn, whereof there were more proofs in the world, because of the nobleness of his horn, they have ever been in doubt; by which distraction it appears unto me that there is some secret enemy in the inward degenerate nature of man, which continually blindeth the eyes of God to his people, from beholding and believing the greatness of God his works.[1]

The syntax here is a bit tangled, but he is accusing doubters of atheism, perhaps even of being under the sway of diabolic powers.

Now, Topsell was actually a person of fairly liberal inclinations, and certainly not one who habitually engaged in hunting for witches. The purpose of this finger-pointing may have been largely defensive – to head off charges of idolatry against himself. Topsell had been writing in a period of intense religious conflict throughout Britain and the rest of Europe. As a clergyman in the Church of England, he sought divine instruction in what he believed was a universal language that transcended creeds: the natural world.

Topsell did not claim to be a naturalist himself, but he studied the lore of animals in old books, largely from pre-Christian times, in search of moral lessons. To give just one example, he wrote in the dedication of his book, 'Who is so unnatural and unthankful to his parents, but by reading how the young storks and woodpeckers do in their parents' old age feed and nourish them, will not repent, mend his folly, and be more natural?'[2] He upheld the ant as an example of industry, the lion of steadfastness, and the wren of courage. The overwhelming number of the lessons he found in nature were moral or practical, not religious. But the capture of a unicorn had become an exceptionally intricate allegory of the birth, Passion and execution of Christ.

The unicorn was also mentioned by several early theologians, and found its way into the

Unicorn, from Conrad Gesner's *Historia Animalium* (1551). Despite appearing in a book of natural history, this unicorn strikes a dignified, heraldic pose.

popular work known as *Physiologus*, probably written by Didymus of Alexandria near the end of the second century CE. According to *Physiologus*, the unicorn cannot be captured by force but will lay his head in the lap of a virgin, and allow himself to be led away. The author clearly identified the virgin with Mary and the unicorn with Christ, saying of it: 'neither principalities, powers, thrones, nor dominions can comprehend him, nor can Hell hold him'.[3] Upset by this deification of an animal, Pope Gelasius I condemned the story of the virgin and the unicorn as heresy in 496 and had *Physiologus* placed on the Church's list of forbidden books, but the tale continued to gain in popularity. *Physiologus* was not only copied but expanded and incorporated into other books, and it eventually provided the basis for the medieval bestiaries, with their moralized natural history, that became popular around the eleventh century.

In the European Middle Ages, the symbolism of the unicorn was far more important than any question of its physical existence. People regarded nature as composed of allegories, through which God revealed a divine plan. The authors of medieval bestiaries were not interested in documenting tales about animals, only in expounding their symbolic

'Virgin Capturing a Unicorn', after an illustration in a 12th-century European bestiary. It is hard to tell whether the maiden is beckoning to the armed man or trying to shield the animal.

The True Unicorn

From the Unicorn Tapestries, Flanders, 1495–1505. The spear wound in the unicorn's side is like that of Christ, and the holly around its neck recalls Christ's crown of thorns. The man pointing on the left may anticipate the animal's immanent resurrection.

meanings. The lore of the unicorn reflected not only traditional Christianity but also the practice of chivalry, especially of courtly love. A knight was expected to be, like the unicorn, fierce and unyielding in battle yet endlessly gentle in his devotion to his lady, whom he would serve selflessly.

The allegories in the early bestiaries were fairly simple. As the eagle rejects any eaglets that will not stare directly at the sun, for instance, so God will reject any person who cannot bear the divine light. Gradually, some of these extended metaphors became more complicated, ambivalent and mysterious. These reached a sort of culmination in the Verteuil tapestries, also known as the 'Unicorn Tapestries', produced around the end of the fifteenth century and now in the Cloisters of the Metropolitan Museum of Art in New York. Here, a maiden and hunters are depicted going about the brutal work of capturing a unicorn as a solemn ritual, rather like a Mass, aware that they are sinners yet also cognizant that the transgression is necessary for repentance and, finally, redemption. Late medieval and Renaissance pictures of a virgin holding a slain unicorn on her lap at times resembled those of the pietà – depictions of Mary holding the dead Christ.

But why was this allegory necessary? Its purpose was surely not to explain the story of Christ to the unlettered, for it was at least as complicated as the original tale. The story seems as much

'Sight', one of a series of six tapestries representing the senses, Brussels or northern France, 1480–1500 CE. The mirror, a traditional attribute of the Roman goddess Venus, was often used in the early modern era as a symbol of feminine vanity, but here, contrary to convention, the woman is not looking into the glass. Instead, she is placing the mirror in front of the unicorn, which has its forefeet in her lap. The intricate allegory of this and the other tapestries in the series has not been definitively explained. One theory, however, holds that the unicorn represents the lady's deceased beloved, to whom she will remain faithful.

'The Unicorn Defends Itself,' from the *Unicorn Tapestries*, Brussels or Northern France, 1495–1505. The wounded unicorn is a symbol of Christ, and the hunters pursue it in a stylized, solemn manner, a bit like the re-enactment of the capture and Crucifixion of Jesus at a Mass.

'The Unicorn in Captivity', from the Unicorn Tapestries, Brussels, 1495–1505. This is the last in a series of tapestries showing the hunt, killing and resurrection of the unicorn, which form a complex allegory that has never been entirely explained. Here the unicorn, triumphant over death, is held only by a thin chain and a low fence, yet it willingly accepts the bonds of love.

designed to conceal the religious references as to elucidate them. This is the sort of concealment that one might expect from a forbidden religion, one that had gone underground, not the religion of the overwhelming majority. The problem was that conflicts among Christians had become so intense that it was hard for even the most devout believers to talk about their religion without giving offence to somebody.

Topsell wrote as the culture of the Elizabethan age was fading, and Puritanism was on the ascent. The animal guides, sages and companions found in traditional folklore and fairy tales were being demonized as familiars of witches. Any supernatural tales risked being viewed as frivolous or worse: as idolatrous or even diabolical. But, in his *History of Four-footed Beasts*, Topsell included not only the unicorn but also the satyr, sphinx, manticore, gorgon, basilisk, winged dragon, lamia and many other legendary beasts, even though their existence was far from being accepted in scholarly communities. His book is filled with fantastic stories drawn from many sources, from Graeco-Roman mythology to English folklore; he reported that weasels give birth through their ears and that elephants become pregnant by eating the mandrake root. For Topsell and others in the early modern period, the lore of exotic animals became a refuge for the fantasy that was increasingly discouraged by Puritan codes.

From 1642 to 1651, the English Civil War had been fought between Royalists, who retained many

The tomb of a young girl, now in the Louvre Museum, French, early 1500s. Because this girl died early and never had the opportunity to marry, the unicorn has become her eternal companion.

Catholic practices, and Parliamentarians, who were largely Puritans. After his capture, the deposed king Charles I was tried for treason by the new government, found guilty and executed in 1649. In 1653 Oliver Cromwell, leader of the Puritans, dissolved Parliament and ruled under the title of Lord Protector, but found himself increasingly isolated and unpopular. He died in 1658 – as it happened, the very year in which Topsell published his complete *History of Four-footed Beasts* (parts had been published earlier). As Britain slid into near chaos, Cromwell's son Richard took over his father's office, but resigned from it the next year. In 1660 a new parliament, supported by the Army, invited Charles II – son of Charles I – to return from exile in France and take the throne.

Where did Topsell stand in these conflicts? While he says little or nothing directly about religious and political disputes, there are a few hints in his natural history. He tells us:

> Would it not make all men reverence a good king set over them by God, seeing the bees seek out their king if he lose himself, and by a most sagacious smelling sense, never cease till he be found out and then bear him upon their bodies if he be not able to fly . . .

He then tries to add a bit of balance by continuing, 'And what king is not invited to clemency and deterred from tyranny, seeing the king of bees hath a sting but never uses the same'.[4] Topsell

'A Satyr', from Edward Topsell's *History of Four-footed Beasts and Serpents and Insects* (1658). This creature reportedly lived in India. It is essentially a variation on the medieval wild man, but influenced by accounts of apes, which were being brought back to Europe from remote places by explorers.

was apparently a monarchist, as well as a High Church Anglican.

Lore of the unicorn incorporated many elements of Catholic tradition. Unicorn horns, or 'alicorns' (actually the tusks of narwhals), were treated much like the relics of saints, something abhorred by Puritans, and the healing powers attributed to these horns were much like religious miracles. Alicorns, or segments of them, were placed in elaborate containers made of

'Ego sum Papa' (I am the Pope), from a handbill against Pope Alexander VI, Paris, late 15th or early 16th century. This Borgia Pope, though a skilled diplomat and patron of the arts, was renowned for his corruption and loose morals, and he did much to provoke the Reformation.

Cover to the pamphlet, John Taylor, *The Devil Turn'd Round-head* (1642). After copulating with the Devil, a witch gives birth to a Puritan. The object in the Roundhead's right hand is an upside-down 'firedog' from a fireplace, used to hold skewers for meat. Near his left hand is a spit on which the roast would be impaled and turned. Together these objects signify that the man has just emerged from, or will ultimately return to, the furnace of Hell.

gold, silver and precious stones, very like reliquaries; these were kept in chapels and worked into the shapes of crosiers, chalices and sceptres. They shared, in sum, the full magic, glamour and pageantry of the Catholic Church. For Topsell, the unicorn, and probably the other fantastic creatures, were like the miracles which Christians, particularly Catholics, had used to prove the truth of their faith.

The unicorn in the West has been constantly drawn into the religious, political and scientific disputes of the modern era. Perhaps this is why the unicorn is characterized as not only fierce but shy, and conceals itself in remote forests. In addition to explaining why the unicorn is seldom seen, the legend explains the reticence concerning a

The unicorn as a symbol of the Holy Spirit, alongside the Pope, from Paulus Scaliger, *Explanatio Imaginum* (1570). Surrounded by medieval splendour and mystery, the unicorn was generally associated with the Catholic side in religious conflicts.

Unicorns, illustration from Joannes Jonstonus, *A Description of the Nature of Four-footed Beasts* (1678). While naturalists already doubted their existence in the 16th and 17th centuries, many books of natural history still included the unicorn, and explorers continued to search for it in distant lands.

creature which one could hardly even mention without stirring controversy. Perhaps even Topsell had some secret doubt about the existence of the unicorn. After all, if it were truly a subject of knowledge, the unicorn could not be an object of faith.

Though we live in a far less overwhelmingly Christian society today, our reactions to the unicorn are not so different from Topsell's. Do you believe in the unicorn? If you are like me – and, I think, most people – then you find it hard to answer 'yes', but do not like to answer 'no'. Throughout the nineteenth and early twentieth centuries,

explorers continued to look for the unicorn in remote places, from the Central Asian plains to the African rainforest. The unicorn has, over millennia, acquired an iconic power that now transcends any system of belief. It can be hard to deny the physical reality of the creature without also disavowing what it represents: the transcendent power of the imagination.

Topsell might be classified as a very early European Romantic, but his sentiments have an element that is universal. The play of sensuality and imagination that forms our perception of animals can liberate us, if only partially and momentarily, from the restraints and limitations of our culture, including preconceived ideas derived from religion, philosophy or politics. This involves, as I endeavour to show in this book, questioning fundamental ideas about life, death, time and identity. This is generally more apparent with animals such as the unicorn, which we designate as 'imaginary', but extends to every single creature, from the dragonfly to the dragon.

H. J. Ford, 'The Two Damsels Rescue Roger from the Rabble', illustration to Andrew Lang, *The Red Book of Romance* (1921). As unicorns slowly vanished from books of natural history, they became increasingly associated with the transcendent power of imagination. Here they are mounts for two maidens whose purity drives away the evil imps and monsters.

Raphael Sanzio, *Woman with a Unicorn*, 1505. The young woman is probably Giulia Farnese, who had been mistress to Pope Alexander VI. According to medieval legend, a unicorn can only be captured by a virgin, but this unicorn appears to be a toy. The woman's expression combines worldly sophistication with childlike innocence and vulnerability.

'The True Unicorn'. A variety of unicorn, formerly from the Museum of Rudolph II, c. 1610. In the early modern period, people often explained the contradictory accounts of unicorns as references to different varieties. This one seems to be a donkey with the horn of an antelope.

J. J. Grandville, *Repas de Corps*, c. 1842. Here the unicorn, as an 'imaginary' animal, seems to have a special status in relation to his 'real' colleagues.

To Find a Unicorn

Let us suppose for a moment that there is a sudden wave of unicorn sightings in, say, northern Minnesota. Several people feel either elated or disoriented, and the local mayors are under pressure to explain what is going on. Foresters search the woods but find no trace of the creatures. Cameras hidden in the woods manage to take a few lovely shots of bears, but that is all. Traps are set up for the unicorn, but they only manage to snare the occasional hunter. But the reports of unicorns continue, so, after all else has failed, authorities resort to the time-honoured method described in medieval bestiaries: they have a young maiden in a pretty summer dress sit down in a field of wildflowers beside the wood. Sure enough, after a short time a unicorn approaches shyly and lays its head in her lap. Immediately, men who have been lying in wait rush up and capture the unicorn. As anticipated, it is an equine figure with a large horn in the middle of its head.

The unicorn is placed in a spacious pasture surrounded by high walls and, just in case it might somehow escape, fitted with a radio collar. But now the hard part begins. How does one determine whether a unicorn is authentic? That it could only be captured by a maiden in a meadow

The True Unicorn

Bookplate of Mary Churchill, Belgium, 20th century. In this variant of the old legend, the lion captures the unicorn, which has been lured by a young woman not with weapons but with a paintbrush.

might seem like strong evidence, but it is only circumstantial. One might carry out a DNA test on the unicorn, but to what would you compare the result? In fact, the DNA could only be used to refute claims of authenticity: if the result was close to that of a horse, people might say that the creature was 'just a horse'. Depending on its DNA, people might decide the animal was a goat or even a human being, but not a unicorn. In the end, the only way of checking would be to compare the animal to old pictures of a unicorn, but which pictures? Is a true unicorn large or small? Does it have a straight horn or a curved one? Is it black or white? Perhaps any captured unicorn could only be judged 'inauthentic', since it could never do justice to our expectations.

Gustave Moreau, *Oedipus and the Sphinx*, 1864. Oedipus and the sphinx gaze directly into one another's eyes with a combination of fear and wonder. Oedipus appears a bit androgynous, and the picture was probably at least partly inspired by depictions of Eve and the dracontopede.

TWO
ANIMAL ENCOUNTERS

> For I will consider my Cat Jeoffry.
> For he is the servant of the Living God duly and daily serving him.
> For at the first glance of the glory of God in the East he worships in his way.
> For this is done by wreathing his body seven times round with elegant quickness.
> For then he leaps up to catch the musk, which is the blessing of God upon his prayer.
> Christopher Smart, *'For I Will Consider My Cat Jeoffry'*

OF ALL IMAGINARY ANIMALS, the most profoundly fantastic is, without any doubt, the one often referred to as 'man' or 'human being'. It is very difficult to have a clear image of how 'man' appears, since its body is almost invariably covered with furs, textiles and plastic. Its natural state, if it has or ever did have one, is a complete mystery. To compound the confusion, it constantly imitates other animals, wearing feathers like a bird or howling like a wolf.

And that is just the beginning. Not only do human beings shroud their bodies, but they disguise their smell with shaving lotion, perfume or deodorant. They dye their hair and cover their skin with paint or permanent ink. They project images of themselves into boxes or on to screens, and their voices all over the world. Other animals, especially those in the wild, must often think that human beings do not have bodies at all. Creatures of the woods may take people for dreams, hallucinations or shape-shifters.

As human beings, our perspective is constantly confused by feelings such as collective pride, shame, fear and aspiration. If we try to say what humankind is, we are probably just saying what we would like it to be or what we fear it could become. An informal, working definition of 'human being' might be 'one of us', so the boundaries of what is considered human vary enormously by culture, by historical era and even in the course of an individual's day-to-day experience. In ancient and early medieval Europe, the bear was considered, if possibly not quite 'human', sufficiently close to being so that there were numerous stories of male bears coupling with human women, and many kings in Scandinavia traced their ancestry to bears.[1] Western intellectual leaders have at times regarded apes as human, while withholding that status from various tribes, nations, religions, races or individuals.[2] The Karam people of New Guinea consider the cassowary, a large flightless bird related to the emu, human.[3] The closest thing to our concept of 'human' among the Chewong, a forest-dwelling people of Malaysia, is a fluctuating perception of affinity that is not greatly based on either morphology or descent. At times this sense of belonging to a common realm of experience may embrace a parrot or a banana leaf, while excluding some men and women.[4] Many people in

J. J. Grandville, 'Animals Masquerading as Human Beings', 1842. Note the fallen mask on the ground below, which, looking up at the masquerading animals, seems to represent humankind.

contemporary society regard their pet dog as 'part of the family' – in effect, as a human being.

There have been numerous attempts to identify a feature that distinguishes human beings, such as using fire or making tools, but all are subject to challenge. Let us say, as some thinkers have done, that burying the dead is the distinctive human trait. What about elephants, which also cover up their dead? In response to that question, we may either drop or modify the definition of 'human', or else we may retain the definition and decide that elephants are actually people. In fact, we are likely to do a bit of both, as we continually try to align our imaginative images with our observations.

There are legal, biological, anthropological, theological, philosophical and poetic definitions of 'man', but most of them deal with only one facet of the way people conceive humanity. Because every feature of human beings, from physiology to beliefs, is continuously disguised, airbrushed, rethought, hidden, exaggerated or otherwise altered, human identity is uniquely elusive. No other animal, imaginary or not, is even remotely so difficult to define. If you don't know what a 'spider monkey' is, finding out is not a problem. You need only look up the definition in an encyclopaedia. If you don't know what a 'human being' is – and, of course, nobody does – there is no place you can go to find a satisfying answer. Any attempt at definition will be tentative, speculative, anachronistic or obscure, as well as subject to many challenges. The reality behind the concept of 'humankind' is constantly overwhelmed by millennia of illusions.

The creation of fabulous animals is largely a matter of projecting this protean nature of human beings on to other creatures. We might, in summary, reasonably say that 'humankind creates itself'. It would not be a very great oversimplification to say that this is, in some form, the position that most Continental philosophy has taken since around the middle of the twentieth century, from existentialism to social constructionism. But humanity at no point exists in isolation, so it might make more sense to say, with Paul Shepard, that 'animals make us human'.[5] We construct our ideas of humanity largely through encounters with animals. Since the last decades of the twentieth century, this process has been investigated by scholars of human–animal relationships

in the academic area called 'anthrozoology' or 'animal studies'.

Much of the original impetus for anthrozoology came from Keith Thomas and Harriet Ritvo, who in the 1980s uncovered the symbolism of human domination over animals and the natural world that pervaded Euro-American, especially British, culture in the early modern and Victorian periods.[6] This was apparent, for example, in the geometric organization of gardens and the confinement of large predators such as tigers in cramped cages. But their analyses assumed a polar opposition between humanity and nature that has become difficult to take for granted, as researchers increasingly reveal how seemingly pristine, natural landscapes such as the Amazon Basin have, for millennia at least, been strongly influenced by human settlements.

This book extends anthrozoology to the imagination, to myth and legend, a realm that has seldom been very anthropocentric. In folktales throughout the world, all forms of life, from human beings to foxes and trees, interact with something close to equality. In this book I try to show how civilization and nature blend in the domain of imagination, finally revealing our human claims to dominance to be illusory.

Eve's Snake

The only talking animal in the entire Bible, if one does not count Balaam's ass, is the serpent in the Garden of Eden, and it only speaks to a single person: Eve. The serpent, as we all know, persuades her to eat the fruit of the Tree of Knowledge, which she then also gives to Adam. God then expels the first man and woman from Paradise, and curses the serpent, which must from that time forth crawl on its belly (Genesis 3:1–19).

In the early modern period, Eve, and by extension all womankind, was often blamed for the evils in the world, from bad harvests to disease. Some legends claimed that Eve had children with the Devil, who became demons that torment humankind. But she has also been honoured as a saint as well as a precursor of Mary, who has been called the New Eve. People believed that the sin of Eve and the subsequent banishment of her and Adam from Paradise were necessary for the ultimate salvation of humankind, so they looked to her with gratitude as well as anger.

Sinner or saint, Eve probably represents the foremost model of a human intimacy with an animal in all of Western culture. There are others such as St Anthony, who preached to the fish, and St Francis, who preached to the birds, but these relationships lacked reciprocity. In European medieval and Renaissance paintings in particular, Eve and the snake are generally shown trading highly meaningful and intimate glances, as Adam stares cluelessly into space.

After about the middle of the eleventh century, the figures of Eve and the serpent in Eden began to blend. Misogynistic sermons and tracts of the late Middle Ages and Renaissance increasingly described Eve, and all women by association, as

'Eve Tempted by the Dracontopede', illustration from the *Queen Mary Psalter*, London, 1310–20. Here the dracontopede has more elaborately stylized hair and more delicate features than Eve, yet is a composite of many animals from the waist down.

usually had a woman's head on a serpentine body; its face was typically depicted as almost identical to Eve's but, as an image of feminine vanity, the monster often had hair that was more elaborately styled. The serpent-woman might also wear a crown in order to embody dreams of power. The furtive looks that Eve and the dracontopede often exchanged suggested an erotic relationship.

Over the centuries, the dracontopede became an increasingly complex blend of womanly and animalistic features. The undulating form of the snake was often used to suggest the curves of a woman's body. In many versions, the dracontopede had the arms, breasts and torso of a woman, but a serpentine lower body. In others, she was half woman and half lizard. These images inspired many other hybrid figures in the early modern period, such as locusts with human female heads.[7]

snake-like and bestial. Until the latter twelfth century, devils had always been depicted as having hideous forms, with bulging eyes, huge mouths and terrifying fangs. Then, however, the influential French cleric Peter Comestor had argued that the serpent had taken a form similar to that of Eve, what he called the 'dracontopede', in order to earn her trust. Accordingly, the dracontopede

The idea that women were closer to nature than men are persisted in the modern period. When nature appeared threatening, that association could still lead to misogyny. When, however, nature became a refuge from the noise and the stress of urban life, the feminine intimacy with nature appeared benign, at times almost sacred.

Animal Encounters

Masolino, *Temptation of Adam and Eve*, Church of Santa Marina de Carmine, *c.* 1434. In this painting, the serpent or dracontopede is almost identical to Eve except for having more stylish hair. As Adam and Eve prepare to eat the apple, neither of their faces shows much emotion, but Adam is a bit more fearful, while Eve appears more confident and aware. The dracontopede hovers over Eve in a very knowing manner.

Over the centuries we have gradually lost contact with animals of the wild, especially with large predators. Throughout the world, once-fearsome carnivores have become rare or extinct, and so many people confuse real lions and bears with their images in heraldry, cartoons or advertising. People longed to recapture a lost intimacy with animals, and so pets became an obsession of the rising middle class of the nineteenth century. The dream of a profound understanding across species even impels some people to invite wolves, tigers, bulls, stags, buffalos, bears, hyenas, chimpanzees, crocodiles or venomous reptiles into their homes, risking their lives and those of others. They feel, as Eve appears to in paintings of the late Middle Ages and Renaissance, that they share a mystical bond with an animal that enables them to interact with it in safety, ignoring the warnings of 'ordinary folk'.[8]

One such 'modern Eve' was Grace Wylie, who in her early life had been terrified of snakes but learned to handle even the most venomous ones without any tools or protective gloves, and so confidently that spectators were amazed. She worked as a herpetologist at the Brookfield Zoo in Chicago, where she allowed cobras and pythons to move freely in her office, believing that they had been

tamed. This got her fired, at which point she moved with her huge collection of snakes to Hollywood, where she worked as a film consultant and hired out her snakes out for use in movies. In 1948 she agreed to pose for the press with her newest acquisition, a 5-foot cobra from India. When Wylie gently patted its back, hoping to get a nice pose, the cobra suddenly struck; she died 90 minutes later in hospital. The psychologist Karl Menninger states that Wylie's 'totemic attachment' to snakes had a sublimated 'erotic and masochistic element', like that suggested between the dracontopede and Eve.[9]

The Bishop's Stag

According to legend, St Hubertus was a courtier of King Pepin of Herstal, the ruler of Francia, who loved nothing more than the hunt. Once, while chasing a stag on Good Friday, he became separated from his hunting companions; he found himself alone in the depths of the forest when the stag suddenly turned around and faced him. There was a tiny crucifix between the horns of the stag, and a voice from its mouth admonished Hubertus to end his heedless ways. Hubertus then not only gave up hunting but also distributed all his wealth to the poor and dedicated his remaining years to the service of God, eventually becoming bishop of Liège. In similar ways, animals constantly challenge us to rethink our values and change our lives.

And yet encounters with animals are so deeply personal that it is hard to generalize about what they mean. Perhaps that is why Hubertus never condemned the chase – in fact, he remains the patron saint of hunters to this day. Attempts to grant rights to animals begin to flounder on the circumstance that the natural world, which is the province of animals, is so totally remote from the norms of human society. We can only grant rights within our own realm, what we call 'civilization', and these rights will inevitably vary from one culture to the next.

Acts which in human society would be called 'theft' and 'murder' are not only commonplace among animals but are performed without hesitation or regret. Killing and dying are so much a part of the texture of everyday life as to seem unremarkable. Out of thousands of tadpoles, perhaps a single one may become a frog, which will then fall prey to a heron. Perhaps one rabbit in a dozen may reach maturity, only to be consumed by a hawk or raccoon. If we look at nature in terms of what we expect from human society – for example, life expectancy or medical care – then life in fields and forests appears unspeakably bleak, far more so than in the most desolate slums known to humankind.

This circumstance led intellectual leaders of the late eighteenth and nineteenth centuries such as William Paley and William Smellie to question whether the existence of predation was a flaw in the very nature of creation. 'Why has Nature established a system so cruel?' Smellie asked. 'Why did she render it necessary that one animal could not live without destruction of the other?' In the end,

J. B. Coriolan, illustration from Ulisse Aldrovandi, *Monstorum historia* (1642). Until around the 19th century, Europeans had thought of the horns of a stag as essentially branches, like those of a tree, growing out of its head. This stag hosts even more luxurious growths.

St Hubertus, after a painting by William of Cologne, 1380. Note that the saint carries on his Bible an image of the stag with a cross between its horns, which inspired him to devote his life to God.

he accepted this as a divine mystery, but others who were less fatalistic sought to correct this flaw by hunting many predators such as the wolf to near extinction.[10] Though we now speak about this less candidly than the Victorians did, we are probably no closer than they to accepting the reality of predation. And yet, when we walk through a meadow on a spring day, our impression is of anything but misery. However precarious their lives may be, the young rabbits are frolicking, and all life seems to be joined in a single ecstatic rhythm. Whatever we may think of its moral status, the hunt, when not necessary for food, is an attempt to overcome our ambivalence about the natural world by participating in its ways with other creatures on something approaching equal terms.

Medieval Europeans usually saw the hunt as an uncomplicated, innocent sort of enjoyment through which they could take part in the exuberant life of the woods and meadows. Like pet-keeping for many people today, it was a refuge from all of the complications of human relationships, as well as an opportunity to enjoy the wind, sunshine and beauty of the woods. The hunt did not evoke

Une jeune brebis fort tendre ouvrit le bal avec une panthère sur le retour; ce couple, valsant à peine du bout des pattes, captiva longtemps mes regards. Un quadrille délirant composé de singes et de guenons coiffées à l'épagneule fut exécuté ensuite et suivi d'un menuet plein de grâce et de modestie. Un renard faisait les yeux doux à une poule. Une perdrix coquette tenait en arrêt sous son coup d'œil fascinateur un braque amoureux.

J. J. Grandville, from *Un autre Monde* (1844). At a masked ball, a young lamb dances with a female panther, and a fox directs an amorous glance at a hen. Grandville satirizes the way all of the paraphernalia of civilization mask the reality of predation, something that was especially distressing to Europeans of the Victorian era.

revulsion, for before the advent of modern medicine, people were far more used to the sight of blood, and to death, than we are today. When the throat of a stag was cut, ladies would sometimes bathe their hands in the blood in order to make their skin paler.[11] The hunt also kept people out of mischief by providing an outlet for any pent-up aggression. But, also like pet-keeping today, the hunt was at times stigmatized, not so much as cruel but rather as frivolous. Together with banqueting and eroticism, the hunt was considered an animalistic pleasure.

To civilize the chase, hunters of the nobility brought with them all the accoutrements of courtly life. Lords and ladies would hunt dressed in fine clothes, and hunters would head out in large parties, in which labour was intricately divided according to one's rank at court. At the end of the hunt, the carcass would be divided among the participants according to their contribution, from the lord, who might receive the head, down to the dogs. The stag was a symbol of Christ, and people believed that, just as Christ rose from the dead, the stag could rejuvenate itself by eating a snake, sloughing off its old skin and shedding its antlers. This made the hunt into a ritual enactment of the Crucifixion, but that religious symbolism did not seem to interfere with the exuberance of the chase. After all, the hunt simply reflected our place as fallen human beings.[12]

The story of St Hubertus is not unique or original. Very similar stories had been told of St Placidus and St Eustace, which go back to the late Roman Empire when the stag was not yet considered the ruler of the forest but only food for common people, who were not permitted to hunt boars or bears.[13] But that does not mean that the tale is not authentic. There are elements in it that seem not only plausible but so natural that, apart from the magical aspect, they could easily have occurred many times and to different people. First of all, there is the way in which the stag separates Hubertus from his companions. In effect, it detaches him from the environment of the court, what for him was 'civilization', and leads him into a realm of wonder. In a similar way, the search for the Grail begins when the knights of King Arthur pursue a white hart and become lost in the woods.

In addition, stags will sometimes turn and directly face a pursuer. It is easy to imagine how, lost in a forest, this could appear to be a confrontation with fate. Cut off from the usual pageantry, custom and ritual, the act of killing the stag would have lost much of its meaning. Saint Hubertus was forced to reconsider his way of life in a very intimate way. All animals, like the stag of Hubertus, can lead us into other realms. Aaron Katcher, one of the pioneers of animal-assisted therapy, believed that the therapeutic power that came can come from contact with animals lies in their ability to convey something 'prior' to what we know as civilization. More specifically, it is that animals live in cyclical time, and to contemplate or interact with them offers us a relief from the linear time that structures human lives, with all the fears and anxieties that it entails. 'The constancy of the animal',

he writes, 'is the constancy of cyclical time, life in cycles of day, month, season, lifetime.'[14]

Our abstract categories do not apply very well to the natural world, for they were created to describe the world of men and women. Nothing we can say of animals which is not banal is ever entirely wrong; nothing is ever fully right. They do not lack 'consciousness', nor do they have it. They are neither 'articulate' nor 'mute', 'intelligent' nor 'stupid', 'kind' nor 'cruel'. They are not 'immoral', 'moral' or 'amoral'. They are also not 'inferior', 'superior' or 'equal' to human beings. They are, in summary, so profoundly different from human beings that our concepts are inadequate to describe them.

There is no universally accepted term for this acknowledgement of the profound differences between people and animals, or for the philosophical approach to animals through their radical alterity. I am also reluctant to endorse any name for it. For one thing, it seems contradictory, or nearly so, to slap a label on a conception which is intended to point beyond the limits of our frameworks and taxonomies. For another, attempts to designate every intellectual nuance with a standardized phrase risks the creation of jargon, which can obscure more than it illuminates. For the most part, I prefer the approach of poets, who endeavour to extend the powers of everyday language, to that of philosophers, who often prefer to coin new terms. Fairness, however, compels me to note that this sort of alterity, or something close to it, has been discussed eloquently by Joanna Bourke under the label of 'negative zoélogy' and by Roberto Marchesini under that of 'non-human alterity'.[15]

We cannot help but impose our categories on animals. On some level, all life is one, but we divide it into units, into separate 'beings'. We measure the interests of the heron against those of the frog, the interests of the rabbit against those of the hawk. We put a splotch of red paint on a chimpanzee and then place her in front of a mirror, to test whether she touches it to show a 'sense of self'. That is how we behave, and we can no more help it than a bat can refrain from snatching insects or a spider can refrain from spinning webs. We conceptualize; we anthropomorphize. But creatures slough off our concepts as surely as a snake casts off its old skin. Animals return us to a primordial time before we had encompassed the world in names, categories and elaborate conceptual frameworks. They invite us to reconsider the whole of human culture, perhaps even to create it anew, always generating new creatures of the imagination in the process.

The Philosopher's Cat

In some ways at least, our animal companions may be almost as much 'imaginary' animals as a unicorn. This is the insight, or something close to it, of Jacques Derrida in the famous epiphany he had when his cat gazed upon him naked:

> No, no, my cat, the cat that looks at me in my bedroom or bathroom, this cat that is

Odilon Redon, *The Cyclops*, 1914. The monster here is depicted with sympathy, as a symbol of alienation from society. It seems to gaze out shyly at us, as though we had just disturbed it, but its thoughts may be focused on the woman, whose favours are unattainable.

perhaps not 'my cat' or 'my pussycat', does not appear here to represent, like an ambassador, the immense symbolic responsibility with which our culture has always charged the feline race, from La Fontaine to Tieck . . . from Baudelaire to Rilke, Buber, and many others. If I say 'it is a real cat' that sees me naked, this is in order to mark its unsubstitutable singularity. When it responds in its name . . . it doesn't do so as the exemplar of a species called 'cat,' even less so of an 'animal' genus or kingdom . . . it comes to me as *this* irreplaceable living being that one day enters my space, into this place where it can encounter me, see me, even see me naked. Nothing can ever rob me of the certainty that what we have here is an existence that refuses to be conceptualized.

Derrida goes on to say that he is ashamed of his nakedness before the cat,[16] a feeling that is close to the combination of fear and fascination that a prey species, such as our remote hominid ancestors, may have felt in confrontation with feline predators.

Even by gazing at a creature, without even saying a word, we abstract it from a larger environment and draw it at least a little way into our world.[17] Animals in the wild do not have names, or at least not ones that people can recognize, and by bestowing a name, we further anthropomorphize – we 'civilize' – a creature. In the book of Genesis, when Adam names the animals (Genesis 2:20) he asserts his dominion over them. Today, however, when we name an animal we actually do even more than that. We locate it in an evolutionary line of descent, thereby placing it in a certain family, genus and species. The cat becomes *Felis* and *catus* as well as 'Cleopatra', acquiring not just one name but an entire inventory of them. With every name we surround the animal with more culturally determined expectations, as well as, in most cases, more hopes and fears. The realm of human beings is language, and a name – or, far more often, several names – is a badge of membership.

By placing an animal within an intricate system of classification we calm many initial fears, whether physical or psychological. We cushion the impact of a psychological confrontation with a creature that, like all animals, can seem at once disconcertingly 'human' yet profoundly alien. To look into the eyes of a cat or to watch a spider weave is an experience that takes us back to something pre-cultural. It can awaken primal responses that remind us, for a moment at least, how arbitrary most of what we conventionally call 'civilization' really is.

In a critique that has itself become as famous as Derrida's passage about his cat, Donna Haraway writes:

> He [Derrida] came right to the edge of respect . . . but he was sidetracked by his textual canon of Western philosophy and literature and by his own linked worries about being naked in front of his cat . . . Derrida failed a simple obligation of companion species; he

did not become curious about what the cat might actually be doing, feeling, thinking, or perhaps making available to him in looking back at him that morning.[18]

In other words, Derrida writes only about what the animal inspires him to think and feel, to a point where he seems self-absorbed. Finally, the cat turns out to be little more than a segue into ruminations about Descartes, Kant, Bentham, Heidegger and Adorno. Derrida might, however, have done no better if he had consulted articles by zoologists or manuals on feline care. Perhaps Derrida had been writing as a poet when he suddenly remembered that he was really a philosopher.

This tension between the poet and the academic philosopher runs through the essay by Derrida. The poet constantly wants to reach out to this alien presence, the cat, but the philosopher says that is impossible. The poet senses, or at least longs for, a moment of transcendence, but the philosopher insists there is no such thing. The poet wants to spend all afternoon watching and playing with the cat, but the philosopher says he should move on to Bentham and Descartes. Every now and then the poet manages to get a few lines in, but the philosopher interrupts, opens a huge book and tells the poet to shut up and read. But before he allows himself to be silenced, the poet does manage to express an important insight, and the philosopher cannot force him to take it back – an animal transcends all attempts at conceptualization, even by learned academics.

That Derrida is conflicted is shown, furthermore, by a simple contradiction. While insisting that the being cannot be classified or named, he continues to call it a 'cat'. In fact, after telling us that the feline cannot be grasped in concepts, he spends much of his essay attempting to do precisely that, a bit like a man who talks incessantly about the need for silence. But suppose Derrida had drawn a picture of the being instead of labelling it? Or suppose he had written a poem about it? Suppose he has even told a story or two about the creature? In that way, he might have recognized its autonomy, and he would not have needed to bestow any name upon it.

Illustration for a traveller's tale, French, 15th century. At the end of the Middle Ages, accounts of travels became increasingly fantastic. In this one, mermaids, or sirens, blow their trumpets, together with dolphins and other creatures of the sea. The traveller sets foot on an island where a white horse is used to symbolize primeval purity.

THREE
What is an 'Imaginary Animal'?

> . . . something is amiss or out of place
> When mice with wings can wear a human face.
> Theodore Roethke, 'The Bat'

SUPPOSE A ZOOLOGIST, after an intensive investigation, announces that 'The yeti is actually a bear.' Many people would take that to mean that the yeti did not exist, but that is not actually what the words, if we take them in a remotely literal way, actually say. Rather, they tell us something about how the yeti should be classified. We could still understand the comment as dismissive, since, compared to a yeti, even a bear can seem rather ordinary. But maybe the yeti is not an 'ordinary' bear. Maybe it is a previously unknown species of bear, one of extraordinary strength and intelligence. And, even if that is not the case, perhaps the statement by the zoologist should be read as a tribute to the ursine family.

And what is a 'bear'? What, in any case, is a 'real' animal? Modern biology is often dated from the first edition of *Systema naturae* by Carl Linnaeus in 1735, which attempted a systematic classification of all living things. The taxonomy of Linnaeus, however, was basically a methodical ordering of the categories that had been suggested by tradition or 'common sense'. A problem was posed by animals that appeared ambiguous, such as bats, which Linnaeus, like many of his contemporaries, initially regarded as mice with wings. In later editions he classified bats as primates, and then finally placed them in their own order, Laurasiatheria, which is where they have stayed ever since.

Like other naturalists of his day, Linnaeus classified whales and manatees as fish. (Scientists now, of course, regard them as mammals.) The hippopotamus had generally been viewed as part pig and part horse, but Linnaeus classified it as a rodent. Most of his categories made intuitive sense to his contemporaries, but science was increasingly teaching people to mistrust appearances, thus creating a growing barrier between professional knowledge and experience. Nearly two centuries earlier, Copernicus had shown that the earth was not fixed, and the other heavenly bodies did not revolve around it. Kepler proved that heavenly bodies did not move in perfect circles but in ellipses, while Galileo discovered that their surfaces were not perfectly regular. More recently, Newton had demonstrated that white light was not entirely homogeneous but composed of many colours. Chemists were demonstrating that matter was not entirely solid but contained many elements.

This process would continue to accelerate from Linnaeus to the present. Zoology has now undermined still more traditional categories, showing for example that, our impressions to the contrary, the hippopotamus is most closely related not to other land mammals but to whales and other cetaceans. It has now not only contradicted the notion that the whale is a fish but discredited 'fish' as a biological category by showing that creatures traditionally contained in that category do not have a single evolutionary ancestor.[1] But detaching an animal from experience renders one vulnerable to new illusions, since casual observation ceases to be a valid test of its reality. Perhaps this is one reason why the scientific revolutions of the Renaissance were accompanied by an increase in sightings of mermaids and other creatures of ancient mythology.

How can one tell if an animal is 'imaginary' or 'real'? Confronting this formidable question, it may be a little reassuring to think of it as simply a dimension, or perhaps an extension, of taxonomy. Imaginary animals, after all, are not only constructed out of human hopes and fears; in most cases they also involve tangible objects – alleged griffin claws, unicorn horns, Sasquatch footprints or photographs of the Loch Ness monster. There are often reports of sightings of, even of elaborate adventures with, a creature of hearsay. Of course, our tests are far more sophisticated than those that were available in the Renaissance, but they are not always unequivocal or infallible. If the genetic code from a strand of yeti hair seems to resemble that of a man, a believer might respond that this is simply because the yeti is related to humankind. To decide whether or not the yeti exists, one must first determine whether to regard it as a bear, an ape, a human being or something else.

Is the bonobo a chimpanzee? Are fungi such as mushrooms animals or plants? Is the panda really a bear? Should the Neanderthal be considered a human being? Is the now-extinct Tasmanian wolf – which barked, hunted and looked rather like a dog yet carried its young in a pouch – a carnivore or a marsupial? Taxonomists are forever trying to establish their discipline on a more scientific basis, and their efforts generate all sorts of intricate measurements, graphs and charts, but ultimately they must still rely on an intuitive sense of the natural order.[2]

The same applies to the classification of animals that are known largely through rumour or tradition. Is the unicorn a horse, a goat, a rhinoceros or something else entirely? Is the satyr a human being? Is the Holy Spirit a dove? Is the mermaid a porpoise, a seal, a manatee or a woman? Are cynocephali people? Dogs? Or baboons? In many cases, our answers ultimately decide whether we consider the creature in question 'imaginary' or not.

Responding to Thomas Browne, who denied the existence of the griffin, the Scottish minister Andrew Ross wrote in the mid-seventeenth century:

And even though other writers say that griffins are fabulous, their saying so is certainly not sufficient to proving them so, for there are many such 'mixt and dubious' animals in the world. Acostos tells us of the Indian *pacos*, which in some parts resembles the ass, in others the sheep. Lerius speaks of the *tapiroussou* in Brazil, which resembles both an ass and a heifer. And there are many other mixed animals that we read of such as flying cats, flying fish, and some sort of apes with dogs' heads called *cynocephali*. Our bats are partly birds and partly beasts.³

Ross was writing only a little more than half a century after Christopher Columbus had set foot on the New World, and animals such as the llama and the tapir were known only from a few confused accounts by explorers. The new fauna were so strange that people were at a loss to describe them, and they relied on analogies with more familiar creatures, which often produced accounts of fantastic composites. Today, scientists would regard the description of a llama as a combination of a sheep and an ass as either erroneous or metaphorical, but I believe that Ross's larger point remains valid. There are many creatures that appear to be odd hybrids, yet are entirely real.

What is Imaginary?

Probably few people, except for modern fantasy novelists and artists, have ever deliberately set out to create an imaginary animal. Most of the figures that we now designate this way are viewed across a gulf of culture and history. They seemed genuine to the people who described, sculpted or painted them. They may not always have been considered literal depictions of a subject, but the very concept of 'literal' truth – purged of symbolic, allegorical and emotional dimensions – is largely a product of modern Western culture. As 'truth' became more sharply separated from the rest of experience, the domain of 'imagination' emerged on its boundary. According to Samuel Sadaune, writing primarily in reference to France, 'It was not until the thirteenth century that a precise frontier between the real and unreal, normal and paranormal, natural and supernatural appeared. This frontier was the fantastic.'⁴

The word 'imaginary', a near synonym for 'fantastic', enters the English language only in the fourteenth century. It is tempting to speculate whether there might be an etymological influence between the words 'imaginary' and 'magic', which also first appears in English during the 1300s. The former word comes ultimately from the Latin *imago*, meaning 'likeness of something'. The latter comes from the Latin *magos*, meaning 'sorcerer', which was borrowed from the Persian *magus*. Whether or not there is any direct connection between these words, the two concepts have always been intimately related. There has always seemed to be something 'magical', and therefore dangerous, about likenesses, which is the reason for the biblical injunction against 'graven images',

Illustration from the *Book of Marvels*, written in Old French by Rustichello da Pisa in the 13th century from stories told by Marco Polo. The figure in the foreground on the lower right is an alligator, but the artist has greatly embellished the author's accurate description in order to gratify a popular taste for ever-greater wonders.

observed with various degrees of strictness in Judaism, Islam and many varieties of Christianity. 'Real', the major antonym of 'imaginary', enters English in the fifteenth century, and goes back to the Latin *res*, meaning 'thing'. All three concepts are understood in relation to a new conception of truth that was emerging in the sciences and in religious fundamentalism in the modern period.

This notion of a purely literal truth meets with increasing scepticism in a postmodern era. 'Experience' and 'imagination' may still sound like opposites, but recent research in cognitive psychology and many other fields has shown that their relationship is a lot more complicated. Perception consists largely of imagination, since the individual must construct the object from conceptual frameworks, visual stimuli, sounds, memories and so on, a process that has both cultural and biological dimensions. This is usually done almost instantaneously, but it is far from simple. Our experience does much to determine

what stimuli we notice, and prior beliefs affect how we implicitly classify and interpret them.⁵

Even the ways in which we divide all of life into separate organisms, though we usually think of this as self-evident, turn out to be rather subjective. Why, for example, do we regard most cells in our bodies as part of us, but the bacteria in our stomachs, which are essential for digestion, as separate organisms? Is a foetus a separate human being or part of the woman who carries it in her womb? And why don't we regard a beehive as a single organism, of which the various highly differentiated sorts of bees are different parts? Is the *Armillaria ostoyae* in eastern Oregon, a fungus which covers an area of about 4 square miles, the world's largest organism or a collection of tiny ones? Biologists now regard fungi as genetically closer to animals than plants so, if it is a single creature, it would be hard not to think of it as a 'monster'. But such questions lie on the border of biology and philosophy, and do not have any final answers.

What is an 'Animal'?

Our word 'animal' comes from the Latin *anima*, which can mean either 'breath', 'soul' or 'butterfly'. All three of these meanings, which themselves are subtly interconnected, contribute to our understanding of what an animal is. Definitions that are more biologically oriented will emphasize physiological processes such as drawing breath; those that are more religious or philosophical may emphasize either possession of a soul or its secularized equivalent, consciousness; pictorial representations of the soul will often show it as a butterfly or a tiny person with wings. The very concept of an animal as understood today is an intimate part of a world view that we at times call 'scientific' and, like other grand paradigms, it rests on assumptions that are very difficult to articulate, elucidate or explain, and impossible to prove.

Many non-Western languages, such as Classical Chinese, have no equivalent of the Western concept of 'animal'.⁶ Many indigenous peoples such as the Achuar (Jivaroan people) of the Amazon regard plants and animals as having their own societies, with particular rules and customs. Some, such as the Australian Aborigines, consider tribal affiliation – which extends to plants, animals and features of the landscape – to be more important than divisions between species. We may at times take it for granted that living things may be divided into stable categories such as animals, plants, human beings and so on, and that all of these categories are subject to further subdivisions. Most of our science, religion and law may be predicated on that assumption, but it is not by any means self-evident. For some indigenous cultures, particularly in the Americas, identities of living things are too fluid, elusive, transient and complicated to fit neatly into a fixed, let alone a hierarchical, arrangement.⁷

The anthropologist Tim Ingold has observed that the term 'animism' has been misunderstood in Western culture as the mistaken attribution of

consciousness to inanimate objects. In animistic cultures, however, awareness is not localized in specific objects at all, but rather is generated by the ways in which they interact. In his words:

> Animacy . . . is not a property of persons imaginatively projected onto the things with which they perceive themselves to be surrounded. Rather . . . it is the dynamic, transformative potential of the entire field of relations within which beings of all kinds, more or less person-like or thing-like, continually and reciprocally bring one another into existence. The animacy of the lifeworld, in short, is not the result of an infusion of spirit into substance, or of agency into materiality, but is rather ontologically prior to their differentiation.[8]

Through habit and tradition, we in the West still generally think of consciousness in terms of the Cartesian paradigm of what Gilbert Ryle called the 'ghost in the machine'.[9] Consciousness is seen essentially as a possession which may be obtained, gained or lost. But this model, now intensely questioned even by many prominent Western scientists and philosophers,[10] has never been accepted in most human cultures.

Perhaps somewhat ironically, technologies developed only in the past few decades now provide us with the metaphors to understand ways of thinking that were once derided as 'primitive'. Just as networks are spread over many computers, mobile telephones, printers, scanners and other devices, so awareness may be spread across several minds, a phenomenon sometimes known as 'distributed consciousness'. With respect to a network, one might wonder in which device all of those images, voices, texts, melodies, emoticons and so on reside. The only possible answers seem to be either 'all of them' or 'none'. Similarly, consciousness is not generated in a single being but, rather, in relations among many. To put this another way, if one were to depict the bearer of consciousness, insofar as that is possible from an animistic perspective, it might be a fantastic being with the features, including heads, of many different kinds of creature.

The anthropologist Philippe Descola distinguishes four essential paradigms used in organizing experience – totemism, animism, analogism and naturalism.[11] The purest totemism is found in the cultures of Australian Aborigines. Animism, generally combined with totemism, predominates in indigenous cultures of the Americas and Africa. Analogism predominated in Western cultures during the Renaissance as well as, at least until historically very recent times, those of China and most of East Asia. Naturalism, which is based on the division of experience into the realms of 'civilization' and 'nature', has been the preferred paradigm in Western culture from the early modern period up to and including the present.

The perspectives of animism and totemism probably exclude the concept of an imaginary animal, at least as understood in ways that are

familiar to people in Western culture. They blur, or even efface, boundaries on which this concept depends – between human beings and animals, living things and inanimate objects, reality and imagination. From the perspective of analogism, the differentiation between real and imaginary animals is not necessarily important, since both the mental and physical worlds are understood through complicated allegorical or metaphoric patterns. Only in the perspective of naturalism, essentially that of modern science, are imaginary animals likely to seem clearly distinguishable from real ones. But, though one of the four perspectives may dominate in certain cultures or historical eras, the outlooks are not always mutually exclusive.[12] An animist might ask his cat for advice, while a naturalist would study the characteristics of its breed; a totemist would declare himself a 'cat person', and an analogist would watch the eyes of the cat in hope of gaining wisdom. Many cat owners, of course, will do all four.

Even scientists need to accept our basic perceptual categories mostly on faith, since the range of alternative possibilities is so elusive and so vast. Perhaps we should use the term 'imaginary animals' with a slight touch of irony, and ask the reader to supply mental scare quotes, particularly when those animals appear in a culture that is very different from our own. We must acknowledge that what we call an 'animal' might, in another cultural context, be closer to a human being, a deity or a spirit. What we call 'imaginary' might have a very palpable reality, but in a cultural environment very different from our own. But those are not the cultures in which we have been raised, and while we may try to understand them in relatively abstract ways, we cannot really enter into them.

And by identifying animals as individual beings and thereby abstracting them from their environment, we already begin, even without bestowing names, to impose a human, and perhaps even a Western, order on their lives. Researchers at times even implicitly assume that their factions within the academic community represent the template not only for all humanity but for animals as well. Studies to determine whether animals have a 'sense of self' or a 'theory of mind' always seem to assume that any animal would necessarily locate the self in its body, even in a specific part of its body, such as the brain. That is an odd conjecture, since that model is far from universal, even for human beings. Some people locate the self in landscapes, tribes, writings, the realm of spirits, a line of descent, deeds and so on, and something of the sort could well be true of animals as well. Bears or deer, like animistic cultures, might not divide awareness into 'minds' at all, yet have a perpetually fluid sense of self.

It also seems easily possible that fish in a school might perceive themselves more as a single organism than as a collection of individuals. Furthermore, animals that rely heavily on senses other than sight might imagine the self in ways very different from our own. A dog, which navigates by smell far more than sight, may regard itself as

a scent, one which it leaves at home and along paths to revisit later. A bat, which navigates by sonar, may think of itself as a sound, while perhaps an anemone senses that it is something like a current in the sea.

Becoming Animal

A rudimentary explanation of imaginary animals is suggested by the theory of biophilia, which was defined by Edward O. Wilson as 'the innately emotional affiliation of human beings to other organisms'.[13] Since the overwhelming majority of imaginary animals possess some human physical or mental characteristics, perhaps imaginary animals are representations of this sort of affiliation. Those who affiliate with horses, for example, may imagine centaurs.

'Biophilia' became an academic catchphrase in the late 1980s and the 1990s. It drew on the energy of the environmental movement while offering a rationale for emerging fields such as animal-assisted therapy. The idea seemed to unify many intellectual trends, but it has faded since. For all its marvellous suggestive power, advocates were unable to describe their central concept with enough rigour and clarity to satisfy the requirements of even the soft sciences.

A helpful elaboration of the concept, however, is provided by the Italian anthrozoologist Roberto Marchesini and his theory of zootropia, which holds that human identity does not lie in a special feature such as possession of a large brain or use of fire but, rather, is constructed through identification with other creatures.[14] The best evidence of this is the ubiquitous use of animal imagery in symbols of human identity, whether individual or collective. Examples of this pervade every aspect of human society, from ancient Egypt to the present. Nations are constantly represented by animals, from the British bulldog to the Chinese panda. Sports teams, such as the Toronto Blue Jays or the Baltimore Ravens, are very often named after animals. In the United States, a donkey symbolizes the Democratic Party, while an elephant symbolizes the Republicans. Creatures from doves to tigers are used to represent popular products, and pop sociology sometimes divides the human race into 'dog people' and 'cat people'.

In religion, Christ is still often represented by a lamb or a lion, while the Holy Spirit is represented by a dove. The Jewish religion, which traditionally has a far stricter interpretation of the biblical ban on idol worship, is still represented by the Lion of Judah, and Muhammad's human-headed horse, Al-Buraq, is among the most iconic figures of Islam. The elephant-headed Ganesh is one of the many beloved animal deities of Hinduism, while Old Monkey, who can soar on clouds, is similarly popular in Buddhism.

Food is very intimately tied, though almost entirely on an unconscious level, to conceptions of individual and collective identity. On the one hand, since we very literally become the things we eat, just as they become us, people fear that eating meat could bestialize them. They believe

What is an 'Imaginary Animal'?

Muhammad riding Al-Buraq, Iran, 15th century. Nothing in the Koran alludes to Al-Buraq having a human head, and the figure appears to have come from Iranian folk traditions. The name of the steed means 'lightning' in Arabic, perhaps an allusion to the speed of its flight.

that if they eat beef, or too much beef, perhaps they could come to resemble cattle. On the other hand, since we create our identities in part through identification with animals, the person who eats beef might also resemble a predatory beast.[15] In Louisa May Alcott's novella *Transcendental Wild Oats*, a member of a vegan commune in 1860s America, appalled that a young girl has eaten fish, says, 'Know ye not, consumers of flesh meat, that ye are nourishing the wolf and tiger in your bosoms?'[16]

Because food is such an important and complex part of human identity, there are many strong cultural and subcultural taboos connected with it.[17] We experience consumption of meat as a mild violation of the taboo against cannibalism, since – whether from a cow, human being or frog – flesh and blood usually appear much the same. Eating meat carries a bit of both the revulsion and excitement that comes with a transgression. The Bible contains elaborate dietary rules according to which people are forbidden to eat, or even touch,

'unclean' animals such as reptiles, amphibians, birds of prey, carnivores, ants and pigs (Leviticus 11:1–23).

The late Elizabeth Lawrence, a veterinarian and pioneer in anthrozoology, writes: 'Through . . . symbolizing, there is a kind of merging – animals take on human qualities, and humans take on animal qualities.'[18] Even when they are not being used directly as symbols or metaphors, animals remain essential points of reference in defining attributes that are important to us. The quality of fierceness is still best understood by allusion to carnivores such as lions and wolves, while tenderness is associated with nesting birds. Even as ever more wild animals vanish from our daily lives, human culture remains pervaded by totemism.

In short, animals are the major templates used in the construction of human identity, whether universal, tribal or individual. Imaginary ones in particular are a record of the changes in humankind, as we absorb, lay claim to or try to disown features that we discover in other creatures. And because people constantly not only appropriate aspects of the appearance, habits and abilities of other animals but draw on their identities as well, in ways that are almost as various as the animals themselves, there is a great diversity among human cultures and individuals.

What is an Imaginary Animal?

So, finally, what is an 'imaginary animal'? Most of the time, we think that we know – at least well enough to recognize one. Nevertheless, it is surprisingly difficult to give a definition of the term, and we keep running up against ambiguous cases. Are cynocephali, which have the bodies of human beings and the heads of dogs, really 'imaginary animals', or should we call them 'imaginary people'? We would probably consider the Egyptian deity Anubis, despite having the torso of a man, to be essentially a canid, but St Christopher, even with the head of a dog, seems to be a human being. That is simply because the latter is closer to our traditions and, in consequence, less profoundly alien.

That a concept, in this case 'imaginary animal', eludes attempts at precise, empirical definition does not mean that it is meaningless. If it did, nearly all abstract discourse would be impossible. Lawyers, and even philosophers, constantly evoke, for example, 'rights' in legal and moral discussions, usually without worrying about how rights are defined or even whether they exist. It is particularly unreasonable to demand, as academics so often do, absolute precision from one's adversaries while making no attempt to reach that standard oneself. And attempts to use abstractions according to very exacting definitions are more likely to result in pedantry than in clarity. Language follows the fault lines of human perception, even when these are not well understood.

For some purposes, we have little choice but to take the phrase 'imaginary animal' in a fairly naive sort of way. A rough, working definition, which is flexible enough to be applied across many

J. B. Coriolan, 'Cynocephalus', illustration from Ulisse Aldrovandi, *Monstorum historia* (1642). Aldrovandi reports that these creatures, with human bodies and dogs' heads, live in Asia Minor and are rugged and ingenious enough to resist the Tartars.

cultural boundaries, is this: 'real' refers to what we usually consider fairly normal, while 'imaginary' refers to what does not conform to our expectations about reality; 'human' means 'one of us', while 'animal' means 'one of them' (that is, the Other). An imaginary animal is a creature that seems to belong to a realm fundamentally different from, yet somehow allied with, our own. Its most basic characteristic is the combination of relatively familiar features with heightened alterity. It makes strange characteristics appear familiar, and familiar ones appear strange. This is implicit in many of the terms that are applied to imaginary animals: 'monster', 'prodigy', 'wonder', 'freak', 'miracle', 'marvel' and so on.[19]

The most useful way to define an imaginary animal may be through its psychological, spiritual and social role. An imaginary animal is a sort of 'second self' for an individual human being, an association of people or even the entire human race – something we might have been, might become, fear turning into or aspire to be. It can even be a creature that we ourselves do become, perhaps in dreams or in some alternate life – for example, a werewolf. Understood in this sense, an imaginary animal is at least very close to what the Franco-American philosopher René Girard called the 'monstrous double', the Romanian historian Lucian Boia called '*l'homme différent*' and Roberto Marchesini termed the 'theriomorph'.[20] Despite all the vast differences in conceptualization in different cultures, religions and philosophies, using animals as a second self seems to be virtually universal. Mythologies throughout the world tell of intimate kinships that people have established with animals, whether as shape-shifters in the present or as ancestors in the remote past.

Most of the imaginary animals that are prominent in human culture have some physical feature of a human being, whether a face, a torso, hands, legs, voice or something else. Among the

Monkeys from a European book of natural history, 1806. Before Darwin, the 'human' qualities of apes did not appear distressing, and people felt little inhibition about anthropomorphizing them. These varieties of monkey come across as sprites or perhaps children.

obvious examples are centaurs, mermaids, sirens, werewolves and cynocephali, as well as characters from popular culture such as Mickey Mouse. Others, such as dragons and griffins, may not have such tangible human characteristics, yet they serve remarkably well as bearers of human ideas in allegories or in heraldry. No matter how strange or exotic, imaginary animals are always grounded in the human world.

Animals are humanized primarily by voice in the tradition identified with the half-legendary storyteller Aesop, who is said to have lived on the Greek island of Samos in around the sixth century BCE. To give just one example of a tale attributed to him: 'A vixen sneered at a lioness because she never bore more than one cub. "Only one", she replied, "but a lion".'[21] In this case the two animals represent social classes in human society, but the one-dimensional psychology still makes these creatures appear bestial and, at times, almost endlessly foreign to us. If they temporarily bear human meanings,

What is an 'Imaginary Animal'?

A sloth and monkey, from a European book of natural history, 1806. When we look through natural history books over two centuries old, we have the impression of entering a fantasy world. These creatures have bestial bodies, but their faces are clearly human.

less interested in the literal truth of the story than in the lesson that 'The true Panther, our Lord Jesus Christ, snatched us from the power of the dragon-devil on descending from the heavens.'[22] At any rate, these animals are transported from the forests and plains to the landscape of ideas, thereby becoming both more human and more strange.

In an epic poem from the latter twelfth century entitled *The Conference of Birds*, by the Persian Sufi Farid al-Din Attar, thousands of birds, led by the hoopoe, begin a pilgrimage to their king, the Arabian phoenix, or simurg. It is a long and hazardous journey during which the birds are constantly threatened by fatigue, volcanos, thirst, storms, sun and despair. The hoopoe summons the partridge, peacock, pigeon and hawk to begin the journey, but then the nightingale demurs, saying that he is too much in love with the rose, which flowers just for him. The hoopoe replies that the rose is only mocking him with her show of earthly beauty, protecting herself with thorns and vanishing in a day. He then tells the story of a princess who once smiled on a poor dervish. The poor man mistook her pity for love, and stood weeping by her door for seven years, making a fool of himself and endangering his life.

Other birds hesitate as well, and the hoopoe leads them on with stories of love – which may be consummated, tragic or foolish – to raise their spirits and urge them on their way. The birds also tell religious parables and fables to edify themselves and pass the time, but few can endure the hardships of the journey. Finally, only 30 birds

these are almost the sort of lessons that oracles of Aesop's time might find in the flight of birds.

The symbolism of animals in medieval bestiaries is more elaborate, since their behaviour conveys not only practical lessons but also religious messages. We do not know whether the writers of medieval bestiaries and their readers really believed that all other animals followed the fragrant breath of the panther, but that the dragon was paralysed with terror. They were certainly

THE GORILLA.

'The Gorilla', from Philip Henry Gosse, *The Romance of Natural History* (1860). Prior to Darwin, apes were generally depicted as gentle, benign and almost human. The theory of evolution made them appear threatening, and in consequence they were depicted as vicious monsters with huge fangs.

are left, and they gain access to the simurg, to find that the king of birds is their own reflection in the pristine waters of a lake. For the author, this shows the wisdom of the Sufi mystic Hallaj, who was martyred for crying out 'I am the Truth.'[23] Our lesson here is somewhat more modest: that, in our pursuit of fantastic creatures, our most profound revelations may be about ourselves.

'Creatures of Fable', from F. J. Bertuch, *Bilderbuch für Kinder* (1801). On the left are Greek creatures that correspond to the elements of air, earth and water: 1, harpy; 2, griffin; 3, satyr; 4, titan; 5, sea horse (or 'hippocamp'); 6, nereid. On the right are additional creatures from ancient myths and legends: 1, centaur; 2, chimera; 3, Greek sphinx; 4, Egyptian sphinx; 5, grylle ('grotesque' or 'drollery'); 6, siren.

FOUR

EVERY REAL ANIMAL IS IMAGINARY

*I dreamed I was a butterfly, flitting around in the sky; then I awoke. Now I wonder:
Am I a man who dreamed of being a butterfly, or am I a butterfly
dreaming that I am a man?*

Zhuangzi

PERHAPS THE EARLIEST theory of the origins of fantastic animals comes from the Greek philosopher Empedocles, who lived in Sicily during the fifth century BCE. According to him, bodily parts were created by Love, and then joined by Chance. Eyes went out in search of foreheads, and arms wandered until they found shoulders, headless bodies and disembodied heads. These were joined in arbitrary combinations: human heads ended up on cows, while heads of cows were joined to necks of men. Faces were placed backwards on their bodies, and features of men blended with those of women. Of all those myriad forms, only a few managed to survive and reproduce. This theory, which foreshadows Darwin's idea of natural selection, was probably inspired by comparing the creatures of earlier myth with those the author saw around him. The author was an older contemporary of Socrates, and thinkers of his comparatively rationalistic age often looked on the phantasmagoric world of Hesiod with consternation.

Empedocles saw the cosmos as a perpetual conflict between Love, which continues to unite things, and Strife, which tears them apart. In some eras, Love is ascendant, and there is order, while in others Strife creates chaos.[1] This resembles many subsequent theories, such as that of Sigmund Freud near the end of his life, according to which human culture, and perhaps even life itself, was the product of an eternal conflict between Eros and Thanatos.[2]

Even more importantly for our purposes here, Empedocles articulates an archetypal perspective on fantastic animals that comes up frequently in myth, legend, religion and even science. The idea that the creation of the world was followed by a period of chaos, in which monsters of all description predominated, is found not only in Western cultures but across the globe. Athabascan Native Americans, who live in Alaska and the Canadian northwest, believe that fantastic creatures from an era of chaos, their numbers greatly reduced, managed to survive by taking the form of 'wechuge', which are human in most respects but can be recognized by bestial traits such as pointed teeth, wildly staring eyes and hairy bodies.[3] This paradigm has even entered biology, where some palaeontologists such as Stephen Jay Gould have argued that the origins of life in Precambrian times was, over

Fantastic creatures from Konrad von Megenbergs's *Buch der Natur* (1478). Virtually all imaginary animals are composites, or variants, of familiar ones. About half of them have at least some human features.

Are Monsters Primitive?

The dominant paradigm in the study of humankind from around the latter eighteenth century to the last few decades of the twentieth held that history was a record of ever-increasing rationality in which Europeans and North Americans

Lucas Cranach the Elder, engraving of a monster allegedly taken from the River Tiber at Rome in 1496, Nuremberg, early 16th century. In this monster, called 'the Pope's donkey', attributes of many animals are blended almost randomly in order to create an impression of chaos.

500 million years ago, followed by a vast profusion of forms, producing greater biological diversity than in any subsequent era.[4] Throughout the world, many people regard the appearance of fantastic creatures as a portent of chaos, and believe that their proliferation signals a breakdown of the cosmic order. For orderly life to continue, the monsters must be destroyed, though no victory over them is ever necessarily final. They may linger in some remote location, or else be recreated once again.

were leading the way. This process might then be divided into stages, identifiable by certain intellectual or stylistic features, which enabled one to know how 'advanced' in this process a given culture was.

In respect of imaginary animals, this model, like many historically important ideas, was most eloquently argued just as it was starting to be intensely challenged by anthropologists and historians. In the latter twentieth century, Heinz Mode's *Fabulous Beasts and Demons* (1975) held that fantastic creatures only developed with the advent of cities and writing – that is, what people called 'civilization'. According to Mode, 'fabulous beasts' originated in the first civilizations in Egypt and Mesopotamia, appeared a bit later in India and went on to achieve their full development in Greece, Rome and other civilizations of the Mediterranean while moving east to China.[5] In other words, they had followed the pattern that, from the nineteenth century to the mid-twentieth, was held to characterize sophisticated society.

But Mode greatly underestimates the creativity of pre-literate civilizations. In the art of cultures he regards as 'primitive', he tends to view unrealistic features and elements as mistakes, while in supposedly 'civilized' cultures he views these as creative expression. The oldest known imaginary animal may be a figurine with the head of a lion and the body of a man found in Hohle Fels cave near the city of Ulm in Germany in 2003, which dates from about 30,000 BCE, and fantastic composite creatures, despite Mode's claim to the contrary, were not especially rare in prehistoric cave paintings.[6] He also fails to fully appreciate the inventiveness of indigenous civilizations such as those of Amerindians, Africans and Australian Aborigines in blending features of many animals into new forms.

Mode's fundamental error is probably to confuse the fabulous beasts themselves with certain ways of conceiving them. The monsters of ancient Greece and Rome tend to be more formulaic than those of many other cultures, as well as, at least for those educated in Western cultures, easier to recognize and describe. Even the most fantastic creatures were generally classified in a fairly systematic taxonomy, based on regular anatomical features and not unlike the categories of natural historians. The Greek sphinx, for example, generally has the head of a human woman, the body of a lion, the wings of an eagle and at times a tail that culminates in a serpent's head. Medusa, the gorgon whose mere gaze could turn people into stone, was said to have the face of a woman and snakes for hair. But in visual depictions these figures appear no more than moderately frightening, and perhaps that is part of the reason why their representation was conventionalized. Even the most artful paintings and sculptures seldom or never evoke the same terror as those conjured by the feverish imagination, when a person has little or no idea of what to expect.

By contrast, Quetzalcoatl, the divine feathered serpent in the mythology of the Aztecs and other

Medusa, after a painting by Caravaggio, 1597. Medusa is recognizable by her hair of snakes, and representations of her have usually been highly conventionalized. In ancient Greek depictions she often had a grotesque grin, but Renaissance artists gave her a beautiful and tragic face. Caravaggio combines the two traditions by giving her attractive features but an expression of horror.

Mesoamerican peoples, combines features of birds, snakes and human beings in various combinations. This deity can be either male or female, and can have a human or serpentine face. We cannot always tell arms from wings or scales from plumes in images of Quetzalcoatl, at least not without close analysis. Its form, in other words, is far from fixed; it appears to be forever changing and evolving. In many respects, the Mesoamericans were more inventive, if arguably less scientific, than the peoples that laid the foundations for Western civilization.[7]

New Flesh on Old Bones

Some imaginary animals were probably inspired by actual ones with severe birth defects, such as a calf born with two heads or a lamb with a single eye in the middle of its face. Others may have been the result of sighting animals under tense or confusing conditions, especially in unfamiliar landscapes. Yet another explanation is provided by the mass extinctions, especially of large mammals such as the mammoth or giant sloth, at the end of the last ice age. An ancestral memory of these departed creatures might have been passed over many generations in oral traditions, especially the recollection of their vast size and ferocity, to merge in imagination with surviving species and become monsters of legend.

The conception of imaginary animals could have been influenced by remains, especially bones, of animals that had become either extinct or rare, from dinosaurs to the great mammoths. In years when Earth is relatively temperate, dead animals from the Pleistocene epoch are occasionally found in colder regions such as Siberia, with their bodies almost fresh after thousands of years, as the ice sheets that once encased them melt. As late as the first decades of the nineteenth century, until Cuvier's theory of extinction had gained acceptance, people still generally assumed that any bones must belong to an animal of a variety that

could still be found alive. When the bones of a woolly mammoth were dug up in North Carolina, and later Kentucky, people referred to the exhumed creature as the 'American elephant' and anticipated that it would eventually be discovered in the wild.

There are plenty of myths of enormous creatures which may have been inspired by megafauna, even though they are difficult to link to specific species.[8] One theory, based on an examination of very early jade figures, holds that the qilin, or 'Chinese unicorn', was initially a species of rhinoceros that later became extinct in China.[9] Among Native Americans there have always been legends of the 'happy hunting grounds', perhaps referring to a time before the extinction of the great megafauna at the end of the last ice age. It is even conceivable that stories of giants, which are found in nearly every culture, were at least in part inspired by memories of Neanderthals, Denisovans and other hominids, passed on in oral traditions.

But why didn't Amerindians think of mammoth bones simply as remains of creatures that are no longer alive, much as we do today? Why didn't Europeans think of two-headed lizards simply as deformities, rather than as a kind of dragon? And why do people everywhere constantly create not only images of, but elaborate stories about, fantastic beasts? With only a few exceptions, theories that attempt to explain imaginary animals by means of misperceptions generally involve a great deal of conjecture and speculation. The skull of a mastodon, which has a large hole where the trunk once extended, does, for example, seem suggestive of a Cyclops, but that does not necessarily mean that there is truly a connection between the two. Even more significantly, misperceptions generally can do no more than help to explain a few features of isolated creatures of the imagination. Certainly in medieval times, narwhal horns were often mistaken for unicorn horns, and rhinoceros horns were displayed as griffin claws. But such errors explain only a small part of the

Quetzalcoatl, after an Aztec wall painting. Flying serpents are found in the mythologies of many cultures, and it is even possible that Quetzalcoatl is distantly related to the Chinese dragon. Like other representations, this is an intricate blend of avian, serpentine and human features.

A dragon and its skeleton, formerly from the Museum of Rudolf II, Prague, *c.* 1610. Emperor Rudolf II neglected affairs of state in order to devote himself to his vast cabinet of natural wonders and curiosities, including a grain of sand from the earth from which God created Adam. This skeleton, imported from the East, is from a vast pictorial inventory that he commissioned of his collection. Reportedly that of a dragon, it actually consists of the bones of a cat with wings from a bird. Next to it is a reconstructed dragon, probably based on the skeleton.

'The True Unicorn'. Sea unicorns, formerly from the Museum of Rudolf II, Prague, c. 1610. From the late Middle Ages onwards, unicorns were often portrayed with the spiralled tusk of a narwhal. The figure in the centre shows that by the 17th century people had made a connection between the unicorn and the narwhal. That did not greatly change the representation of the former, perhaps because people believed that every land animal had an equivalent in the sea, so very similar horns might be found on unicorns in both elements.

extensive lore of unicorns and griffins. The claws tell us perhaps as much about griffins as an opposable thumb tells us about human beings.

Whence Imaginary Animals?

The anthropologist Steven Mithen considers the anthropomorphizing of animals, which is an important step in the formation of imaginary ones, to be a key factor in the evolution of human beings. According to his chronology, around 500,000 years ago our human ancestors developed a 'theory of mind' – that is to say, the ability to interpret the behaviour of other individuals by attributing to them 'beliefs and desires other than one's own'. This made possible relatively complex societies with division of labour. About 50,000 years ago, this understanding was applied to animals, enabling human beings to enter into a vast range of relationships with other creatures

beyond that of predator or prey. Mithen calls this 'cognitive fluidity', essentially the ability to respond to phenomena in ways that are not strictly compartmentalized. Most significantly, the conceptual boundaries that once separated human beings from other creatures collapsed, enabling artists to depict fantastic composites of people and other creatures. Cognitive fluidity enabled early humans to hunt with a great deal more sophistication: instead of simply attacking individual animals, they were able to strike strategically, driving entire herds into ambushes or off cliffs. Eventually, it also enabled human beings to enter into increasingly complex, symbiotic relationships with animals, initiating the process we call 'domestication'. Wolves were probably first domesticated by the first non-nomadic people, around the end of the last ice age, after which those wolves rapidly evolved into dogs. Sheep and goats were brought into the human world a millennium or two later.[10]

A sense of both oneself and other creatures as discrete entities complicates our perception of animals enormously. When we begin to 'enter into the mind' of an animal, we effectively divide our perception of it into two beings: there is the animal that we see directly and another unseen one, its inner 'self', which remains at least partially hidden from us. We call this by many names, such as 'consciousness', 'soul', 'sentience' or 'life force'. The 'mind' of an animal has become separable from its body, thus opening up possibilities such as shape-shifting. It also raises the prospect of conceiving of minds without bodies – ghosts, spirits, fairies or demons – that might be lurking anywhere. In short, cognitive fluidity makes possible the intricate blending of self and other, as well as of reality and fantasy, that creates not only imaginary animals but most of human culture.

In addition to opening up vast new possibilities for both solidarity and manipulation, cognitive fluidity also creates confusion and anxiety. It generates psychological vulnerabilities, which in turn produce a need for intricate defence mechanisms such as projection, where a person makes accusations against others to hide his own guilt, and denial, when a person refuses to acknowledge an obvious truth. Along with the ability to lie and deceive, people also learn how to fool themselves. Human beings not only need to fear starvation and predation, but loss of social status and even self-respect. Personal identity becomes more fragile and needs to be shielded, not only physically but mentally.

The psychological vulnerability of human beings is reflected in the apparent unwillingness of the prehistoric artists who painted walls of caves to realistically depict the human face.[11] In his extensive survey of themes in prehistoric art on walls of caves, André Leroi-Gourhan identifies several pictures as representing human countenances, yet not a single one of these shows a realism approaching that of the bison and horse heads painted in the same period. All of the human faces, virtually without exception, are in some way zoomorphic; many, especially males, have zoomorphic cranial forms and 'an animal snout with a bulbous nose'.[12] There are also 'ghost' figures, in which two large eyes gaze

Illustration to Nizami's Khamsa (Five Poems), Muhammad's ascent into Heaven, Iran, 1539–43. Note that while his horse, Al-Buraq, has a human face, the features of Muhammad himself are covered with a veil.

The Unicorn of Lascaux, painted in around 16,000 BCE. The long, parallel horns are a geometric pattern imposed on an otherwise fairly representational picture of an aurochs. Their purpose and/or symbolism are unknown.

out of a rounded mass a bit like a shroud. Many otherwise nearly human figures bear horns.[13] A 30,000-year-old painting in the Chauvet cave in France, for example, shows the head and upper body of a bison on the legs of a man, and the famous 'Sorcerer' at the Trois-Frères cave shows the horns and head of a stag atop a quasi-human body with a bushy tail.[14]

Perhaps this avoidance of realistic portraiture is due to a taboo resembling the biblical injunction against 'graven images'. Cave artists would place an animal head on a human, or partly human, torso, to create figures a bit like the animal-headed deities of ancient Egypt. Much later, but in a somewhat analogous way, Islamic paintings traditionally place the sun or a veil over the features of Muhammad. The face is where intimate emotions, the very 'soul' of a human being, are most revealed, and 'capturing' this in art can confer a frightening power.

Mark Derr has identified another very similar taboo in cave art. In the Chauvet cave there are footprints of a boy of about eight years old, accompanied by a wolf, who passed through together 26,000 years ago. Even then, the walls were covered with paintings that had been created around 12,000 years earlier. The prints may be the earliest relics we have of the partnership across lines of species, which would eventually turn the wolf into what we know today as the dog. Wolves, together with human beings, were the most common predators at that time. But in spite of their formidable presence, depictions of dogs and wolves are absent from the cave paintings at Chauvet and, generally, rare in Palaeolithic art. This could be due to a perhaps unspoken prohibition against representing a divine being.[15]

The human–animal composite figures are the most dramatic among the imaginary animals of

cave art, but they are not the only ones. Perhaps none of the imaginary creatures in caves is as anatomically complex as the Greek chimera or the Chinese dragon, but they show much play of the imagination. Many organic patterns on the walls of caves are now difficult to decipher with confidence, but they may well describe mythological creatures.[16] Among the most famous is the one known as the 'unicorn' of Lascaux, which generally resembles an aurochs yet has two impossibly long, straight horns, a bit like the antennae of an insect.[17] The horns of this creature are drawn as nearly straight lines, which contrasts with the undulating shape of the horns painted on bison and stags. They seem less a part of the 'unicorn' than a sort of abstract sign superimposed on it.

Predator and Prey

Is the capacity to empathize with other creatures really exclusive to human beings? Several predators such as wolves, dolphins and ravens also hunt cooperatively, in a way that at least suggests that they may be able to project themselves into the minds of other animals. For the past few decades, much of the debate about the theory of mind has centred on a 'mirror test', in which a spot of paint is placed on an animal, which is then positioned in front of a mirror to see if the creature can recognize itself. If the animal rubs off, touches or even pays close attention to the spot, researchers take that as evidence of a theory of mind. So far, a few (though by no means all that were tested) chimpanzees, orang-utans, dolphins, elephants and magpies have 'passed' the test, and more animals will certainly do so in the future. This, however, is no more than very circumstantial evidence that an animal is self-aware, since passing only requires recognizing a connection between the spot and the reflected image. Furthermore, the inability to comprehend this link does not prove that an animal lacks any sense of self but, at the very most, only that the creature does not associate the self with a reflection of its body.[18] In any case, if animals other than human beings do indeed have a theory of mind, then the ability to imagine fantastic animals may also not be confined to human beings.

One reason to suspect that the capacity of animals to empathize across lines of species may be limited is that predators seem to take little or no care to avoid causing agony to their prey species. Chimpanzees will rip off the limbs of captured monkeys, and wolves will begin to devour elk that are still alive; but empathy may not always be limited to, or even involve, the inclination to avoid causing pain to others. The claims of utilitarians to the contrary, people actively seek out pain in many situations – for example in extreme sports, war, initiations and martyrdom. People also constantly look for vicarious pain in spectacles ranging from the Roman circuses to modern horror movies. This may not necessarily be a distortion of the natural order, as people sometimes assume, and we should consider the possibility that animals do this as well.

The wolf, for example, might feel the pain of the elk it kills, yet find it invigorating. This may not be what we usually consider compassion, but it is not necessarily sadism either. Rather, it may be a relationship that is far more difficult to understand in anthropomorphic terms. Both compassion and sadism assume that each of the two participants is a completely separate individual, but predation may often involve a merging of identities.

Dogs have an ability to read human moods and gestures that can at times seem almost uncanny. Chimpanzees are generally unable to comprehend what humans intend by pointing, yet dogs do this even without being taught. This ability probably comes from a long period in which wolves were the predators and hominids, or even anatomically modern humans, were the prey. Predators and prey constantly observe one another, to a point where they may even know their adversary better than their own kind.

In his *History of Religious Ideas*, Mircea Eliade proposed that 'the mystical solidarity of predator and prey' was the foundation of religion,[19] and something of the sort, for example, seems to be recalled in the Eucharist, in which worshippers – almost like predators – consume the body and blood of Christ. I suggest that this 'solidarity' pervades many of the relationships within the natural world. If this is the case, the psychological complexities that lead to the blending of species and the consequent creation of fantastic beasts may also not be entirely confined to human beings. In their respective imaginations, the wolf and the elk may become one being, a wolf-elk; the owl may merge in its imagination with the mouse, and the mouse with the owl. Similarly, perhaps the dogs in our home see themselves as at least half human, or else see humans as half dog.

Though people cling to life very tenaciously, they can also welcome death, as deliverance from care, a transition to a better world, a conclusion of a destiny, an adventure or for many other reasons. Sacrificing our lives is such a temptation that society has imposed a severe taboo against suicide. Perhaps many other animals, such as whales that beach themselves, are drawn to this sort of sacrifice as well. Members of indigenous hunting societies such as the Plains Indians believe that animals willingly sacrifice themselves to hunters, in part out of a covenant with the hunter and his tribe,[20] and the impression that animals offer themselves is not confined to hunters. Traditional farmers as well often feel that their animals let them know when the time for death has arrived.[21]

Animals have often been observed sacrificing themselves to predators. This is most frequently seen when a bird or pig, usually a mother, exposes itself to predators in order to distract them from its young. A crane fly (daddy-long-legs) will leave behind a limb to conciliate a predator, while many reptiles will offer part of their tails.[22] In the first instance, one creature voluntarily dies so that others may live, and in the latter two, a part of the body is surrendered to preserve the rest. When a motive is not so obvious, the sacrifice may not be so easy to recognize. It is extremely difficult or impossible

to know for sure when death is deliberately chosen, but apparent suicide – behaviour that has no evident purpose but self-destruction – has been observed in a vast number of animals, including butterflies, chimpanzees, crested penguins, termites and naked mole rats.[23]

Creatures in the wild live a life of perpetual insecurity, in which death from what we sometimes call 'natural causes' is unknown. As Seton-Thompson wrote, 'The life of a wild animal always has a tragic end.'[24] We use the term to designate a peaceful death, in bed at the end of a long life, but wild animals invariably die from causes such as predation, disease and starvation. They do, to an extent, have the privilege of choosing the time of their death, and I find it easy to imagine that animals may at times allow themselves to be taken as prey for a variety of reasons, including weariness, curiosity and empathy with predators.

How does the world appear to an octopus? A bat? A goose? A deer? No answer to such questions will ever be complete, but Temple Grandin believes that animals, a bit like autistic human beings, see the world in terms of pictures rather than abstractions.[25] Most people simplify their perception by thinking in terms of categories, even stereotypes. In Grandin's words, 'Autistic people and animals are different: we can't filter stuff out. All the zillions and zillions of sensory details in the world come into our conscious awareness, and we get overwhelmed.'[26] Ideas, in other words, are grasped in terms of stories or images – perhaps of fantastic beings – rather than theories. This suggests a phantasmagoric domain, a bit like that depicted in the paintings of Hieronymus Bosch (who could conceivably have been autistic[27]), in which there are no species but an endless variety of individual creatures. Since people are ultimately animals, perhaps this phantasmagoria is a sort of default perception to which human beings keep returning when their usual habits and ways of thinking are disrupted by a serious crisis. In this case, it may be that our comparative uniqueness as people consists less in imagining fantastic beasts than in creating 'real' ones.

Grylles

The creation myth of Empedocles corresponds very closely to a visual tradition that goes back all the way to ancient Egypt, Crete, Iran and China. This is the creation of grylles, also called 'drolleries' or 'grotesques' – composite monsters, perhaps best known from reliefs on Gothic churches or the margins of medieval illuminated manuscripts. In the ancient world they were depicted on wall paintings, coins, gems, metalwork or any surface that lent itself to decoration. Today, they still adorn facades of buildings in cities like Paris and New York, and continue to provide a counterpoint to the heroic deeds depicted in temples and palaces.

Despite the unfettered imagination they display, grylles are surprisingly consistent in style across the ages and cultures. They show almost endless combinations of plants and animals, heads and limbs, as well as men and beasts. Some have heads

Every Real Animal is Imaginary

Drolleries drawn by Muriel Parker after the medieval originals. The unrestrained play of imagination by artists of the Middle Ages in drolleries contrasts with their intensely passionate yet highly formulaic religious works.

with legs but no bodies, while others have faces on their bellies or rumps. Some have the long necks and heads of cranes growing out of human craniums, or the bodies of fish supported by the legs of men. Centaurs, dogs and birds have elongated tails that culminate in second heads, which gaze back at their faces.[28]

In fact, the tradition may be even older than the earliest urban civilizations. Leroi-Gourham has identified a similar phenomenon in the cave art of Palaeolithic Europe. In every cave containing monumental pictures of bison, deer, horses, felines and

Allard du Hameel, grotesque from an engraving showing the Last Judgement, after a painting by Hieronymus Bosch, 15th century. This monster does not conform to any standard type, but it is about equally vegetable, animal and human.

According to Jurgis Baltrušaitis, 'without doubt the sculpted stones with effigies were intended to have magical powers. A supernatural force exudes from the displacement, the repetition, the monstrous exaggerations and the mélange of living forms.'[30] There is no reason to connect the grylles with formalized practices or beliefs, but they depict a sort of primeval fertility that generates not simply new creatures but also new forms of life.

These figures were so popular that they were often found in the most sacred places, but not

Demons forming the letter 'T'. After an illustration in the French calligraphic manuscript *Rouleau mortuaire de Saint Vital*, 12th century. The curvilinear lines of calligraphic letters provided scribes of the Middle Ages with an opportunity and an excuse for play.

mammoths, there are always areas with meandering lines carved or traced on walls and ceilings, which form unfinished, though at times finely modelled, figures and signs. Interestingly, these tend to be found just past the entrance to a cave, and before the majestic tableaus of the inner sanctuary, which corresponds to the sort of place one might expect to find drolleries in a medieval cathedral.[29] It is hard to guess if the parallels are due to any continuity in tradition. But, in both the Palaeolithic and medieval designs, the emergence of fantastic figures suggests a sort of primal creation, not entirely unlike what Empedocles described.

Italian Renaissance bracket carved with the face of a green man, with many features of a satyr. The green man, who is composed largely of vegetation, is a motif going back to ancient Mesopotamia. It entered Europe through contacts with the Islamic world in the late Middle Ages, and has remained popular ever since.

Every Real Animal is Imaginary

without eliciting occasional protests from pious figures such as St Bernard of Clairvaux, who complained in 1125:

> What is the meaning of these obscene monkeys and raging lions? And of the horrid centaurs, the wild men, the blaring huntsmen? Here you see many bodies joined in one head and there many heads on one body ... Everywhere there is a profusion of the most varied forms, as motley as they are astonishing, so that people prefer to read in stones rather than in books and spend the whole day gaping at every detail of these oddities instead of meditating on their prayers.[31]

About 100 years later the Spanish cleric Lucas of Tuy, who would soon become an archbishop,

Gargoyle from the Church of St Père Sous Vézelay, 13th century. The dwarf, below, seems to be looking down at the town, but the gargoyle is focused on something in the distance.

Gargoyle, Notre Dame de Paris, 14th century. Something in Paris has caught this gargoyle's attention, and it is looking down very intently over the city.

defended these images by saying that, although lacking any edifying symbolism, they still served God by drawing people into the Church.[32]

While artists and craftsmen of the European High Middle Ages generally had to work within strict rules mandated by the guilds as well as the Church, they could give free rein to their imaginations when creating the gargoyles on the roofs and walls of churches. The stone figures were loosely based on real animals, but they freely combined parts of human beings, birds, mammals, insects and reptiles in nearly endless ways to create a vast menagerie of hybrid creatures.[33] These images foreshadow the freedom that would be claimed by modern artists, and at least match the work of those artists in inventiveness.

Creators of heraldic crests during the same era were allowed no such liberty, yet their products were

Wilhelm von Kaulbach, 'Reynard the Fox appearing before King Lion', 1867. This picture is close in spirit to the late medieval tales of Reynard, in which all animals are essentially heraldic symbols. Here the lion confers his favour on the upstart fox, while the once mighty bear, now mocked and humiliated, looks on in frustration.

just as fantastic. Heraldic crests were probably first made for shields in the late twelfth century, as a means of distinguishing knights wearing full armour from one another during jousts, and the designs quickly spread throughout Europe. They were used to represent kingdoms, families, cities and eventually commercial enterprises. When these institutions changed – whether by marriages, battles, treaties, interests or otherwise – their crests were altered accordingly, in order to reflect symbolic meanings but with little regard for common sense. A bit like hieroglyphs, heraldic crests blended images of all sorts to create increasingly fantastic composites. Thus you find lions with wings, fish tails, crowns, halos or human heads. In many cases the lion stands almost upright, and carries some item such as an anchor, cross, sword, battleaxe, rose or flag in its paws. As heraldry became increasingly complicated and esoteric, the symbolism grew irrelevant for most people, who simply admired the fantastic designs.

Creatures of the Margins

Perhaps because they were not intimately tied to any religious or philosophic set of beliefs, grylles spread easily across national and cultural boundaries, and found their way to Persia and the Eurasian steppes. From the ancient world through early medieval times, they probably represented something analogous to what we might call 'wild nature', even though that concept was still only incipient in the civilizations that produced them. In high Gothic art they were often identified with supernatural powers, and in the Romantic era they suggested the play of unrestrained fantasy. In every case, however, they symbolized some sort of primeval condition that existed prior to the works of civilization.

Throughout most of the world, grotesques – fantastic animals – are, above all, creatures of boundaries. They are found in particular at the periphery of more prestigious cultural monuments such as altarpieces or illuminated manuscripts, where expectations are not so exalted and conventions

Every Real Animal is Imaginary

J. J. Grandville, 'Caged Heraldic Animals', *c.* 1860. Heraldic beasts are like zoo animals, in that both are constantly on display.

are not quite so binding: on the edges of doors and windows and the roofs of temples, in tales told around the hearth, books of folklore, children's stories, comic books, B-movies, tattoos, video games and so on. Medieval authors placed them above all in the margins of manuscripts, since they also mark the boundaries of our understanding. Cartographers of the late medieval and early modern periods placed them in oceans or on islands that marked the furthest ends of the world. Tales throughout the world generally place fabulous beasts in locations that, from the point of view of human civilization, are marginal as well – deserts, deep woods, remote islands, glaciers, ocean depths, mountain peaks, caves and swamps. Science fiction writers place them in the remote reaches of outer space or in alternate universes. According to the Revelations of St John, they also proliferate as

we approach the end of time. And because they challenge our conceptual powers, monsters also seem to exist at the limits of language.

These are places where such animals can, if not wait in hiding, at least escape some of the scrutiny that is reserved for consecrated artefacts and ceremonies. In a parallel way, imaginary animals pervade our unconscious minds, constantly surfacing in dreams, fantasies and unguarded moments. We find them in the patterns formed by clouds and ink blots and on weathered stones. They are far less ubiquitous, though still present, in formal works of literature and art, and seem to belong to the primal chaos that human beings are forever trying, with only partial or temporary success, to order and control. And every now and then, especially in times of uncertainty, grylles step out of the margins into works such as the phantasmagoric paintings of Bosch and Jan Breughel in sixteenth-century Flanders, the prints of J. J. Grandville in nineteenth-century France, the children's books of Dr Seuss in twentieth-century America and the contemporary woodcarvings from Oaxaca, Mexico.

To summarize, the creation of mythical creatures is not a legacy of any particular period, culture or tradition. Rather, it is a sort of substratum that runs through all of human society, and perhaps is found among other animals as well, a result of having imaginative powers far in excess of what is needed for practical tasks. We are not satisfied with the mundane world of everyday existence, thus we invent imaginary animals, just as we create imaginary objects, histories, people and worlds. When we tell stories, as people always do, we abstract the characters, human and animal, from the context of everyday life, and at least begin to transform them through imagination. As tales are retold, becoming legends and myths, several individuals may be conflated into one. If these characters are of different species, they may fuse to become a fantastic composite such as a centaur or mermaid.

Where cultures vary radically is in their manner of dealing with this profusion of imaginary forms, which can easily become disorienting. In some cultures, such as that of Australian Aborigines, the line separating imaginary creatures from real ones is relatively permeable, while in others it is more distinct. Some civilizations, such as those of ancient Greece and Rome, attempt to standardize fantastic creatures so they may be classified in much the same manner as real ones. Others, such as that of medieval Europe, tend to demonize them. Still others try to forbid their depiction, as was often done in Jewish, Islamic and Protestant cultures. Most cultures use combinations of these and other approaches.

Changing Bodies, Changing Minds

Human psychological needs, which are mostly unconscious, continue to determine how actual animals are perceived and drawn. It is not a very great oversimplification to say that every animal in literature or the visual arts becomes 'imaginary'

after a few centuries have passed. That is not only because it, or at least our record of it, is tied to an anachronistic world view; it is also because taxonomies themselves have changed, and it is never possible to know for sure exactly what animal, by contemporary classifications, an ancient manuscript refers to. In a great many, possibly even most, instances, this is also true of eighteenth- and nineteenth-century works. We no longer put great trust in the observations of even the most scientifically oriented writers of the ancient world, for example Aristotle. What further complicates any evaluation of the accuracy of ancient authorities is that, in many cases, the range, habits and even the appearance of animals may have changed over the centuries. Many species become extinct before being scientifically identified and, at a slower but still significant rate, new species are constantly being created. So perhaps the eagle that carried off the infant Ganymede in Greek mythology was a falcon, raven, vulture or even some other, now-extinct bird.

This is not just an esoteric matter to be consigned to zoologists. Mythic, religious, cultural and ideological considerations influence our perception of animals in very pronounced ways. Our perspective on animals is strongly influenced by two apparently contradictory impulses: pride makes us wish to stress human uniqueness, but a collective loneliness makes us emphasize our similarity to other creatures. Almost all of us probably hold both of these inclinations simultaneously, and our descriptions of animals, which are never really objective, reflect the tension between these.

Michael Pastoureau has shown that this tension has run through Christianity since its inception. On the one hand, there is an inclination to regard human beings as created in the image of God, and thereby fundamentally different from animals. This has often led clerics to severely condemn anything that could lead to confusion between man and beast – including wearing animal masks, imitating the bearing of animals, celebrating animals or even regarding animals with affection. The opposing tendency has been to see human beings as only part of a great community of living things. This has a foundation in the works of Aristotle and, in the Christian traditions of western Europe, is most closely associated with St Francis. But its most influential expression is in several passages from St Paul, for example:

> creation still retains the hope of being freed, like us, from its slavery to decadence, to enjoy the same freedom and glory as children of God. (Romans 8:21)

This suggests that animals as well as human beings can be redeemed by Christ, an idea that led medieval scholars to ask many questions: are animals resurrected after death? If so, do their souls go to the same Heaven as those of human beings? Should animals fast on holy days or rest on Sundays? Should they be judicially tried and punished for crimes?[34]

Either of these two broad tendencies, when carried to a sufficient extreme, can almost entirely obscure the reality of the creatures in question. If,

like the philosopher Descartes, we stress human uniqueness, there is a danger that animals could become, at least in practice, reduced to physical processes. The distortions of anthropomorphism, which come with attempting to deny any essential distinction between animals and human beings, are a good deal more colourful. There is a lively tradition of assembling vast collections of fantastic anecdotes to document the belief that animals' emotional lives and intelligence do not differ essentially from those of human beings. This goes back at least to Aelian, a Hellenized Roman of the second century CE, and includes Michel de Montaigne in the French Renaissance.[35] Such authors would tell, for example, how tuna show their knowledge of mathematics by swimming in geometric formations, and how dogs – with great shrewdness and persistence – solve murder mysteries, while rooks prosecute their criminals in judicial courts of law.

The major representative of this tradition in modern times is the Reverend J. G. Wood, whose extraordinarily prolific career spanned most of the Victorian period. In *Man and Beast: Here and Hereafter* he collected over 300 stories to illustrate how other creatures, from sparrows to elephants, have institutions that parallel those of human beings. To give one example:

> As for the ants . . . they have armies commanded by officers, who issue their orders, insist on obedience, and on the march will not permit any privates to stray from their ranks. There are some ants, which till the ground, weed it, plant the particular grain on which they feed, cut it when ripe, and store it away in subterranean granaries. There are ants which are as arrant slaveholders as any people on earth ever were. They make systematic raids on the nests of other ants, carry off the yet unhatched cocoons, and rear them in their own nests to be their servants. There are ants which bury their dead . . .

He goes on to tell of an ant funeral in which the bodies by an anthill were solemnly carried off and buried individually. A few ants refused to bear their burden and were immediately killed, then tossed together unceremoniously in a pit.[36]

Wood's conclusion was that animals, just like human beings, have immortal souls, which meant that people could be reunited with their beloved dogs and cats in the next life. For pet owners this was very good news indeed, and Wood became arguably the most popular writer on animals in all of history. Should we call these ants and the other animals in his tales 'imaginary'? They seem to be, but that judgement is not simply a matter of accurate observation but also of the interpretation of animal behaviour, so it is difficult or impossible to prove him wrong.

But, as the debates on evolution intensified, Wood felt he had to distinguish sharply between animals and human beings in order to uphold Christian beliefs. He seldom mentioned Darwin, and when he did, it was simply to dismiss evolution with some mocking reference to how it allegedly

Every Real Animal is Imaginary

LE JOKO. L'OURANG-OUTANG.

Orang-utans, from a French book of natural history, 1846. Even before Darwin, several biologists such as Buffon and Lamarck had developed theories of evolution. This picture, consciously or not, combines evolution with the biblical account of creation. The ape holding an apple corresponds to Eve, while that larger one leaning on a staff is a simian Adam.

confused monkeys with people.[37] He banished almost all anthropomorphism, in fact almost all stories, from his final books on natural history.[38]

If one looks through most zoological encyclopaedias from the nineteenth and early twentieth centuries, and any of them from the eighteenth century and earlier, one has the sense of entering a fantasy world. In the eighteenth and early nineteenth centuries, for example, the pictures of apes were generally benign. They were shown as little men and women, walking upright or leaning on a staff, usually with very human, and very amiable, expressions on their faces. As theories of evolution were propounded first by Georges-Louis Leclerc and Lamarck and then, most significantly, by Darwin and Alfred Russel Wallace, many came to think of apes as a threat to human status. Some early illustrators in the years leading up to the publication of Darwin's *On the Origin of Species* (1859) combined, perhaps unconsciously, evolution with the biblical story of creation by showing two apes in the traditional poses of Adam and Eve, holding out or eating an apple and becoming human. When the debate around Darwin intensified, many illustrators depicted apes as hunched over and snarling malevolently, with bulging eyes and large fangs. Images and descriptions of animals always contain such projections of contemporary hopes, fears and aspirations, which only become clearly illuminated with the passing of centuries.

It is true that we now have far more detailed records of contemporary animals, and even of some that are now extinct, than the Victorians did. These

include films, samples of DNA and very extensive descriptions. This does not guarantee, however, that current taxonomies, either scientific or popular, will last indefinitely. How people of the future classify creatures will depend on what qualities they find interesting and important, and there is no way to confidently predict what those will be. Perhaps scientists of the future will consider form more important than heredity, and in consequence declare the whale once again to be a fish.

Legends, Old and New

The creation of imaginary animals is certainly not the product of illusions that were current centuries or millennia ago but have now been dispelled by systematic study. Rather, it is a process that continues today, as people constantly envision new creatures, from chupacabras to aliens. If anything, new technologies have probably accelerated this process. We may monitor places like the depths of forests and the bottoms of lakes with cameras, but these constantly pick up hazy images, unexplained flickers and puzzling shadows, which some will then interpret as manifestations of an ape-man or a mermaid. We can perform sophisticated tests on strands of hair or on excrement, but these usually allow for a range of imaginative interpretations. Rumours travel faster today than ever before, and within a few hours a report of an ape-man sighting is likely to be all over the Internet. These monsters are today very far from fading into oblivion – there has actually been a huge increase in references to the North American ape-man Bigfoot, or Sasquatch, in the late twentieth and early twenty-first centuries.[39] The Bigfoot Field Research Organization regularly sends people into woods and swamps, and while Bigfoot has yet to be found, they often come back with mysterious reports, audio recordings, plaster casts of tracks or tufts of hair.[40]

Paul the Octopus, housed in a zoo in Oberhausen, Germany, recently received enormous international acclaim – and a few death threats – for being amazingly successful at predicting the outcome of football (soccer) games. When there was an important match coming up, Paul's handlers would place two otherwise identical boxes of mussels in front of him, each box marked with the insignia of one of the opposing teams. The team whose box Paul selected first would almost invariably prove victorious. His greatest achievement was to correctly predict the outcomes of all eight games in the 2010 World Cup final, and statisticians calculated the probability of this being due to chance was one in 256. Paul is a 'legend' only in a very broad sense of the term, since his story has been spread primarily by the mass media rather than simply by word of mouth, but it shows that people today are not so different from our ancestors as we may at times think. While learned priests of old may have foretold the future by examining the entrails of animals in temples after sacrifice, soothsayers of today show all the ingenuity and deliberation of scientists designing an experiment.

There are always at least six ravens kept at the Tower of London, wandering freely around the

grounds but with their wing feathers trimmed so that they are unable to fly very far. The Beefeaters who serve as tour guides at the Tower will tell you that the ravens were domesticated in the seventeenth century on the orders of King Charles II, because of an ancient prophesy that Britain would fall if they ever left the Tower. Many other stories have been told of them, for example that they alerted police to the plot to blow up Parliament in 1605, or that they guard the Crown Jewels. In actuality, the ravens were only brought to the Tower in 1883, as props for tales of Gothic horror told to tourists by the Beefeaters. The idea that Britain will fall if the ravens leave the Tower actually dates precisely from July 1944, when ravens were being used as unofficial spotters for enemy bombs and planes during the Blitz.[41] Despite what many thinkers hoped or feared, contemporary people have not lost the capacity to make myths.

Many tabloid newspapers, as well as a few television shows, have now shed their last remaining inhibitions about disseminating sensational reports. New developments in areas such as biotechnology and artificial intelligence have given them plenty of new material, as they generate rumours far more spectacular than even the most impressive genuine accomplishments. The following headlines were collected from papers such as *The Sun*, the *National Examiner* and the *Weekly World News* in the last decades of the twentieth century:

Foot-long Cockroaches Terrorize Renters – Lab Mutants Escape

Fisherman's Wife Gives Birth to Lobster Baby

Russians Turn Basketball Player into Bigfoot

Sperm Bank Horror – Goat Gives Birth to Half Human/Half Animal

I was Bigfoot's Love Slave

Hindus Wed Frog to Bring Rain

Family Haunted by Ghost of Thanksgiving Turkey

Sewer Worker Turns into Toad

Tribe Sacrifices Male Virgins to Giant Flesh-eating Parrots[42]

These macabre anecdotes have the character of urban legends about hitchhikers who vanish near graveyards or babysitters who place the child in a microwave,[43] and some of them probably have a basis in folklore.

'Satyr Shown in Spain in 1760', Russian popular print of the second half of the 18th century. This image may have been inspired by sightings of a feral macaque, a popular pet among European aristocrats in the early modern period.

FIVE

EVERY IMAGINARY ANIMAL IS REAL

> The other one, Borges, is the one to whom things happen. I wander through Buenos Aires, and pause, perhaps mechanically nowadays, to gaze at an entrance archway and its metal gate; I hear about Borges via the mail, and read his name on a list of professors or in some biographical dictionary. I enjoy hourglasses, maps, eighteenth century typography, etymology, the savour of coffee and Stevenson's prose: the other shares my preferences but in a vain way that transforms them to an actor's props.
> Jorge Luis Borges, 'Borges and I'

AS DARKNESS APPROACHES, a hunter in the woods glimpses a humanoid creature of enormous size, lifting a huge stone. The man stares as the creature drops the rock and approaches him, and their glances meet for a moment. The hunter is too paralysed to shoot, but he manages to run away. A motorist takes a sharp turn on a remote country road. Her car collides with the creature, stunning it only slightly but making a dent in her mudguard. The creature retreats, but leaves behind a massive footprint. A young man and his girlfriend are meeting in a lover's lane, when they hear a roar behind them. They turn around, to see a huge figure with gleaming eyes silhouetted against the evening sky . . .

Such encounters are reported from time to time in just about every state in the United States, as well as in almost every country in the world. The monster has various colourful names including Sasquatch (Canada), Bigfoot (northwestern U.S.), skunk ape (Florida), Lake Worth monster (Texas), Grassman (Ohio), Momo (Missouri), Patagonian giant (Argentina), wild man (medieval Europe), Abominable Snowman or yeti (Tibet), yeren (China), nguoi rung (Vietnam), orang pendek (Sumatra), yowie (Australia), almas (Caucasus Mountains) and so on. All of these manifestations have at times been dismissed as frauds or hallucinations, but a few, such as the yeti, are considered to be at least possible by zoologists.

Bigfoot and His Companions

Just about every imaginary animal has some basis in experience, often an encounter reported by one or two solitary individuals in a remote area at night. The creatures, as well as the stories told of them, are likely to become more elaborate as witnesses attempt to explain details or bits of evidence. Why is there a hole in the door of the car? It might be because the monster pierced the door with its horn . . .

In North America, Algonquian-speaking peoples of Canada told stories of the windigo, a hairy giant that feeds on human flesh and has a heart of ice. It has a huge mouth and teeth like daggers but no lips, and can swallow beavers, or even people, in a single gulp. It is likely that the windigo and similar Native American demons and goblins were originally members or deities of tribes

J. B. Coriolan, 'Satyr with a Trumpet', illustration from Ulisse Aldrovandi, *Monstorum historia* (1642). According to Aldrovandi, these creatures live, among other places, in Mauritania and the mountains of India. They have the feet of goats and the bodies of humans, and are very lustful. The figure was probably influenced by several recently reported varieties of apes and monkeys.

J. B. Coriolan, 'Antoinetta Gonzalez', illustration from Ulisse Aldrovandi, *Monstorum historia* (1642). Her father, Petrus Gonzalez, was captured in the Canary Islands in 1556, and, since he was covered with hair and did not initially speak any European language, was considered a 'wild man'. After he was befriended by Henry II of France, taught Latin and allowed to marry, his family was intensively studied by scholars.

that had vanished and were demonized by their successors,[1] a bit like the Titans that preceded the gods of ancient Greece. Tales of these creatures eventually blended with similar ones from European and African lore to create the spectres of Sasquatch and Bigfoot.[2]

For non-Native Americans, Sasquatch, Bigfoot and their relatives may have represented the Native Americans themselves, who once seemed to be similarly mysterious creatures lurking in the woods around early colonial settlements. The name 'Sasquatch' originally referred to one large

native, who lived in the Canadian wilderness in the early twentieth century. The name 'Bigfoot' is also Native American, and was first used, so far as I have been able to tell, for a chief of the Osage tribe who lived in the late eighteenth century. For both Native Americans and settlers, the ape-men represented survivals of a primeval world that had almost perished.

There are countless other creatures that are widely rumoured and occasionally 'sighted', but whose existence has so far not been confirmed. The most famous is certainly the Loch Ness monster, which reputedly has a neck about 6 feet long, a humped back and fins. Similar creatures are reported in many lakes, including Lake Manitoba in south-central Canada, and Lake Champlain, located across the borders of Canada, New York State and Vermont. Among the creatures of rumour that are taken most seriously by researchers is the Mokèle-mbèmbé, which has reportedly been encountered in the jungles of central Africa since at least the late nineteenth century. It is a huge, reptilian animal resembling the dinosaur apatosaurus (formerly

Eagle Man, a demon in tales of the Membrenos Apache, the Pima and other Native American peoples. According to some legends, he was initially human but allowed himself to be transformed into a monster by a witch.

Monster or demon depicted on a Crow Indian shield. In their variety and strangeness, the monsters of Native American legends are at least comparable to those of the Old World.

'The Flying Head', from a United States Bureau of Ethnology Annual Report (1880–81). The Great Head, or 'Flying Head', is an Iroquois monster who perches high on a mountain and eats human beings. This picture illustrates an Onondaga legend that one once spied on a woman baking acorns and, thinking she was swallowing live coals, fled in terror.

'Stone Giant or Cannibal', from a United States Bureau of Ethnology Annual Report (1880–81). According to one legend, the stone giants once tried to exterminate the Seneca Indians, but were tossed into a pit by the god of wind. According to another, a human being can only triumph over a stone giant by finding his removable heart.

known as brontosaurus), and rumours of the proximity of a Mokèlé-mbèmbé are still enough to send entire villages into a panic.

Reports of the chupacabra, which allegedly sucks the blood of goats and sheep, started in Mexico and Puerto Rico in the late twentieth century and quickly spread throughout Latin America, to the southwestern United States and even to Russia. Descriptions of this creature vary greatly, but according to some accounts it is a reptile about 3 feet high with green skin, large fangs and spines along its back. According to others, it more closely resembles a wolf or coyote. The persistence of such sightings shows that what we are calling 'imaginary animals' are not just survivals from another era, or an exclusive product of any particular civilization. Rather, their creation is a constant part of the human condition. They

are forever evolving in the human imagination in a way rather analogous to biological evolution, adapting, absorbing and dispensing with motifs, like fragments of the genetic code.

How Bigfoot Became a Unicorn

Accounts of monstrous human beings with hairy bodies and enormous strength may date to long before the start of what we call civilization. They could have been inspired by encounters with apes or even with members of species closely related to ours, such as the Neanderthals and the Denisovans. At any rate, they follow an amazingly consistent pattern from ancient times until today. Consider the following account:

> there was a trapper who met him [a humanoid] one day face to face at the drinking hole, for the wild game had entered his territory. On three days he met him face to face, and the trapper was frozen with fear. He went back to his house with the game that he had caught, and he was dumb, benumbed with terror... With awe in his heart he spoke to his father: 'Father, there is a man, unlike any other, who comes down from the hills. He is the strongest in the world, he is like an immortal from Heaven. He ranges over the hills with wild beasts and eats grass; he ranges through your land and comes down to the wells. I am afraid and dare not go near him. He fills in the pits which I dig and tears up my traps set for game; he helps the beasts escape.'[3]

American enlistment poster from the First World War. This figure owes much to the European lore of the wild man, to Victorian depictions of gorillas and perhaps even to American legends of Bigfoot.

This passage could very easily be an account of a sighting of Bigfoot or a sasquatch during the twenty-first century. In fact, it is of the appearance of Enkidu in Gilgamesh, the world's oldest known epic. The earliest complete manuscript of Gilgamesh we have is from the library of the Assyrian

king Ashurbanipal, which dates from the early eighth century BCE. There are several fragmentary versions in other ancient languages, and scholars generally trace its composition back to the early second millennium BCE.

At the suggestion of his father, the trapper goes to King Gilgamesh, who sends a prostitute to seduce the mysterious stranger. She tames Enkidu, much as the virgin would tame a unicorn in medieval lore. The two lie together for six days and seven nights, and then Enkidu returns to the animals:

> Then, when the gazelles saw him, they bolted away; when the wild creatures saw him they fled. Enkidu would have followed, but his body was bound as though with a cord, his knees gave way when he started to run, his swiftness was gone. And now the wild creatures had all fled away; Enkidu was grown weak, for wisdom was in him, and the thoughts of a man were in his heart.[4]

Soon, Enkidu is hunting wolves and lions for the shepherds. He goes to the city of Uruk, where he first wrestles and then becomes fast friends with King Gilgamesh, and they have many adventures together.

Another ancient figure has a similar story, and even has a horn, like that of the unicorn, in the middle of his forehead – the hermit Rishyasringa, or 'gazelle horn'. Versions of his tale appear in a few ancient texts including the Mahabharata, a Sanskrit epic which was written down in its present form between 300 BCE and 300 CE, but probably came from a far older account in oral tradition. The story begins as the sage Vibhandaka glimpses a celestial nymph while bathing and ejects semen into a lake. A hind drinks up the semen with the lake water, and becomes pregnant with Rishyasringa. She gives birth to a child who has the form of a human being, except for a single horn protruding from his brow. His father raises Rishyasringa as an austere hermit, without any contact with other human beings. There is a great drought in the land of Anga, and the ruler, King Lomapada, learns from Brahmans that the kingdom is under a curse which will only be lifted by the coming of Rishyasringa.

King Lomapada sends a courtesan, who builds a hut of leaves that floats on the river. She sails down the river to Rishyasringa, who has never before seen a woman and knows nothing of the ways of civilization. Rishyasringa offers her the humble foods that he is accustomed to, but she gives him fruits from gardens, wine, garlands and luxurious clothes. She charms him into entering her hut, and then together they sail to Anga, where a torrent of rain begins to fall. King Lomapada gives his daughter Santa in marriage to Rishyasringa, together with cattle, slaves and land. Vibhandaka comes to Anga, full of anger at the loss of his son and planning to burn the entire kingdom (for his power rivals that of the sun), but he is appeased upon seeing Rishyasringa and Santa in their full splendour. At the

order of his father, Rishyasringa, having accomplished his duties and sired a son, returns to the forest with Santa.[5] In its broad outline, this story closely resembles that of Enkidu, in which a powerful man with no knowledge of women or society is seduced into leaving the wilderness for civilization.

Other Unicorns

The occidental unicorn starts to take on the form familiar to us today in an account by Ctesias of Cnidus, a Greek physician and historian who was appointed to the court of the Persian king Darius II, around the start of the fourth century BCE. Among his books was an account of India, of which only a few brief fragments, transcribed in medieval times, remain. These fragments include a report of an animal resembling a wild ass, though at least as large as a horse, with a long horn in the middle of its forehead. Ctesias tells how dust from the horn is administered in a potion as a protection against toxins. The horns are made into drinking vessels, and those who drink from them are cured of epilepsy and are immune to poison. He adds that the animal is so swift that no horse or any other animal can overtake it.

The ancient physician gives his account a tone of scientific authority by providing a lot of specific detail about the colour of the animal and even concerning its ankle bone,[6] but the description does not match any documented creature. He may have been referring primarily to an Indian rhinoceros, a gazelle seen in profile or perhaps some variety of deer. This animal, the unicorn, was later mentioned by Aristotle, Pliny and other authors of the ancient world. It eventually became conflated with a horned animal known as re'em, the origin of which is similarly uncertain but is mentioned several times in the Bible. The re'em may have initially been a wild ox, an antelope or any large animal with horns. The Book of Daniel also contains a reference to a goat with a horn growing from its forehead, which, moving without touching the ground, defeated a great ram in a fight (8:5–7).

The Persian unicorn, or karkadann, whose name in Sanskrit means 'Lord of the Desert', has the heavy body of a rhinoceros, the hooves of a horse, the tail of a lion and a loud bellow that terrifies all other animals. Growing from its forehead is a large, curved, black horn. The karkadann is renowned for its ferocity, and kills even an elephant, which it then raises on its horn. The victory, however, does not last long, for the blood of the elephant blinds the karkadann, which soon finds itself helplessly pinned to the ground by the dead adversary's weight. The karkadann can be charmed by the ring dove or, like the unicorn in the West, by a woman.

The Chinese unicorn or qilin is perhaps the most iconic of all. It has the slender body of a deer, the hooves of a horse, the scales of a fish and the tail of an ox. Its chest is yellow and its back is of many colours. Its small, curved horn is white or silver, and far too delicate for combat.

Part of a unicorn horn (actually from a narwhal), formerly from the Museum of Rudolf II, Prague, *c.* 1610. A bit of dust might be ground from such a horn by an apothecary, after which it was placed in a drink in order to neutralize any possible poison. Elizabeth I once paid the equivalent of a third of a million pounds (half a million U.S. dollars) in today's currency for one.

The qilin is so gentle that it will not tread on fresh grass. To signify its divine nature, the qilin is sometimes depicted emerging from fire or clouds. Is the Western unicorn attracted to human girls because it can find no females of its own species? At any rate, the unicorn differs greatly in this respect from the qilin, which not only includes both genders but can represent the perfect harmony between them. The name is a combination of *qi*, which denotes the male, and *lin*, which denotes the female, and their union represents wedded bliss.

The qilin is one of the four auspicious animals of Chinese lore – the others being the dragon, phoenix and tortoise – and may be seen only on

Protections against poison, formerly from the Museum of Rudolf II, Prague, *c.* 1610. On the far right are two bezoars, stones from the intestinal tract of an animal which, placed in a goblet, reportedly protected the drinker against toxins. In the centre is a sort of 'unicorn horn', and on the right is a pill-box made of unicorn horn.

especially significant occasions, usually to celebrate the reign of a just emperor who has brought or is expected to bring peace and prosperity, or the death of a sage. In one widely disseminated legend, the first emperor of China, Fu Xi, glimpses a qilin beside the Yellow River and copies the marks on the animal's sides and back, which then become the Chinese alphabet. (The same story is sometimes told of a tortoise.) In another legend, just before Confucius's birth a qilin appears to his mother, carrying in its mouth a piece of jade carved with a prophecy that her son, though without rank, will rule like a king. She ties a ribbon to the qilin's horn, and the creature wanders away. Much later, Confucius hears that hunters had killed a qilin and, filled with foreboding, goes

to see the body. On seeing the ribbon still tied to its horn, Confucius weeps, for he knows that his death will soon follow.

The Unicorn and the Lion

Ever since James I ascended the throne in 1603, the lion of England and the unicorn of Scotland have been the two supporters of the Royal Arms of the United Kingdom, but their significance is not entirely clear.[7] The human tendency to think in terms of binary oppositions makes almost all animals that are paired in this way seem like contraries, even in the absence of much supporting evidence. Accordingly, the lion and the unicorn respectively may suggest day and night, sun and moon, war and peace, or fierceness and gentleness. They may also represent reality and imagination – in fact, this coupling probably contributed a great deal to the unicorn's subsequent use as a symbol of fantasy. But this contrast does not stand up very well to closer scrutiny, since the lion turns out to be as much a product of fable, symbolism and tradition as the unicorn is.

From ancient times until the Middle Ages, the bear rather than the lion had been regarded as the king of beasts in Europe, especially in the north. Walking upright had made the bear easy to anthropomorphize, and enormous strength made it virtually invincible to other animals. The lion, by contrast, was the king in more tropical regions, where bears were not indigenous. Lions had an ambivalent reputation in the Bible, which told

Arms of Princess Louise of Wales, Duchess of Fife. The lion of England and the unicorn of Scotland are used as supports, while the crest contains many other national and regional symbols.

how such heroes as David (1 Samuel 7:34–35), Samson (Judges 14:5) and Daniel (Daniel 6:1–28) had triumphed over them. Medieval painters sometimes showed the entrance to Hell as the gaping jaw of a lion. But these animals gradually became assimilated into Judaeo-Christian symbolism, where they had come to represent the Tribe of Judah, which was to produce the Messiah. The lion was said to wipe out its tracks with its tail as it walked, just as Christ hid his divinity to become a man.

As Europe became more Christianized, the clergy struggled to replace the pagan bear with the Christian lion. This involved hunting the bear to extinction in many areas, making a muzzled bear

dance in chains at festivals and belittling the bear in stories – but it still would be several centuries before the royal status of the lion came to be widely accepted.[8] The lion's ascent to the bestial throne took place roughly around the twelfth century; for many centuries previously, hardly anybody in Europe had actually seen a lion. They knew the animal only through a few references in the Bible and other ancient texts. This gradually changed with the Crusades, as more people travelled to the exotic lands of the Near East and more lions were brought back to show at fairs and in menageries. But 'lion' remained a fairly generic word for any furry animal with a large maw, which seemed capable of devouring human beings. The lion often looked rather like a bear in medieval sculptures;[9] just as the unicorn was often given a beard, the lion was often painted with the sort of luxuriant moustache that suggested a noble warrior.

A variant of the crest of Queen Victoria, 19th century. In this rendering of the Royal Arms, the artist has depicted the lion and unicorn in a more naturalistic style than is customary. They seem to be looking at one another a little uneasily.

In 1195, Richard I, known as *Coeur de Lion* or the Lionheart, chose as his royal arms three golden feline figures with their tongues extended, arranged horizontally against a red background. Parallels with similar motifs used in France suggest these animals were initially intended as leopards, and the debate about their nature has never really been resolved, but they have always been popularly accepted as being lions.[10] All in all, the lion of heraldry has about as much resemblance to that of the African savannahs as the unicorn does to a rhinoceros. Both the unicorn and lion of crests and storybooks are impossible to imagine apart from the symbolic meanings that have grown up over millennia, and it is hard to say which of the two is more fantastic.

A variant of the Royal Crest for Britain, 19th century. This is a good example of the extremes to which allegory was taken in heraldry. The English lion grows out of a rose, symbol of the Tudors, while the Scottish unicorn grows out of a thistle, symbol of the Stuarts.

From the London magazine *Punch*, 6 March 1901. This is a satire on the controversy as to whether the red dragon of Wales should be included, along with three lions, in the heraldic crest of Great Britain.

Tracking the Unicorn

The complex history of the unicorn, and similar beasts of legend, has been traced in detail by scholars. But extensive as this record is, there are many gaps in it. We do not know, for example, just what link there is, if any, between the story of Enkidu and that of Rishyasringa, or between the latter and the tale of a unicorn in the Physiologus. The gaps are a bit like those in the fossil record, and they invite speculation. Certain shared themes in all of the stories, beyond the motif of the horn, suggest a common genealogy. All of the various unicorns, even the karkadann, are capable of great gentleness. All are, at times, symbols of moral purity. Perhaps there is a single line of descent from the tale of Enkidu to that of Rishyasringa, which then branches in several directions, producing the qilin, the karkadann, the unicorn of Western bestiaries and many similar creatures. Perhaps at least some of these fantastic animals originated in independent traditions, which later influenced one another.

Vladimir Propp has written,

in its origin folklore should be likened not to literature but to language, which is invented by no one and which has neither author nor authors. It arises everywhere and changes in a regular way, independently of people's will, once there are appropriate conditions for it.[11]

One might go further and compare folkloric evolution of imaginary animals, which are mostly products of folklore, with the biological evolution of real ones.

This analogy prompts the question of whether the methods of biological classification and research could be applied to the study of folklore, and indeed this has long been done. In the early twentieth century scholars of the Historic-Geographic School attempted to place folklore, which had previously been a relatively unstructured discipline, on a scientific basis by compiling elaborate indices of motifs and tale types, in order to trace the evolution of folktales. This culminated with the 1958 edition of Stith Thompson's massive *Motif-Index of Folk Literature*.[12] Well over half a century ago, folklorists had explored the quantitative methods that are just now starting to become popular in the humanities, and their experience may tell us a bit about the successes and limitations that researchers using these methods in related disciplines will encounter.

One difficulty encountered by the Historic-Geographic School in trying to chart the evolution of folktales is that the nature and distribution of tales is dependent on circumstances that cannot be easily reconstructed, such as the appearance and itineraries of a few gifted storytellers. Furthermore, our records of oral traditions, no matter how conscientiously collected, are always very incomplete, and our classifications are usually less a matter of profound structures than of almost arbitrary details. The greatest service of the Historic-Geographic School has probably been to find ways of classifying and inventorying tales so that it is relatively easy for researchers to locate them. Analysis of the geographic distribution of folklore motifs has also confirmed that most tales have a limited geographic range, though a few, such as 'Cinderella', are virtually global. But folklorists who hope to trace the evolution of a story in more than a very approximate way must still at times resort to less highly structured methods.

One might certainly attempt to trace the folkloric evolution of creatures such as the unicorn or dragon in a similar way. Improvements in computer technology since Thompson wrote the *Motif-Index* could enable researchers to do this with far greater sophistication. One might, rather in the manner of biologists, measure the relative length of a unicorn's horn against its height, and try to trace how the ratio has changed over the centuries. Creating a database to trace the origins of imaginary animals would be a massive undertaking, since it would involve cataloguing countless visual representations, many of which are in the basements of museums or in private collections. This would be hard to finance in difficult economic

times, and it is by no means certain how much it could tell us about imaginary animals in the end. Those who seek to predict the course of the economy often find that the most important trends are hidden in a vast blizzard of data, and may do best to rely on educated intuition. Those who search for terrorists often have to lay aside their charts and graphs and rely instead on anecdotes and hunches. Those on a quest for a yeti or a unicorn must to do the same.

The Perytion

The Book of Imaginary Beings by Jorge Luis Borges and Margarita Guerrero briefly describes the fantastic creatures of folklore and literature. It covers 117 of them, from Abtu to the zaratan, all attested by learned references. Yet one creature stands out from the others in this menagerie – the perytion. There is only one known document that has described it, a 'Treatise on the Perytion', which Borges and Guerrero quote in part, and which begins:

> The perytion inhabits the island south of Atlantis, and is a creature half stag, half bird. It possesses the head and feet of the stag, and, as for the body, it is that of a perfect bird, with all its feathers and plumage.
>
> The most astonishing feature of this beast is that when it is struck by the rays of the sun, the shadow it throws upon the ground is not that of a figure, but rather that of a human being; from this circumstance, some have concluded that the perytions are the souls of men who died far from the protection of the gods . . .

The Treatise goes on to say that when a perytion kills a man or woman, the deities again look on the animal with favour, and it obtains a shadow that corresponds to its own form. Scipio and his soldiers were nearly destroyed by a flock of perytions on their sea voyage to Carthage, but, fortunately for them, each perytion would kill only a single man, and so some survived.

And what is the source of the treatise? The authors explain that it was quoted in a sixteenth-century work by a rabbi, whose identity remains uncertain, in Fez, who copied it from the book of an unidentified Arab author. The original was lost when Caliph Omar burned the library at Alexandria, but a copy of the rabbi's pamphlet was stored at the University of Munich; it disappeared during the Second World War, so the genesis of the creature, Borges and Guerrero concede, is extremely obscure.[13]

Borges first became known as a book reviewer; he would imagine tales so grand in conception that they could never really be composed, and then invent writers and publishers for them. He would then critique the novels in literary journals, leaving curious readers to search for them in vain. In all likelihood, the perytion is one such 'novel', and the 'pamphlet' is itself a fantasy. Yet the reviews by Borges were not simply sham, for they themselves

are read as literature today. As to the perytion, some readers may be tempted to object, 'Fraud! The perytion is not a *real* imaginary animal! The authors made it up.' Borges, were he still alive, might then reply, 'So, you concede that imaginary animals are real . . .'.

Herbert Draper, *Ulysses and the Sirens*, 1909. In ancient Greece and Rome, the sirens were birds with the faces of women. They became conflated with mermaids in the Middle Ages, and then were increasingly sexualized in the Victorian and Edwardian periods. As soon as they leave the water these sirens lose their fish tails and become seductive young women.

SIX
MONSTERS

O devil, devil!
If that the earth could teem with woman's tears,
Each drop she falls would prove a crocodile.
Out of my sight!
Shakespeare, *Othello* (IV, i)

WHY DO PEOPLE LOVE MONSTERS? Largely because of them, Dante's *Inferno* is far more popular than his *Paradiso* or his *Purgatorio*, and Bosch just might be the most popular painter of all time. Many explanations for the popularity of monsters have centred on the idea that there is a profound kinship between the sacred and the profane. The Romanian historian Lucian Boia refers to imaginary animals, at least those with some human characteristics, as '*l'homme différent*', which may be translated as 'the human other'. He writes that

> In order to know this person of a thousand faces, at times without a face at all, one must displace oneself to the furthest limits of the human, even beyond them, in order to enter a zone where contours are imprecise or the generally accepted norms of the human condition are continually transgressed.

This is a manifestation of 'radical alterity', and is disorienting even without sharp teeth, pointed horns or magical powers. On a moderate scale, this creature may even be a being within the parameters of fairly normal humanity yet in some way extreme – a dwarf, giant, Amazon or cannibal, for example. Otherwise, it is a creature that has some features which at once differentiate it from humanity and simultaneously dramatize some aspect of the human condition. The sirens of Greek mythology, for example, sing beautifully in order to lure sailors to their doom. They are usually depicted in antiquity with the torsos and heads of women but the bodies of birds (and, since the Middle Ages, as mermaids), which corresponds to the impossible nature of the harmony promised by their songs.[1] Monsters are creatures that, by providing the sharpest possible contrast, help us to define our humanity.

Another theory is suggested by the work of the theologian Rudolf Otto, who called the sense of the sacred the *mysterium tremendum*, or 'wholly other'. This is the awareness of a reality that cannot be grasped by our concepts and that eludes every attempt at formulation. We cannot even rightly say that God 'exists' or that he is 'good', for God transcends dualities such as those of good and evil. This is a reality so great that finally

all of our rationalizations fall away, and we can only stand in wordless contemplation of the divine presence.[2] Both the sacred and the profane, then, join in eliciting a sense of the numinous.

Perhaps the most intellectually sophisticated attempt to explain the apparent kinship of things sacred and profane is that of the anthropologist Mary Douglas in her book *Purity and Danger* (1966). She argues that religious prohibitions such as those in the Old Testament, especially in Leviticus, sustain and reinforce the categories by which people of a culture divide up the world. Her view, in many ways the opposite of Otto's, is that holiness is order, while its contrary is confusion. Accordingly, 'clean' animals are those 'without blemish', those which conform perfectly to type. Following the Creation, Yahweh divides creatures into those of the water, sea and air. Leviticus calls animals that do not appear to have the appropriate structure and means of locomotion 'unclean'; thus creatures that seem to have 'hands' instead of front feet, yet use these hands for walking, are abominations – animals such as the mouse, crocodile, chameleon and mole. A worshipper who touches them may not approach the temple until he has been purified. The pig defies conventional categorization because it has cloven hoofs but is not a ruminant, so it is also considered unclean (Leviticus 11:1–8). By defying our attempts at conceptualization, certain creatures undermine our existential security, blending human and animal, fish and fowl, or male and female.

J. B. Coriolan, 'The Crane Man', illustration from Ulisse Aldrovandi, *Monstorum historia* (1642). Possibly more than any other of Aldrovandi's monsters, the crane man appealed to the popular imagination in the latter seventeenth century. Crane men were sometimes said to live in the remotest parts of Africa, where they made war against the griffins. One was also reportedly captured in Hungary by the Italian Count Serin in 1664 during a war against the Turks.

Sirens, from a wall painting at Pompeii, mid-first century BCE. In Greece and Rome, sirens were generally painted as birds with heads of women, a representation probably derived from the Egyptian practice of painting the *ba* or soul as an avian with a human, usually female, head.

But, according to Douglas, no system of classification can ever be entirely complete or comprehensive, and there will always be anomalies. For that reason, it is necessary to sacralize some things that would normally be considered abominations. Blood may be considered unclean under most circumstances, but it is brought into the temple during animal sacrifices.[3] This might explain why Christian painters include an occasional zoomorphic monster, such as the cynocephalic St Christopher, among the blessed in Heaven.

The aesthetic of the Sublime, popular in the latter eighteenth and nineteenth centuries, found a cosmic grandeur in situations that were violent

'Sirin, the Heavenly Bird', Russian popular print of the early 18th or late 19th century. The sirin of Russian legends has the head and chest of a woman, a splendid crown, the body of a bird and a beautiful, seductive voice. It lives near the biblical Garden of Eden.

Argus sea monster, from *Monstrum in Oceano Germanica* (1537). Creatures of the sea often seem so strange as to almost elude any description, but they are generally depicted as composites of more familiar creatures. This one seems to have eight eyes, like a spider, together with the scales of a fish, feet of a duck and head of a boar.

or extreme.⁴ Violent tempests, cataclysms and primeval forests had an intense Romantic appeal for the Victorians. The era's increasing secularism produced nostalgia for the religiosity, and even the barbaric splendour, of the Middle Ages and, in a world that appeared desolate of enchantment, demons could even bring one closer to God. But unlike late medieval and Renaissance artists, the Victorians, particularly those associated with the Pre-Raphaelite Brotherhood, were focused far more on angels than on devils. The occasional imps in their paintings seem more mischievous than fearsome, and these figures dramatize not diabolic authority but transcendent supernatural powers.

All of these theories make fantastic animals – particularly demons – repudiations of the human form and, in many cases, even of the cosmic order. This is a recurring theme in the study of them, which is at times called 'monsterology', but that perspective is not by any means universal. The theories have an elegant simplicity and some explanatory power, but they do not do full justice to the complex play of observation, imagination and conjecture that goes into the creation of fantastic creatures.

Eat and Be Eaten

In his book *Deadly Powers: Animal Predators and the Mythic Imagination* (2012), Paul A. Trout provocatively argues that a fear of being eaten by predators is the origin of religious awe and, ultimately, the foundation of all worship. As evidence, he points out that features of predators such as the gaping mouth, huge teeth, powerful claws and intense stare may be found in many figures of myth and religion, such as the Egyptian deity Sekhmet, the Hindu goddess Kali and the Chinese dragon. According to Trout, early human beings and their ancestors lived in perpetual terror of the enormous carnivores of prehistoric times. As they gradually developed new weapons and worked their way up the proverbial food chain, human beings began to identify with these predators, and often assumed their characteristics in the imagination. As people attempted to defend themselves against, conciliate, subjugate and trick the great predators, these figures were given ever more varied and colourful forms.⁵

J. Augustus Knapp, *Abraxas*, early 20th century. All opposites combine in the ancient Greek figure of Abraxas, which the psychologist C. J. Jung considered a more elevated deity even than Yahweh.

This theory makes the tale of humanity a relatively simple one – an ascent from subjugation to supremacy among the animals. But I suspect that Trout, like many good storytellers, is so caught up in the drama of his tale that he at times neglects to check it against the evidence. Large predators are by no means predominant among early divine figures. In prehistoric cave paintings, which certainly evoke awe, herbivores such as horses, mammoths, cattle, ibexes and rhinoceroses are more prominent than carnivores such as large cats and bears. Some powerful flesh-eating animals such as wolves and crocodiles are rare. In the earliest known shrines, in Çatalhöyük in

'The Mouth of Hell', from *The Hours of Catherine of Cleves*, 1440. Hell has often been conceived as a giant predator, with a mouth like that of a serpent or, in this case, a lion.

Anatolia, the animals most venerated were not carnivores but bulls.[6] The animals that have figured prominently in religion and its iconography have always been a very broad mix with regard to size, habitat, food and just about everything else.

While Trout is certainly right that early human beings and their ancestors constantly lived with the prospect of being devoured by predators, he probably overstates the terror that this evoked. Most wild animals also live with this likelihood, yet it does not seem to dominate their lives, which retain plenty of scope for play, if they are inclined to that, and relaxation. They are like the squirrels that run nonchalantly across telephone wires over busy streets, in addition to defying birds of prey, yet give no impression of being terrified as they chase one another in fun. We regard both death and pain with far more terror than wild animals do, because we have become so unused to both. For our remote ancestors as well, the spectacle of death was an everyday experience, and they probably had no philosophy that endowed it with a terrifying sense of finality.

Living in an era where homes contain entire cabinets of painkillers, sedatives, rubs, antidepressants and similar products designed to relieve every conceivable physical discomfort from sore muscles to itchy skin, we can also hardly imagine the sort of pain that our ancestors, like most animals, took for granted. Certainly, they did not welcome a painful death, but they would almost never have had an entirely peaceful one, and they may have accepted death by predation in a spirit of earnest play. Perhaps they even saw such killing as a relatively benign option, compared with the prospects of death by starvation or disease.

But the fear of predators remains central to many tales and images of imaginary animals. If authors such as Trout have exaggerated even its truly enormous importance, that is one more testimony to the hold that monsters retain over our imaginations. These might not necessarily be the oldest or most profound of imaginary animals, but they certainly generate the most literature, both popular and academic.

Slaying Dragons

No ruler or priest has ever come close to banishing imaginary animals from tales or from books, though some have tried. Not all societies have felt comfortable with fantastic creatures. Some, especially those that ascribe to one of the Abrahamic religions, have seen them as idolatrous and even diabolic. Others, such as those of ancient Greece and Rome, have often perceived them as barbaric, grotesque and irrational, as desecrations of the natural world or the human form. But during a crisis, the unspoken taboo against fabulous beasts can disappear almost entirely, producing a sudden profusion of bizarre creatures.

A wilderness filled with monsters that must be slain in order to make room for civilized life is an old, and fairly universal, cultural motif. Several heroes of legend made it their business to kill monsters in order to banish chaos and prepare the

Extinct animals, from S. G. Goodrich, *Johnson's Natural History* (1867). Prehistoric animals are depicted after the model of medieval dragons, rearing up to strike. There is no sense that the various creatures belong to different eras, and an evolutionarily modern bird appears alongside the dinosaurs.

way for civilization: the Mesopotamian Gilgamesh, the Greek Theseus, Sun Wukong of Chinese legend, the Anglo-Saxon Beowulf, the Pöqanwhoya twins of Hopi myth, Mantis of the !Kung people of southern Africa, and the American Davy Crockett among them.

This view even found its way into popular science, where the savage dinosaurs were often depicted with great exuberance, while their demise was interpreted as evolutionary 'progress'. This is reflected, for example, in the way that the dinosaur *Tyrannosaurus rex* was, until the late twentieth century, generally depicted based on the model of the medieval European dragon, rearing almost upright and dragging a massive tail. This 'king' of dinosaurs was one more embodiment of primeval chaos, which needed to be overcome to make way for the eventual triumph of humankind.

The English word 'monster' goes back to the Latin *monstrum*, a derivative of the verb *monere*, meaning 'to warn'. Soothsayers have often interpreted the appearance of monsters as a sign of impending disaster, and reports of imaginary animals, especially monsters, proliferate in times of

A traditional picture of the dinosaur *Tyrannosaurus rex*. Until the last decades of the twentieth century, palaeontologists modelled their images of *Tyrannosaurus* after the medieval dragon, rearing upright on powerful hind legs and fighting with its smaller forelegs. In this picture, the Tyrannosaurus, by adopting that posture, has just exposed its belly to an attack by another dinosaur, which charges with a horn, almost like a knight on horseback with his lance.

crisis, when catastrophes force people to reconsider the very foundations of their culture. To overcome their disorientation, people facing the prospect of a catastrophe often feel compelled to rethink what it means to be a human being, and, with this, their relation to deities and animals. It was in such a period of uncertainty, according to the Hebrew Bible, that the Israelites returned to the worship of a golden calf (Exodus 32:4–20), probably a form of the Egyptian bull god Apis.

The best example is the biblical Book of Revelation, which was written in response to the persecution of Christians under Nero and other Roman emperors. In the words of Timothy Beal,

Nicolas Bataille, *Apocalypse of Angers*, French tapestry, 1373–87. Frogs spring from the mouths of the Beast, Dragon and False Prophet as they are confronted by an angel of the Apocalypse, a sign of the filth inside them.

John's apocalyptic imagination is the wellspring of an overwhelming, primordial flood of monstrosities, climbing in and out of the world, as the boundaries between Heaven and Hell, sacred and profane are washed away in blood, gore, and bowls of plague and abomination.[7]

The Devil takes the form of a huge red dragon, which appears in the sky. It has seven heads, each with a crown, and ten horns, and sweeps a third of the stars from the sky with its tail. This monster is driven out of Heaven by the Archangel Michael, but then the Beast – which has seven heads, ten horns, the body of a leopard, the paws of a bear and the mouth of a lion – emerges from the sea (Revelations 12).

The Devil and his minions may be terrifying, but the figure representing Christ is even more so. The adversary of the Beast is the slaughtered Lamb of God, which has seven horns and seven eyes (5:6–14). Around the throne of God are four creatures: a lion, a bull, a man and an eagle. Each of these has six wings and eyes all around its face (4:7–8). Standing between the throne and the Elders of Israel, the Lamb breaks seven seals on a scroll. With the breaking of each seal there are new visions of death and destruction, and with the sixth seal:

IMAGINARY ANIMALS

Albrecht Dürer, from *The Revelation of St John* (1493). The combination of stark realism and mystical allegory in this woodcut makes the Beast and his minions especially terrifying.

there was a violent earthquake and the sun went black as coarse sackcloth; the moon turned red as blood all over, and the stars fell from the sky like figs dropping from a fig tree when a high wind shakes it; the sky disappeared like a scroll rolling up and all the mountains and islands were shaken from their places. Then all the earthly rulers, the governors and the commanders, the rich people and the men of influence, the whole population, slaves and citizens, took to the mountains to hide in caves and among the rocks. They said to the mountains and the rocks, 'Fall on us and hide us away from the One who sits on the throne and from the anger of the Lamb. For the great day of his anger has come, and who can survive it?
(6:12–17)

Finally, the Lamb breaks the seventh seal, and there is silence in Heaven (8:1). The Beast and the False Prophet, together with the sinners who followed them, are thrown into a lake of fiery sulphur, where they must burn forever (19:20–21; 20:10). The outbreak of chaos and destruction was, like the Flood that only Noah and his family survived, intended to destroy the old order; ultimately, a New Jerusalem is created for the just. With its wild profusion of images, the Book of Revelation established much of the iconography that would pervade traditional Christianity for the coming millennia, while also contributing to a wide range of secular activities, from political agitation to horror films.

Monsters of the Underworld

The idea of an underworld filled with demons that blend human and zoomorphic features is found not only in Christian but Zoroastrian, Indian, Chinese, Islamic, Maya, Aztec and other civilizations. However, it was especially central in the European Middle Ages and Renaissance. When

The Dragon and Beast cast into Hell, from the *Cloisters Apocalypse*, Normandy, France, c. 1330. In this depiction of the last days, even the Devil has an expression of bestial innocence, as though in recognition that he, like everyone, is simply following the divine plan.

depictions of Hell began to become popular in around 1000 CE, demons were generally modelled after either the satyrs of Graeco-Roman mythology, or else on monkeys. Artists depicting demons gradually began to show greater imagination, in particular by blending features of many animals, such as the wings of the bat, the tail of the snake, the tusks of the boar, the hoofs of the goat, the horns of the ox, the face of the dog and the claws of the hawk.

After European trade with China was established by Marco Polo and others at the late thirteenth to the early fourteenth century, the motif of bat wings was taken from Chinese art and applied to demons (ironic, since bats are a symbol of good fortune in Chinese art). These were intended to distinguish devils more sharply from angels, since their means of locomotion now marked them as creatures of the night.[8] Some Italian artists of the sixteenth century, influenced by the new reverence for the human form, eliminated almost every anthropomorphic trait from their devils, which even ceased to move on two legs. In Raphael's *St Michael and the Dragon* (*c.* 1505), for example, the demons are composites of many bestial features, including the heads of dogs, horns of bulls and necks of serpents. Only their bulging eyes and long, gesticulating tongues seemed to suggest a vestigial trace of human emotion.[9] But devils in works by other Italian

Paolo Uccello, *St George and the Dragon*, 1456–60. The painter seems to be showing off his virtuosity, not only in the skilful use of perspective but in constructing a dragon which combines features of many animals, including butterflies, bats, snakes, dogs, birds and pigs. The only part of the monster that seems remotely human is its eyes, and one of them is being pierced by St George.

Raphael Sanzio, *St George and the Dragon*, 1505. The monster here is a composite of many creatures, worthy of Hieronymus Bosch. Its deformity contrasts with the rest of the picture, in which St George, his horse and the maiden are idealized and unaccountably serene.

artists, such as Michelangelo (1475–1564) and Luca Signorelli (c. 1445–1523), probably out of disillusionment with humanistic ideals, are physically almost indistinguishable from human beings, and express their fury through straining limbs and contorted faces.[10]

But no matter how human or how fantastic, pictures of demons consistently showed at least one zoomorphic characteristic. The lives of wild animals centre largely around food – around eating and, when possible, avoiding being eaten. In sixteenth-century depictions of Hell the sinners are hardly ever shown eating, and when they are, it is a revolting meal such as a toad that the guilty one is being forced to swallow. The devils, by contrast, are constantly shown herding, cooking and devouring the damned. In the familiar world of human dwellings, it is people who do

IMAGINARY ANIMALS

Detail of Luca Signorelli, *The Last Judgement*, 1499–1504. Except for horns and the colour of their skin, the demons here seem almost entirely human. They show their rage through muscular tension and facial expressions.

these things to animals, but in Hell this relationship is reversed.

Heaven in Western painting, especially from the Middle Ages through the Renaissance, is a place of exquisite regularity, where hierarchies are clear and dress codes are seldom tampered with. It may occasionally hold a stately griffin or a dignified cynocephalus, but these are rare, while dragons and basilisks are never seen. Nobody is even seriously overweight, let alone deformed. By contrast, Hell, especially in Renaissance art of northern Europe, is full of fantastic composite creatures, but, imaginative as the combinations may be, they are not arbitrary, and certain motifs appear regularly. Demons often have the torsos of human beings, wings of bats, tusks of boars,

The Limbourg Brothers, 'Vision of Hell', from *Très riches heures du Duc de Berry* (14th century). In late medieval depictions of Hell, zoomorphic demons herd, execute, cook and eat sinners, just as people do with domestic animals.

Hieronymus Bosch, 'Hell', detail from the triptych *The Garden of Earthly Delights*, 1503–04. The punishments of the damned here are closely tied to the biological functions, especially eating and elimination. Sinners are being trussed up, herded and cooked like animals. A demon on a privy swallows human beings and then excretes them.

Martin Schongauer, *St Anthony Tormented by Devils*, 1470–75. The diabolical creatures are largely inspired by remains picked up on the seashore or seen at the fish market.

horns of bulls, tails of monkeys, scales of fish, eyes of cats, ears of donkeys and/or talons of hawks, though they do not conform to any clear pattern or form. If Heaven represents order, Hell is the place of chaos. In John Milton's *Paradise Lost* (1667), the capital of Hell is called 'Pandaemonium', meaning literally 'all demons', but the word has since come to designate any eruption of mayhem.

Martin Schongauer (1448–1491), one of the many northern European artists who specialized in depicting demons, took much of his inspiration from the fish and fowl on display at meat markets, combining their forms in very inventive ways, as in his etching *St Anthony Tormented by Devils* (c. 1470–75). The artist most famous for his portrayal of demons is the Flemish painter Hieronymus Bosch (1450–1516), especially for his triptych *The Garden of Earthly Delights* (c. 1503). Perhaps no other painting in history has so perplexed critics, generating almost endless theories, some almost as imaginative as the picture itself: it is said to

represent the esoteric code of a secret society; life before the Flood; a utopia; the New World; and so on. Perhaps no other painter had such an unfettered imagination as Bosch, though, from everything we know, he was sternly conservative in his religious views.[11]

In the first painting in the triptych, depicting Paradise, most of the creatures are natural, but quite a few, especially those near the water, are not. There is a three-headed bird with scaly wings and a tail like that of a peacock in the foreground of the lower-right corner, next to a sort of merman with a long nose who reads a book as he floats. Many of the creatures are not identifiable as any sort of animal at all, but look as though they might have been constructed from odd bones and shells picked up along the shore.

The fantastic animals proliferate still more in the middle panel, as naked men and women cavort bizarrely with strange creatures of all shapes and sizes. Alongside the relatively naturalistic horses, birds and bears there are assorted unicorns and merfolk, but many creatures elude any attempt at classification. To give just one example, emerging from the forest in the upper-right corner of the painting is a creature with a protruding snout, horns like a deer's, a turtle's shell, a spider's legs and a lizard's tail.

Then, finally, there is the scene of Hell, where disorder reigns supreme and not a single naturalistically depicted animal is left. Fantastic demons torment human beings in diabolically ingenious ways. In the foreground, a demon with the head

Hieronymus Bosch, 'The Garden of Eden', detail from the triptych *The Garden of Earthly Delights*, 1510–15. The creation of Adam and Eve here is attended by a sense of foreboding. Even in Paradise lurk unnatural, and probably demonic, creatures.

of a rabbit and the body of a man carries a sinner, perhaps a man once too devoted to the chase, trussed up and tied to a pole like freshly killed game. A demon in the lower-right corner has a huge eye and mouth, a beak rather like an owl's, a human torso, blue skin and a huge kettle on its head. It sits on a privy, swallowing sinners and then excreting them into a pit. In the midground demons have bound sinners to fantastic musical

Hieronymus Bosch, *The Garden of Earthly Delights*, 1503–04. Perhaps no other painting has mystified critics for centuries to the same extent as this one. Its imagery seems to suggest enormous fertility, but without purpose or restraint.

Hieronymus Bosch, 'Hell', detail from the triptych *The Garden of Earthly Delights*, 1503–04. The artist blends symbols from Christianity, alchemy and folklore, but in ways that elude all attempts at interpretation.

instruments and are forcing them to sing a diabolic song. One poor man looks out of the hole in a drum at the face of a demon with gleaming eyes, a feathered crest, feline whiskers and legs that end in enormous claws, who grasps his instrument in one human hand and pounds it with a drumstick held in the other. In the centre is another with the body of a broken egg and two legs made of hollow trees; on its hat is a bagpipe, and fantastic demons march sinners around its circular rim. And what does all of this mean? The images are all enormously suggestive, yet no interpretation of them seems to explain more than a few, almost arbitrary, details. Whatever the painter's

religious or philosophical beliefs may have been, they do not seem to have either guided or inhibited his imagination.

Monstrous Births

In the early modern period the word 'monster' was used most frequently to refer to people and animals with what we now call 'birth defects' – a cow with two heads, a pig with a single eye, Siamese twins and so on. Such births were thought to presage a disaster, a return to primordial chaos. Folklorists speculate that they may have been the origin of many figures of myth, such as Sleipnir, the eight-legged steed ridden by the god Odin in Norse mythology. These have generally been the most paradigmatic – that is, the most 'monstrous' – of monsters, the ones that evoke the greatest awe or horror. And if that terror is now somewhat softened by scientific explanations of deformities, modern legends and popular entertainments show that it has by no means disappeared. Deformities can also evoke prurient fascination, which is why figures such as bearded ladies and Siamese twins were exhibited in freak shows by entertainers such as P. T. Barnum.

Creatures perceived as strange or anomalous have often been attributed to monstrous births. Jewish and Islamic legends make the innumerable demons of the desert the deformed progeny of Lilith, the first wife of Adam. According to some Christian legends of the late Middle Ages and Renaissance, demons were, as mentioned

Announcement of the birth of two human 'monsters', one with a pig's head and the other with the hind part of a calf, from a broadside printed in Nuremberg, 1578.

previously, the products of an adulterous union of Eve and the serpent of Eden. Other legends make them the progeny of Adam's daughter, of Cain, or of Noah's son Ham.[12] In historically more recent times, Helena Blavatsky, co-founder of Theosophy, believed that apes were descendants of a race of people from the 'lost continent' Lemuria, who had copulated with animals.[13]

But monstrous births could evoke not only revulsion but also wonder. In the popular tale of

Melusine, the water fairy of Lusignan, the young Count Raymond kills a hunting companion by accident and wanders through the woods, lost and, in any case, afraid to return home. He encounters Melusine near a fountain. She befriends him and agrees to marry him, but only on the condition that he must never observe her when she takes her bath on Saturdays. They live happily for a time in her castle and have several children, but all of them are deformed – Urian, who had one red eye and one blue one, as well as the ears of a hare; Eudes, with one ear far larger than the other; Guion, with one eye placed far above the other; Antoine, with a lion's mane and a mark like a lion's claw on his left cheek; Renaud, with a single eye in the middle of his forehead; Geoffrey, with a tusk like that of a boar; Fromont, with a large patch of hair on his nose; and Horrible, with three eyes. Only the last of these proves to be morally deficient; the others acquit themselves well according to the standards of chivalry, fighting in crusades against the Saracens and building castles, though their families will remain troubled for generations to come.[14]

In time, Raymond grows suspicious of Melusine, and observes her in her bath through a tiny hole in the door, to see that she has become a serpent from the waist down. Later, in an argument, the story goes, he calls her 'odious serpent'. She then permanently assumes her serpentine form and flies three times around the castle singing a moving song of farewell, and disappears. The tale was written down as a long poem by Jean d'Arras in around 1382–94 for the Duke of Berry, who wished to trace his descent from the water fairy,[15] and it was frequently retold and translated. The suggestion of witchcraft that accompanied Melusine must have conveyed at least as much glamour as fear, since many wealthy families of France and Luxembourg later altered their histories in order to claim descent from her. Descendants of Melusine and Raymond included the Kennedys of the late Middle Ages.

Monstrous births occur often in European fairy tales. In 'Hans My Hedgehog' by the Brothers Grimm, a peasant says in frustration that he would rather have a hedgehog for a son than remain childless. Accordingly, his wife soon bears a boy who has the head and upper body of a hedgehog

J. B. Coriolan, 'Sheep with a Monstrous Head', illustration from Ulisse Aldrovandi, *Monstorum historia* (1642). Whatever the origin of this figure may be, the head bears a great resemblance to masks worn by people at Italian carnivals.

but the lower body of a human being. Unable to make his way in human society, Hans My Hedgehog wanders into the forest, where he rides on a rooster, plays the bagpipes and raises pigs. At one point in the folkloric development of his legend, Hans My Hedgehog was probably a spirit of the forest – a troll, elf or goblin – which could be used to terrify village children into good behaviour. His story, however, is similar to that of Madame de Beaumont's 'Beauty and the Beast', for in the Grimms' tale, the loyalty of a young woman, who consents to marry Hans despite his form, enables him to become fully human.[16]

The Minotaur

Among the most monstrous births in all mythology is that of the Greek Minotaur, who has the head and tail of a bull but the body of a human being. According to the myth, Poseidon, the god of the sea, presents Minos, King of Crete, with a beautiful white bull, which rises from the waves. The god intends that Minos should sacrifice the bull to him, but Minos kills another bull, the finest of his herd, instead. In revenge, Poseidon makes Minos' wife, Pasiphaë, fall in love with the white bull, and seduce it by placing herself inside a wooden cow covered with hide. Pasiphaë then gives birth to the Minotaur, and Minos builds an underground maze known as the Labyrinth to conceal the monster. Seven youths and seven maidens are sent by Athens as a tribute to be sacrificed to the Minotaur every year, until the hero Theseus is delivered to the beast. Minos' daughter, Ariadne, falls in love with Theseus and smuggles a ball of yarn to him – to unroll as he wanders so that he can find his way back – and a sword, with which he will kill the Minotaur.[17]

Long before this Greek tale, the bull and cow had been symbols of fertility. In the cave paintings of Europe, the bull is the most frequently depicted animal. In Egypt, the bull was an avatar of the god Ptah, and very closely associated with the pharaohs. The Sumerian Anu, like other gods of Mesopotamia, was at times depicted with the head of a bull and the body of a man. Veneration of bovines continues even today in India, where they are not eaten and are allowed to run freely.[18]

The cult of the bull reached an apogee in ancient Crete. The Labyrinth of myth was probably inspired by the intricately constructed palace of the Cretan king. The vanquisher of the Minotaur, Theseus, was also the founder of the city-state of Athens, credited with bringing civilization by taming the wilderness and introducing the rule of law. The story celebrates not only the triumph of Athens – and, by association, all of Greece – over Crete, but also civilization over barbarism. More specifically, it affirms the superiority of the Greek religion, with its anthropomorphic gods, over the animal cults of other peoples.

The story of the Minotaur is part of a longer mythological narrative, with as many characters as an epic novel and more melodramatic twists of fate than any soap opera. The lives of the Greek gods and heroes characteristically mix elements

George Frederick Watts, *The Minotaur*, 1885. The Minotaur here gazes out at the sea, anticipating the arrival of youths and maidens that will be sacrificed to it. It has crushed a small bird in its hands, a symbol of youthful innocence. Watts painted this canvas as part of a crusade against child prostitution in Victorian England.

that are thoroughly grandiose with others that are not only 'human' but petty and undignified. The tale of the Minotaur, like many stories by Homer, contains elements of satire. Is this really how our august kings and queens behave? That Pasiphaë should prefer the bull to her husband is quite an insult to Minos. That she should have to disguise herself in a dummy in order to mate does not reflect well on her attractiveness. For Minos to hide her progeny in an underground labyrinth is anything but kingly. But, even if the story may largely be a spoof, it is full of images that linger in our imaginations. Through the Renaissance and after, the Minotaur remained a symbol of all that was bestial or primitive, and its slaying was seen as a triumph of civilization over savagery. In the turbulent decade or so leading up to the Second World War, the painter Pablo Picasso, an aficionado of the bullfight, frequently used the Minotaur in his work as a symbol of masculine aggression. Psychologists in the twentieth century often interpreted the Labyrinth as a symbol of the unconscious mind, while the Minotaur represented the atavistic and destructive impulses that lurk within it.

The Basilisk

Among most terrifying of all monsters was the basilisk. According to various accounts, it can kill with its scent, its hiss, the touch of its tail and, above all, its glance. Its name means 'king lizard' and it is generally depicted as a snake wearing a crown. There are several references to the basilisk in the ancient world, but the most famous is from Pliny the Elder's *Natural History* (c. 77–9 CE). He reports that if a horseman pierces the basilisk with a lance, the venom from its body will travel up the handle to kill both rider and horse.[19]

Ancient writers said nothing of the origins or habits of the basilisk, but in the Middle Ages scholars described it as a product of a monstrous birth. The English abbot Alexander Neckham (1157–1217) called it a 'cockatrice' and said it was 'an evil unique in the world'. According to Neckham, the basilisk/cockatrice was hatched from an egg laid by an old cock and incubated by a toad.[20] Later representations of the basilisk emphasized its unnatural character by making it a composite of a vast number of creatures: it might have the comb, wattle and claws of a rooster; the mouth and torso of a toad; the wings of a bat; the horns of a stag; and the tail of a snake.

In the early modern period, when people died mysteriously investigators would sometimes launch a basilisk hunt, observing an area indirectly by using mirrors in the hope that the reflected image of a basilisk would not prove fatal. In 1587 two young girls were found dead in a cellar in Warsaw, Poland. The police assigned a condemned man to investigate and outfitted him with mirrors. When he emerged with a snake, it was judged to be a basilisk.[21]

That may have been the last recorded basilisk hunt, but the idea of the monster was too powerful to simply fade away. Though they were not

Basilisk, formerly from the Museum of Rudolf II, Prague, *c.* 1610. This monster could reportedly kill people with just a glance, and perhaps that is why its features are obscured by shadow.

identified specifically as basilisks, snakes that could kill at a glance continued to be reported almost everywhere from India to Latin America through much of the twentieth century, and such accounts probably continue to be passed on today. According to one terrifying story from Franklin County, Missouri, in the mid-nineteenth century, a young girl had stopped eating dinner but would take a piece of bread and butter outside to a riverbank every evening. One night, her father followed her and discovered that his daughter had been hypnotized by a huge black snake. When the parent looked at the snake, he too became paralysed, and could not move without great pain. Finally, by sheer force of will, he managed to shoot and kill the snake, but his daughter died shortly afterwards.[22]

Cockatrice, from Johan Stabius, *De Labyrintho* (1510). This cockatrice has the wattle of a rooster, the horns of a deer, the wings of a bat, the body of a toad and the tail of snake. It also has an intense gaze which, according to legend, is capable of killing people.

Monsters of the Enlightenment

Fantastic animals are entirely universal in human culture, but they are not always considered to be 'monsters' – that is, creatures that, simply by existing, seem to violate or challenge the cosmic order. Monsters are only possible to the extent that people take a dualistic view of the cosmos, and they represent things that people strive to overcome. Christianity inherited a dualistic perspective from Zoroastrianism and Judaism, and with it a growing proliferation of demons. Similar dualisms continued in the secular traditions that eventually challenged Christianity, especially those of the Enlightenment in the eighteenth century.

In Scotland the Enlightenment was represented by David Hume, in England by John Locke and in Germany by Gotthold Lessing and Immanuel Kant. But the centre of the Enlightenment, where it came closest to being a cohesive movement, was in France, where its advocates included Jean-Jacques Rousseau, Voltaire, Denis Diderot and many others. Like other European trends, the Enlightenment was spread throughout the world by colonialism, to influence such figures as Thomas Jefferson in North America and Simón Bolívar in Latin America. In general, thinkers of the Enlightenment believed in the power of reason and, in some cases, the perfectibility of humankind. But we can spare ourselves the formidable task of defining 'Enlightenment' philosophically, since most of its relevance for us is in the underlying metaphor. Taken literally, the term means 'bringing of light'.

The 'light', of course, refers to 'reason', and it is opposed to the 'darkness' of 'ignorance' or 'savagery'. Although the philosophers of the Enlightenment were often anti-clerical, this was a secularization of Christian imagery, in which light represented the presence of God. Just as the saints of Christianity had killed dragons, thinkers of the Enlightenment sought to expose dragons as illusions. And – also like Christianity – the Enlightenment contributed greatly to the proliferation of monsters in human culture.

Christianity had banished many creatures of pagan religion, folklore and alchemy to a fiery

J. J. Grandville, *Les Lumières leur font peur* (The lights frighten them), mid-19th century. The owl and the bat are a satirical representation of the superstitions banished by 'Enlightenment'.

realm beneath the earth, and the Enlightenment expelled them to realms of darkness – night, dense forests, caverns and the unconscious mind. But within all of these realms, the monsters grew rapidly, both in number and in kind. The Enlightenment continued the preoccupation of baroque Christianity with witches, devils and black Sabbaths, but it reinterpreted them as representing not evil so much as superstition. In sum, the philosophers of the Enlightenment, just like their devout Christian predecessors, were often fascinated by the things they crusaded against. Just as Christian preachers found that they could draw audiences by dilating upon the most horrifying descriptions of Hell, philosophers of the Enlightenment sought out the most appalling examples of superstition.

This iconographical continuity is seen in the late work of the painter Francisco de Goya (1746–1828). Formerly a dandy and court painter to the royal family, he had grown increasingly sickly and embittered in later life when, in 1799, he published a series of 80 satirical prints entitled *Los Caprichos* ('The Caprices'), many of which deal with the supernatural. The first and most iconic of these shows a man slumped down over a desk with his head buried in his hands. Around him are dark figures that look like owls and cats, yet have eyes that appear diabolically human. The caption reads, 'The Sleep of Reason Produces Monsters'.

There is perhaps no better summary of the Enlightenment and its ambivalent legacy. Its noble ideals inspired the American Revolution, but then

J. B. Coriolan, 'Winged Monster with Horns', illustration from Ulisse Aldrovandi, *Monstorum historia* (1642). This is obviously a medieval demon, which, deprived of many religious associations, found its way into a 17th-century book of natural history.

also encouraged the near genocide of the Native Americans. They sparked the French Revolution as well, which produced the Declaration of the Rights of Man, yet soon led to the Reign of Terror, the dictatorship of Napoleon and the restoration of the *ancien régime*. It is not known whether, or in what sense, Goya may have believed in the witches and monsters that filled many the canvases that he painted in the final decades of his life, but if they are only denizens of the human soul, that reality is quite enough to be terrifying.

One of the foremost examples of a monster generated by the Enlightenment is the Beast of Gévaudan. From 1764 to 1767, around the high point of the French Enlightenment, there was a series of over 200 attacks on peasants, mostly female and young, in the woody, mountainous region of Gévaudan in south-central France. The bodies were horribly mangled, often partially eaten and sometimes decapitated. But, horrific though they were, the assaults were not entirely novel, for villagers over the preceding centuries had often fallen prey to wolves, and those deaths had been accepted fairly stoically. The crises had been handled locally, and the memory of them, if it survived at all, was passed down in tales such as that of 'Little Red Riding Hood' or legends of werewolves.

But the new emphasis on human pre-eminence made the deaths by predation more difficult to accept, while the new media such as newspapers ensured that accounts would quickly travel throughout France and beyond. The rationalism of the times mandated that the deeds be not only stopped but also explained. These motivations, together with sensationalism, the vanity of hunters and the wounded pride of magistrates, combined to produce many fantastic accounts. Those who tried to kill the beast and failed assuaged their pride by declaring that it had enormous, even supernatural, powers. The killings were assumed to be the work of a single creature – one monstrous wolf, werewolf, hyena, lion or previously unknown

William Hogarth, *Credulity, Superstition, & Fanaticism*, 1809. The preacher, who looks rather like an ape, is ranting about demons and witchcraft as members of the congregation hallucinate and faint in terror. The artist, however, betrays a fascination with the superstitions he is trying to condemn.

monster. It was said to be enormous, to walk and fight on its hind legs, to be impervious to bullets and to be covered with scales.

For the educated classes of the era, the peasant village had become an exotic place, filled with both the superstitions that they abhorred and the adventures that they longed for. They might indulge both their fascination at the horror of the attacks and their amusement at the perceived childishness of the common people, while vicariously enjoying adventures in a strange and secret world. They exaggerated fantastic elements in local stories, which then found their way into newspapers, gaining new authority. The events became so overlaid with extraneous meanings that the simple reality behind them was almost lost. Very likely, the killings were the work of a pack of wolves, or several packs, and these inspired

Francisco Goya, 'The Sleep of Reason Produces Monsters', from *Los Caprichos* ('The Caprices'), 1797–8. The Enlightenment and Romanticism both continued the Baroque fascination with demons, witches and creatures of the night. The disconcertingly human eyes of the owls and the cat in this print hint that they may be either witches or demons in disguise.

the search for a monster that, despite the killing of some gigantic wolves, has never been convincingly identified.[23] The ambiance of the Beast's reign of terror – darkness and silence, broken only by a few eerie howls and shrieks – fills horror movies to this day.

Vampires

Among the creatures that entered mainstream Western culture during the Enlightenment was the vampire, popularly depicted as a bat-like man with fangs. Demons of the Renaissance had been depicted with bat's wings, and these, in popular iconography, were often suggested, or thinly concealed, by a flowing cape. Some depictions give the vampire other animal characteristics, such as the ability to fly, or to climb walls like a gecko. In most vampire stories, his apparently almost human form, including refined speech, only serves to highlight his essential bestiality. The vampire entered legend at around the beginning of the nineteenth century as a melange of legend, zoology, rumour and history, which blended in highly idiosyncratic ways.

Images of vampires were influenced by late medieval accounts of incubi, who were said to take the form of sexual partners to suck the vital energies of sleeping women, and succubi, which did the same with men. These blended with Catholic accounts of wandering souls in Purgatory with Protestant tales of demons assuming human form. Then there were tales of criminals such as the fifteenth-century Romanian Count Dracula (also known as Vlad the Impaler), who impaled thousands; the fifteenth-century French marshal Gilles de Rais, who allegedly tortured, abused and killed hundreds of children in occult practices; and the seventeenth-century Hungarian countess Erzsébet Báthory, who reportedly killed young women and

then tried to absorb their youthful vigour by bathing in their blood. Finally, there were the tales brought back to Europe by mariners from exotic places of practices like ritual cannibalism and terrifying creatures of the night.

Eighteenth-century explorers in Central and South America discovered a few species of bat, found nowhere else, that would suck blood from cattle and, occasionally, from sleeping human beings. Though the amount of blood they absorbed was not nearly enough to imperil a healthy person, the idea of mingling bestial and human blood was repugnant. It suggested a sort of human–animal hybrid, perhaps the bat-winged demons of late medieval and Renaissance painting. In 1760 Georges-Louis Leclerc, Comte de Buffon, the most popular zoologist of his age, named them 'vampire bats', associating them with legends of spirits who feed on the essence of living people.

In traditional books of cultural history, the Enlightenment is followed by Romanticism in the late eighteenth and early nineteenth centuries, a movement so vast and diverse that it at least partially embraces just about every major literary figure of the era in Europe, and many more throughout the rest of the world. Among the major theorists of the movement were Johann Gottfried Herder and Friedrich Schlegel in Germany, Samuel Taylor Coleridge in Britain and François-René de Chateaubriand in France. As for the Romantic poets, they are so many and so well known that it seems unnecessary to list them. The Romantics, the textbooks tell us, reacted against the Enlightenment by asserting the claims of passion over those of reason, those of nature against civilization and those of fantasy over science. And yet, as becomes more apparent over time, there was considerable continuity between the two movements, for they both saw the world in terms of essentially the same polarities.

One might have expected Romanticism, with its veneration of the imagination and its return to folklore, to have ushered in a new proliferation of imaginary animals. That did not happen, perhaps because Romantic poets such as John Keats and Novalis were mostly focused on the inner world, on feelings and intuitions. As a result they were less likely to project their subjective states outwards, creating fantastic beasts. Rather, what the Romantics did was to refine and develop the monsters of the Enlightenment. The image of the vampire in popular culture was crystallized in works of Romantic literature such as John Polidori's novella *The Vampyre* (1819) and, most importantly, Bram Stoker's novel *Dracula* (1897). These were followed by a proliferation of literary works, operas, pictures, songs, films and comic books about vampires, which continues into the twenty-first century.

At times the vampire would become an object of sympathy, but in the context of the Enlightenment he usually represented the 'animalistic' proclivities that human beings should overcome. He was, and still largely remains, the bear devouring his own cubs, the worm consuming corpses, the leech sucking blood, the lizard climbing walls

Henry Fuseli, *The Nightmare*, 1781. A woman lying on her back (a position that many believed encouraged demons) is visited by a nightmare and an incubus, which ogle her malignantly.

or the spider trapping butterflies. Far more vivid for contemporary men and women than the dragons of old, he is the embodiment of disease – of the predator that moves among us unseen and who can devour human beings even from inside their bodies.

Giovanni di Paolo, *The Creation of the World and the Expulsion from Paradise*, 1445. The angel driving Adam and Eve from Paradise is naked, something very unusual in Western painting. However, we cannot tell what sex the angel is, if any, since a flower covers its genitals.

SEVEN
WONDERS

It had been startling and disappointing to me to find out that story books had been written by people, that books were not natural wonders, coming of themselves like grass.
Eudora Welty, *One Writer's Beginnings*

EXCEPT FOR THE DIABOLIC temptresses of acetic saints and the dracontopede, demons in Christian art have overwhelmingly been portrayed as male, at least insofar as they have human features. Their bodies are angular and heavily muscled, rather than based on curvilinear forms. For all its intensely patriarchal organization, the world of the European Middle Ages and Renaissance may have had an undertone of feminism, since it envisioned Hell as a place without female influence.

In the Old Testament or Torah, angels are, apart from their closeness to God, hardly distinguished from people; in fact both Abraham (Genesis 18:2) and Lot (Genesis 19:1) can mistake them for human travellers. In Christian tradition, however, angels are androgynous, in the sense of being beyond the duality of male and female, and they are usually depicted accordingly. They have soft features, curving bodies and long, flowing hair, as well as robes that extend to the soles of their feet and beyond. Even when they bear the accoutrements of war, like St Michael with his sword and shield, they appear somewhat, though not unequivocally, feminine. No doubt Joan of Arc was able to inspire her warriors in part because, as a woman in armour, she looked rather like an angel.

Although angels did not, outside of esoteric texts such as the apocryphal Book of Enoch, engage in erotic relationships, paintings of them from the Renaissance onwards included child angels, modelled after Graeco-Roman depictions of Eros, or Cupid. Like demons, angels were human–animal hybrids, since they had human bodies and bird's wings. Those extra appendages, however, were so functional and so familiar that they seemed to be accessories, and not at all unnatural.

In terms of our normal experience and expectations, demons and angels are about equally strange. Why, then, do anomalies make demons appear bestial and angels spiritual? The reason is that the former, by their very existence, appear to challenge the cosmic order, while the latter, by smoothing over discontinuities, seem to make creation more complete. Angels filled what appeared to be abrupt gaps in nature – between male and female, as well as between the celestial and terrestrial worlds. We can consider both demons and angels to be imaginary animals, and this is essentially the distinction between monsters and wonders.

Bartolomé Esteban Murillo, *St Michael*, 1665–6. Despite being a warrior of God, St Michael appears very feminine in both physical features and dress.

Pieter Breughel the Elder, *Fall of the Rebel Angels*, 1562. As the angels fall from Heaven, they take on increasingly fantastic, bestial forms. The demon in the lower centre of the painting, just below St Michael, has not entirely lost its angelic form. It retains wings, now those of a butterfly, and long brown hair.

Miracles

Traditions going back to the Bible held that animals, by their very existence, were proof of the power of God. Walt Whitman wrote in 'Song of Myself' (1855), 'And a mouse is miracle enough to stagger sextillions of infidels.'[1] But what if the infidels remained unconvinced? A corollary drawn by many people was that a larger and more fantastic creature would be more convincing evidence of divinity.

This idea is already found in Exodus:

Yahweh said to Moses and Aaron, 'If Pharaoh says to you, "Display some marvel," you must say to Aaron, "Take your staff and throw it down in front of Pharaoh, and let it turn into a serpent!"' Moses and Aaron went to Pharaoh

Persian illuminated manuscript, *Moses and Aaron with a serpent*, 15th to 16th century. This illustration depicts the plague of serpents that afflicted the Israelites as Moses led them out of Egypt. The serpent, clearly influenced by the Chinese dragon, gives off fire from its limbs as it moves.

and did as Yahweh had ordered. Aaron threw down his staff in front of Pharaoh and his officials, and it turned into a serpent. Then Pharaoh in his turn called for the sages and sorcerers, and by their spells the magicians of Egypt did the same. Each threw his staff down and these turned into serpents. But Aaron's staff swallowed up theirs. (7:8–12)

This sort of magical contest between believers and pagans would become common in Judaeo-Christian tradition.

In early accounts of the lives of saints, storytellers would often deliberately include events that would strain credulity, believing that more fantastic stories would offer greater evidence of the power of God. The earliest known reference to Scotland's famous Loch Ness monster is from St Adomnán's *Vita Columbae* (*The Life of St Columba*), written around the end of the sixth century. He wrote that a dragon emerged from the loch just as a follower of the saint was swimming, and was about to devour the poor man when St Columba, who was standing on the bank, made the sign of the cross in the air and commanded the dragon to turn back. The monster retreated in terror, and the pagan Picts, who had witnessed the scene, converted to Christianity.[2]

But St Simeon Stylites is credited with an even more miraculous conversion. The acetic master had spent many decades standing continuously on top of pillars, of ever-increasing height, in his monastery. A huge dragon, which had been blinded because a branch had fallen in its eye, came up to him, sat at the base of his pillar, wound itself in a coil and bowed its head. When the saint looked down the stick immediately fell from the dragon's eye, and its sight was restored. Onlookers were terrified, but the dragon only stopped to worship at the monastery gate, and then returned home peacefully.[3]

A pious sense of wonder often led people to imagine ever more fantastic creatures, yet it could also take far subtler forms. Much in the same way that the Darwin-Wallace theory of evolution faced a serious scientific challenge in explaining the gaps in the fossil record, many traditional cultures feel a need to explain why different varieties of animal are so distinct from each other. If bats and birds have wings, why shouldn't horses and human beings? A goddess with a human body and vulture's wings may, like an angel, help to 'complete' the world by joining people with birds, and Earth with Heaven.

Egypt

Often considered the world's first urban civilization, Egypt may also be the one most pervaded by animal imagery. Depictions of animals are just about everywhere in the remains of ancient Egypt – on wall paintings, graves, jewellery, toys, amulets, board games, combs, pottery and so on. This profusion of animal images began before the Early Dynastic Period. Already by the first dynasty (2920–2770 BCE), animals were being mummified in the

hope that they might accompany deceased people to the next world. The earliest depictions of Egyptian deities were entirely zoomorphic, with the falcon, ibis, crocodile, cow, lion, hippopotamus and cobra being among the most common. By the second dynasty (2770–2650 BCE), gods and goddesses were increasingly shown with animal heads and human bodies. Thoth, the god of wisdom and inventor of the arts and sciences, usually had a human, male torso and the head of either an ibis or a baboon. Anubis, who guided the dead, had a man's body with the head of a dog or jackal; Sobek, god of the Nile, had the head of a crocodile, and Horus, the god of the sky, that of a falcon. Bastet, the guardian of women, had the body of a human female and the head of a cat, while Sekhmet, the goddess of war, had that of a lioness.[4] Dorothea Arnold has written,

> Egyptians unquestionably did not think that any of their deities were actually formed that way. The images should be 'read' part by part, like hieroglyphic script. The human body informs the viewer that no ordinary animal is depicted, and the animal head signifies the superhuman properties of the deities.[5]

I do not doubt this was true at least for educated Egyptians, but there were surely also Egyptians who did not read hieroglyphs. The more literal-minded, a bit like modern-day fundamentalists of many faiths, may have assumed that these images really did represent the actual appearance of the deities.

To be sure, many deities also had other forms. The *ba*, or soul, was a rare reversal of the usual pattern, since it had the body of a bird, probably an owl, with a human head. Ra, god of the sun, and Osiris, god of the underworld, were among the few deities that generally took the form of men. Maat, the goddess of harmony, had the form of a woman but could be recognized by an ostrich feather in her hair. Hathor, the goddess of love, was at times depicted as a woman but at other times as a cow. Horus, as already noted, could be pictured entirely as a falcon, with the sun for one eye and the moon for the other. Isis, a goddess of

The Egyptian god Thoth, inventor of the arts and sciences, after an Egyptian wall painting. Thoth was depicted with a human body and the head of a baboon or, as in this picture, an ibis. He was later equated by the Greeks with Hermes, and was revived in the Italian Renaissance as Hermes Tresmagistus, the patron of alchemy.

From the Papyrus of Ani, an unusually complete version of the *Egyptian Book of the Dead*, c. 1350 BCE. To the left is the god Osiris, judge of the dead, who is one of the few Egyptian deities usually depicted in human form. In the centre, the dog- or jackal-headed god Anubis attends the mummy of the deceased scribe Ani. To the right are Bennu, probably the original phoenix, and the *ba*, part of the human soul with the face of a human being and the body of an owl.

fertility whose cult would later be prominent in Rome, received the form of a woman with outspread wings not unlike those of a Christian angel. Wadjet, the protectress of the pharaohs, often took the form of a cobra; Nekhbet, a patroness of Egypt, had that of a vulture.

Those who regard a religious focus on animals as 'primitive' might expect that such images of the divine would become more anthropomorphic over the centuries. Actually, the very opposite was true for Egypt. In accord with very ancient traditions, the Apis bull, recognized by certain markings, was regarded as an avatar of the creator-god Ptah, and kept in a luxurious palace in the city of Memphis. At the start of the New Kingdom (1550–1070 BCE), this practice was extended to other animals that were associated with deities. Temples were erected to hold crocodiles, rams, geese, baboons, ibises and other animals, which were conscientiously cared for in life and mummified after death. Though not deities themselves, these animals were regarded as divine representatives through which the gods and goddesses might be reached.

The popularity of animal cults continued to increase as ancient Egyptian culture, perhaps the longest lasting civilization in human history, slowly approached an end in the late dynastic (664–332 BCE) and Ptolemaic and Roman periods (304 BCE –395 CE). In a belief that not only individual creatures but entire species might be sacred, people killed and mummified cats, falcons and other animals in their millions, to send them to the next world as emissaries to the deities. In 59 CE a member of a Roman delegation to Alexandria, who accidentally (but unceremoniously) killed a cat, was punished with death by an angry mob.

At least since the days of Herodotus, Europeans have looked at the animal gods of Egypt with a combination of perplexity and admiration, and the fascination with them continues to this day. When the Greeks conquered Egypt, they conflated their

The Judgement of Osirus, god of the dead, Egyptian tomb painting on papyrus, about 300 BCE. The heart of the deceased is weighed against a feather to determine the fate of the soul.

J. B. Coriolan, 'Lycanthropos', illustration from Ulisse Aldrovandi, *Monstorum historia* (1642). Before Egyptian hieroglyphics were deciphered in the early 19th century, people sometimes thought of the god Anubis, who has the body of a man and the head of a jackal or wolf, as a werewolf.

Christ Child across a torrential river, thus himself bearing the full weight of human sins. Throughout these many transformations, the role of the dog-man remained remarkably constant, as one who transports souls safely from this world to the next.[6] The river in the story is – as in Babylonian, Greek and other mythologies – the barrier separating the realm of the living from that of the dead. Many saints took over the attributes and stories of god Hermes with the jackal-headed Anubis, both of whom were guides for the dead. This produced the composite figure of Hermanubis, who was generally depicted as a man with the head of a dog or jackal. He would wear a chiton, a short rectangle of wool or linen that wrapped around the body and covered it to the knees and was then draped over one shoulder and fastened with a pin. Like Hermes, he wore winged sandals and often carried a staff with snakes twined around it. The Romans, many of whom adopted the Egyptian cult of Isis, later conflated Hermanubis with their god Mercury.

As Rome became Christian, Hermanubis/Mercury was identified with St Christopher, a giant who, according to legend, once carried the

Statue of Hermanubis, Egyptian, Ptolomaic period. This god has the body and attributes of the Greek god Hermes, but, like the Egyptian deity Thoth, the head of a dog or jackal.

pre-Christian deities, and a few saints are animals – St Guinefort, venerated in France, is a dog, and St Muirgen (or Liban) of Ireland is a mermaid. But few if any other saints seem as profoundly pagan as Christopher, who does not even appear subordinate to Christ, for he is equal to Jesus in his burden and comparable to him in power.

Icon painting, practised in the Eastern Orthodox Church, first originated in Alexandrian Egypt. The impassive faces of saints in icons, which are highly stylized to avoid violating the biblical prohibition against representational art, recall the animal-headed gods of Egypt. Rather like the eyes

J. J. Grandville, 'Convivial Crocodiles at a Banquet', from *Les Animaux* (1842). The artist is satirizing Egyptian chic in 19th-century France.

St John and St Mark, after figures in Fra Angelico's fresco *Ezekiel's Vision of the Mystic Wheel*, c. 1450. These Evangelists were often painted in Western art as people with animal heads, an eagle's and a lion's respectively, a practice inspired by ancient Egyptian art.

of animals, from snakes to owls, the large eyes painted on traditional icons stare out at us, alert and knowing yet remote. The influence of Egypt on Catholic art is not so widespread, but is also at times less subtle. Like the animal divinities of Egypt, St John the Evangelist has at times been painted with the body of a man and the head of an eagle, St Mark with the head of a lion, and St Luke with that of an ox, especially in the European Middle Ages and Renaissance.

There have been periodic revivals of Egyptian art in Western Europe and North America, including those that began in the latter fifteenth

John Anster Fitzgerald, *Titania and Bottom*, c. 1850. In this illustration of Shakespeare's play *A Midsummer Night's Dream*, written in the last decade of the 16th century, the fairy queen, Titania, is infatuated with a tradesman, Bottom, whom her husband, Oberon, has given the head of an ass. Since the discovery of the *Corpus Hermeticum* in the 15th century, Europeans had been fascinated by the mysteries of Egyptian religion, and the animal-headed figure is probably a humorous allusion to Egyptian deities.

J. B. Coriolan, 'Marine Monster with a Human Face', illustration from Ulisse Aldrovandi, *Monstorum historia* (1642). This creature, possibly some sort of cetacean, not only has human facial features but a very intense expression, and its gestures are readily understandable to human beings.

J. J. Grandville, 'Scarab Family', c. 1842. Scarab beetles were sacred to the ancient Egyptians, for whom the ball of dung pushed by a scarab beetle represented the sun passing across the sky. Here this journey becomes a sort of pilgrimage in which the beetles' horns become mitres and their shells ecclesiastical robes.

century following the discovery of the *Corpus Hermeticum*; at the end of the eighteenth century following Napoleon's brief conquest of Cairo; and during the 1920s following the discovery of Tutankhamen's tomb. Unlike most pagan deities, the animal gods of Egypt have consistently inspired respect, and occasionally veneration, even among passionate adherents of Abrahamic religions.

India

Despite the lack of geographical proximity, writers of Europe and the Near East, from ancient times until at least the Renaissance, have confused India with Egypt. On reaching the Indus River, Alexander the Great thought it was the Nile.[7] Perhaps at least part of this confusion was due to the prevalence of deities with animal torsos and human heads in both lands. There is actually no strong cultural link between the animal gods of Egypt and India, and it appears that similar iconographical styles were largely due to convergence.

Like the religion of ancient Egypt, Hinduism tends to make a far less abrupt division than Abrahamic religions between animals and human beings, and it also subordinates both people and animals to a more extreme hierarchical order. Bovines in India are especially protected, and India, though in ways now a wealthy nation with a vibrant middle class, has one of the lowest rates of meat consumption in the world. At the same time, India has an intricate caste system in which people of the lowest rank are traditionally not permitted to touch, or even look directly at, those very far above them. Legitimate social mobility has been considered possible only through many reincarnations

over millennia. Because, in India, moral consideration is not greatly contingent on human form, the treatment of animals is generally better than it is in Western countries, but the treatment of people with low status is worse. Because there is little concept of universal human equality or solidarity that transcends social divisions in traditional Hindu culture, composite creatures such as human beings with animal heads are never regarded as a desecration of the human body.

Hinduism also views the physical world as ultimately an illusion, and perhaps this is a reason why Hindu tales show such uninhibited exuberance, with the most fantastic participants and intricate plots. Since these tales can, in any case, never be entirely true, there are few constraints against embellishing, and enjoying, them to the full. By blending many forms, human and animal, the Hindu divinities suggest liberation from the social and even the cosmic order among the most exalted beings.

When European explorers such as Pietro della Valle from Italy entered Hindu temples in the early seventeenth century, they must have expected something a bit like Romanesque or Gothic cathedrals, with their stillness and solemnity, or else, as befitting pagan beliefs, palaces of barbaric splendour. Instead they found images of a portly, rather childlike human body topped with an elephant's head with one broken tusk, dancing upon a rat. The figure looked charming and humorous to them, but not threatening or awe-inspiring. Della Valle found the figure utterly

J. B. Coriolan, 'Boy with the Head of an Elephant', illustration from Ulisse Aldrovandi, *Monstorum historia* (1642). This is obviously the Indian deity Ganesh, which is being presented in Europe as a natural phenomenon.

preposterous, but generously conceded that 'all of these so monstrous figures have secretly some more rational significance, though expressed in this uncouth manner.'[8]

The deity was Ganesh (Ganeśa), the god of wisdom and of new beginnings, who is arguably the most popular figure in the Hindu pantheon. There are many stories of his origin. According to one of the most popular, Parvati, consort of the god Shiva, longs for a son and creates Ganesh from the dirt on her body, then directs him to guard her private chamber. When Shiva approaches, Ganesh

Modern but traditional paintings of the Hindu Ganesh, lord of thresholds and new beginnings. Ganesh radiates the exuberance, innocence and endless possibilities of childhood, but it is easy to see how visitors from Christian Europe to India in the Renaissance would have found his image in temples disconcerting. For all the splendour that surrounds him, this god of wisdom, thresholds and new beginnings retains many of the attributes of a little boy. He is often shown eating sweets, as in the picture on the right. A rat, one of his incarnations, is at his feet.

bars his entry and swings at him with an axe. Shiva cuts off the young man's head, at which Parvati cries inconsolably. To comfort her, the god restores Ganesh to life, but he can only accomplish that by cutting off the head of a passing elephant and placing it on the boy's torso.

Ganesh is a relative newcomer to the Hindu pantheon. Though he may have roots in more ancient beliefs, he only began to be actively worshipped in around the fourth and fifth centuries CE. A far older figure is Garuda, the king of birds, who is mentioned in many of the oldest and most important scriptures. He has the head, wings and claws of an eagle but the body of a man. His face is white, his wings red, his body golden, and he is large enough to darken the sky. When he first broke through the shell of his egg, it was with such an explosion of flames that the divinities themselves were terrified. He defeated the gods and stole the elixir of life from them in order to pay to free his mother Vinata

Wonders

Modern but traditional depiction of Garuda, the king of birds, as the mount for the deities Vishnu and Lakshmi. The ancient zoomorphic deity, though still enormously popular, is now subordinated to the newer and relatively anthropomorphic ones.

from slavery. In one Purana, or book of sacred wisdom, the mighty bird tells about the origin of the cosmos, the composition of the heavens and the fate of people after death. The frequency and splendour of early references to Garuda suggest that he may predate even this most ancient of religions, though he is now a somewhat peripheral, if still beloved, figure in the Hindu pantheon.

Also extremely old is the deity Hanuman, who has the face of a monkey and the body of a muscular man. He is a central character in the sacred epic *Ramayana*, in which he helps the hero Rama to rescue his consort Sita from the demon Ravana. Another tale begins as the child Hanuman looks up at the sun, thinks it is a mango and jumps up to pick it, soaring far into the heavens. This angers Indra, the god of thunder, who hurls a thunderbolt that strikes Hanuman in the jaw. Hanuman's father Vayu, the god of the wind, finds his son dead, picks up the body and journeys to

Hanuman, king of the monkeys, fighting the minions of the demon Ravana. There is hardly another figure in religion that appears to be at once so completely a human being, an animal and a deity.

Narasimha, a half-man, half-lion; and Matsya, a fish, but one of the most popular incarnations of him is as the boar Varaha. When the demon Hiranyaksha tried to drown the earth in a cosmic ocean, Varaha rescued the planet by raising it on his tusks. At times Varaha is shown entirely as a boar, but more often he is depicted as a man with a boar's head. Paradoxically, the zoomorphic attributes of Ganesh, Garuda, Hanuman and Varaha do not make them seem less human but instead more so. One reason for this is that these traits are often used to dramatize positive qualities thought of as quintessentially human, such as youthful the land of the dead in search of Hanuman's soul. This leaves the earth desolate; fearing that all life could be destroyed, Indra repents and brings Hanuman back to life. In addition, Indra bestows on Hanuman immortality and invulnerability to all weapons, but the young deity retains a swollen jaw where the thunderbolt had struck. In the last century or so, the popularity of Hanuman has increased and he is now a rival of Ganesh as the most beloved deity of Hinduism. Secularists often consider the monkeys living freely in Indian cities such as Delhi a nuisance, but devotes of Hanuman constantly risk arrest by feeding them.

Vishnu, a supreme god of Hinduism, has many avatars, including that of the hero Rama; that of

The Hindu god Vishnu, in his incarnation as the boar Varaha, standing in triumph over the defeated demon Hiranyaksha at the beginning of a new cosmic era.

Modern but traditional painting of Varaha. In his incarnation as the boar Varaha, the god Vishnu fights the demon Hironyaksha, who has tried to drown the earth in a cosmic ocean. Varaha holds the earth aloft with his tusks while fighting with a single arm. The victory seems effortless here, but the battle between the two lasted 1,000 years, and the victory of Varaha ushered in a new cosmic cycle.

impulsiveness, loyalty and mature compassion. It is also because animals suggest a primal innocence that people feel they are losing or have already lost, yet which they still think of as a human birthright.

China

Western culture, especially that of the late Middle Ages and Renaissance, traditionally divides up creatures into worldly realms, and then finds correspondences, based on analogies with human society, among them. As a king rules over his subjects, the eagle rules over birds and the lion

over beasts. Merpeople, or perhaps Leviathan, rule the sea. In medieval European stories, animals have hierarchies much like those of human beings, in which the large predators such as wolves and bears are aristocrats, while the fox is a wily peasant. But despite these parallels, the various animal kingdoms remain distinct from human society. Chinese mythology, on the other hand, conceives the entire cosmos on the model of the emperor's court.

Arthur Waley has observed that 'It has often enough been put forward as a theory that a people's gods are the replica of its earthly rulers. In most cases the derivation is obscure. But in Chinese popular belief there is no ambiguity. Heaven is simply the whole bureaucratic system transferred to the empyrean.'[9] The Chinese view of the world centres on a cosmic order that transcends divisions between human beings and animals, nature and civilization, even Heaven and Hell. These realms are united by a single hierarchical government.

In Heaven, under the rule of the Jade Emperor, every being has a rank and a role, from Yama, who holds court among and judges the dead, to dragons who rule in rivers and lakes. The court of the Jade Emperor is, just like any palace, filled with conflicts, alliances, intrigues, rebellions and even attempted revolutions. In the novel *Journey to the West*, written by Wu Cheng'en at the end of the sixteenth century, Old Monkey breaks into the celestial garden of the Jade Emperor, steals and eats the peaches of immortality, erases his name from the tablet of Yama, beats back the hosts of Heaven and demands to rule the cosmos. For a while, even the deities are almost helpless before him, except for Buddha, who recognizes the emptiness of Old Monkey's claims and imprisons him beneath a mountain until the time for his redemption has arrived.

In Western culture, particularly in the modern period, any transgression of the boundary between animals and human beings was often regarded as a violation of the cosmic order. In China, however, the ideal of transmigration of souls was widely accepted. This did not always mean that there was greater intimacy between human beings and other creatures, for they could still be separated by eons of transformations. There are many stories of creatures that tried to abruptly rise above their station, only to be defeated, punished and usually demoted to a lower form. In one tale, the goldfish in the lotus pond of the bodhisattva Guanyin gains great power by listening to her wisdom, leaves her garden and transforms an unopened lotus bud into a bronze hammer. It terrorizes people in the form of a sea monster until Guanyin notices its absence and fishes it from a river in a bamboo basket.[10] But, provided the change was not arbitrary or disruptive, there was nothing in the least transgressive in the idea of such a metamorphosis.

The anthropomorphism in traditional Chinese culture does not primarily consist of projecting individual human traits on to individual animals. Rather, it lies in viewing the habits and behaviour of certain animals as extensions of the roles and duties found in human society. The traditional lore

of animals, including fantastic ones, was largely codified during the latter Warring States period (c. 481–221 BCE) through the Eastern Han dynasty (25 BCE–220 CE), when governance became increasingly centralized. In the words of the sinologist Roel Sterckx, 'Rather than describing the internal workings of the natural world as a reality dissociated from human affairs, these texts firmly linked the identification, management, and classification of animals with offices and officials that were part of the all-encompassing bureaucratic state.'[11]

An example is the Chinese dragon, which reigns over the wind and rain. This creature has the undulating body of a snake, the head of a camel, the ears of a bull, the horns of a deer, the eyes of a hare, the stomach of a clam and the tusks of a boar. Along its spine is a row of spikes similar to those of some chameleons and other lizards. Covering its body are the scales of a carp; its legs end in the claws of an eagle or hawk. In one claw or in its mouth, the dragon holds an enormous pearl. These features probably represent the totems or symbols of various tribes, which were amalgamated to create the Chinese people.[12] In addition to being a shape-changer, the dragon can make itself smaller than a caterpillar or large enough to darken the sky.[13] The creature is an entire cabinet of wonders, to which all of nature has contributed.

The lack of a fixed form may have saved the Chinese dragon from the sort of scrutiny to which imaginary creatures in the West are subject. No scientists trek to remote villages in the Himalayas in search of the dragon, or earnestly debate its place in evolution. Nobody places hidden cameras in woods or on riverbeds in hope of photographing it. After all, the dragon could simply change into a butterfly and flutter away. Nobody even worries about whether or not the East Asian dragon is real,

Dragon dancers celebrating the Chinese New Year, New York City, 2011. In the celebration of the Chinese New Year, dancers in costumes of dragons, lions and unicorns enter local businesses to receive small gifts in return for blessings. The popularity of these festivities now extends well beyond ethnic Chinese.

Katsushika Hokusai, *Dragon*, *c*. 1830. According to Japanese tradition, their island is the original home of the dragons, which then moved to China, Korea and other lands. The Japanese dragon lives in a palace under the sea. It is more serpentine than the Chinese dragon, seldom flies and almost always has three claws.

A Chinese Imperial dragon, embroidered on a ceremonial robe from the 19th century. The image conveys enormous movement and energy, yet this dragon is portrayed according to very detailed conventions. The golden skin and five claws mark the dragon as symbol of the Emperor. As the dragon chases a pearl, fire rises from its limbs. Around the dragon are bats, symbols of good fortune.

IMAGINARY ANIMALS

Chinese phoenix, from a piece of silk embroidery, early 20th century. The Chinese phoenix or fenghuang represents the empress, and is paired with the dragon. It is associated in the visual arts with gentle clouds and with luxuriant vegetation, especially flowers.

nor is there a great deal of concern about what the dragon represents. The pearl that it holds can signify the sun, the moon or the earth, or may simply be a magical jewel.

But the wonderful extravagance of the dragon does not place the creature apart from human hierarchies. The Chinese traditionally understand the colours, behaviour, habitat, markings and other features of animals as insignia of a position in the cosmic order. The ordinary dragon has three or four claws, and can be of many colours. The dragon that represents the emperor, by contrast, is yellow or golden and has five claws. It is paired with the fenghuang, or Chinese phoenix, which represents the empress and has a splendour commensurate with her rank. The fenghuang has the beak of a rooster, the neck of a snake, the face of swallow, the back of a tortoise, the hindquarters of a stag, the tail of a fish and the feathers of a peacock, and its plumage shimmers constantly.

J. B. Coriolan, illustration from Ulisse Aldrovandi, *Monstorum historia* (1642). Called a 'Gallus Indicus' or 'Indian rooster', this bird greatly resembles the fenghuang or 'Chinese phoenix', and was doubtless copied by the Italian artist from an East Asian source.

Alchemy in the Renaissance

Alchemy may, in a broad sense, be understood as the study of transformations. How do copper and tin become bronze? How does a tadpole become a frog? How does a seed become a tree? All of these questions, and even more esoteric ones, were in the purview of the alchemists. Rather like adherents of the theory of 'emergence' today, they looked for universal patterns that underlay all changes in form. In describing these transformations, they often referred to allegorical animals. Their colourful writings are full of images such as that of the green wolf swallowing the sun, or the dragon with a second head at the end of its tail. For the alchemists, so-called monsters were anything but anomalies; it was fixed categories that appeared 'unnatural'. If men and horses exist, why shouldn't centaurs? If a serpent could have one head, why couldn't it have two or three? Alchemists drew eclectically on mythologies from the ancient Egyptian to the Native American, then synthesized and extended them to create esoteric symbols and allegories.

Alchemy was a universal discipline, incorporating what we now know as art, science, magic, religion, literature and criticism. It profoundly influenced all of the 'Renaissance men', those creators of the modern world such as Leonardo da Vinci, Francis Bacon and Isaac Newton. It provided many of the metaphors and concepts with which Shakespeare and other creators of the Elizabethan age understood the world.

For practitioners, particularly in the Renaissance, alchemy was only in the narrowest sense about the transformation of common metals into gold. Closely aligned with that quest was the search for the philosopher's stone, which was said to have many mystical properties, and for the elixir of life, which could grant immortality. These pursuits were, however, not simply a matter of hunting for treasure or mixing formulas, since the alchemists

Early modern depiction of an alchemical sky dragon. In alchemy, the dragon represented the life force that resides in metals. This one holds the moon in its mouth and the sun in the coils of its tail, and around it are symbols of the constellations.

J. Augustus Knapp, Rosicrucian representation of the Trinity with many alchemical symbols, early 20th century. Hermetic illustrations such as this were not intended to reveal their meaning at once, but to invite meditation.

believed that their goals could only be reached by somebody who had attained spiritual purity.

Fundamental to alchemical belief was the principle of correspondences, most authoritatively articulated in the famous Emerald Tablet, attributed to Hermes Trismegistus, who was identified with Thoth, the Egyptian god of wisdom. This manuscript was part of the *Corpus Hermeticum*, a collection of occult texts in Alexandrian Greek that were discovered in the late fifteenth century. They quickly attracted the attention of the ruling Medici family in Florence, and were soon translated into Latin by Marsilio Ficino. Today scholars date them to the first to the third centuries CE, but initially many scholars believed they went back almost to the very beginning of time.

The Emerald Tablet stipulated that events on Earth corresponded with those in the heavens, which in turn paralleled processes that took place in metals beneath the ground. Above all, this meant that the human being was a microcosm of the universe, and that all bodily, spiritual and emotional processes had equivalents in the larger universe. One would strive towards perfection by working on all of these levels simultaneously to create a harmonious balance.[14]

The alchemists took the late medieval penchant for complex and ambiguous allegories to its greatest extreme, and extended it far beyond conventionally religious concerns. In fact, just about everything became allegorical, at least in the sense of being able to stand in for something else. Animals often were used as one means of representing the elements, and their combinations could produce fantastic hybrids. The lion or ox might represent the element of earth, while the fish or dolphin represented water; the eagle or phoenix represented air; the salamander or dragon, fire. Their colours and combinations would reveal their current state – a chemical substance being heated and distilled would be depicted as a red or green dragon, depending on its stage of refinement. Winged serpents represented volatile substances such as sulphur, while wingless serpents represented stable ones such as salt. A crucified serpent with wings might represent a volatile substance that has become stable, especially the element mercury.

The patron of alchemy was the Greek god Cronos, a surprising choice since, according to Hesiod, he devours his own children. His consort Rhea, however, saves one child, the infant Zeus, by wrapping a stone in swaddling clothes. Cronos swallows the stone, and Rhea has Zeus carried off to the island of Crete. On attaining maturity, Zeus returns, defeats Cronos and the Titans, forces his father to vomit up his siblings and rules the heavens. Though neither virtuous nor victorious, Cronos appealed to the alchemists as a figure of many paradoxes. The Romans had identified Cronos with their agricultural god Saturn and believed that after his defeat he had journeyed to Rome, where he had presided over a golden age. He represented a depth of defeat and even depravity, but precisely for that reason he was the starting point of the ascent towards

perfection. His metal was lead, but destined to be transformed into gold.

Cronos' astrological sign was Capricorn, the insignia of winter, when the nights are darkest and the weather is coldest but when the New Year is also about to begin. All the other astrological signs are represented by realistic animals or human beings, but the symbol of Capricorn is a creature with the tail of a fish and the body of a goat or, less frequently, a pig. The goat-fish, like many creatures of the imagination, can be traced back to ancient Mesopotamia. For the Babylonians, Kassites and Assyrians, it was a symbol of Enki, also known as Ea, the god of wisdom, of deep water and of magic, a wizard in many ways similar to Cronos. The ultimate unity of opposites was a key idea for the alchemists and, appropriately, Capricorn joins many opposing concepts, such as water and earth. It is also half fish, a symbol of Christ, and half goat, a symbol of the Devil.

One popular Graeco-Roman story tells that the Greek divinities once fled to Egypt to escape the many-headed dragon Typhon, and disguised themselves as animals. Apollo became a falcon or crow, while Artemis became a cat. The woodland deity Pan, who had the horns of a goat, tried to turn into a fish but was so terrified that he could not complete the transformation, so he became Capricorn. But the alchemists were opposed to literalistic thinking, and did not endorse any exclusive explanation for their symbols.

For several reasons, alchemists presented their material in a manner that was deliberately obscure.

From Giovanni Battista Nazari's *Della Transmutatione metallica* (1589). This alchemical representation of the metal mercury is a variant of the Greek chimera, a monster with the head of a snake, a lion and a goat.

Their exalted aspirations often aroused suspicions of hubris or even witchcraft, even though most alchemists of Renaissance Europe were highly devout Christians. Furthermore, the alchemists feared that their discoveries could be abused if they fell into the wrong hands. Finally, they were

sceptical about the power of language to convey their ideas and thus generally did not express themselves directly, but rather through cryptic metaphors. People were expected not simply to interpret their writings or decipher their illustrations but to meditate on these works until their secrets became apparent. In consequence, alchemists have often been accused of pretentious nonsense, and some of them, indeed, have been charlatans.

But their fundamental technique, in art as well as literature, was to represent physical processes in terms of symbols and fables, and then to mix metaphors with no regard for what we might call 'common sense'. This often produced fantastic animals. Thus the pelican feeding its young with blood from its own breast might represent the reddening of matter as it is heated in a flask. A human being might be a forest in which the soul was a deer and the spirit a unicorn. At the mysterious culmination of the quest, known as the 'great work', it was believed that opposites would be united, and the boundary between image and reality would fall away.

Paracelsus and the Elementals

Perhaps the last major figure in the alchemical tradition was the Swiss physician Theophrastus Bombastus von Hohenheim, known as Paracelsus (1493– 1541), who lived the life of a wandering scholar-adventurer. He was repeatedly invited to the courts of Europe because of his reputation as a healer, but he would soon quarrel with his patrons and move on. Paracelsus shifted the emphasis in alchemy from metals to the human body, and he is sometimes known as the 'father of modern medicine'. Prior to Paracelsus, the work of doctors consisted mostly of bleeding and highly invasive, painful surgery that usually did more harm than good. Paracelsus emphasized hygiene and relied more on the body's own recuperative powers. In addition to the usual herbal medicines, he often recommended synthetic ones, which he believed restored the body to its proper balance.

Unlike many other learned men of his time, Paracelsus had no reverence for his ancient predecessors such as Galen. Rather than seek medical information in old books or even among his peers at the universities, he frequented village squares and collected home remedies from local healers and midwives. And, while he was boldly sceptical about learned traditions, he could at times be almost boundlessly credulous about local legends and folklore.

Imaginary animals are essentially emissaries from another world, and accordingly, authors from antiquity often placed them in remote parts of the globe. By the sixteenth century most of the globe had been at least superficially explored by Europeans and therefore contained increasingly less space for uninhibited imagination. A few authors were beginning to centre fantastic tales on the moon or on other planets, as science fiction writers would do a few centuries later, but the heavens were still largely reserved for the angels and for God. Still others miniaturized the

heroes and villains of adventures, for example the mid-nineteenth-century graphic artist J. J. Grandville, who would make insects, or even microbes, into courtiers, fine ladies, soldiers, students, musicians, knights, painters, spinners, businessmen, pedants, bullies, bureaucrats or dragons. Often he deliberately placed them in clichéd poses, not only for satire but, even more, to highlight the strangeness of the figures, as well as to humorously acknowledge our distance from their world of romance.

Paracelsus set stories in worlds in which neither microscope nor telescope could intrude. According to him, amazing creatures called 'Elementals' lived in realms that existed alongside the domain of human beings and occasionally intersected with it. They were never far away, yet we only occasionally had contact with them, for their substance was so different from our own. Paracelsus would discourse upon the lore of sirens or of giants in the confident tone of a master scientist, as indeed, in so many ways, he was. He always followed a sort of logic, and some of his most apparently fanciful works prepared the way for important scientific discoveries. He located these creatures in a way that combined a folkloric inheritance with a relatively scientific orientation, and perhaps even foreshadowed the theories of contemporary physicists about parallel worlds.

Paracelsus's theory clearly anticipates the enormously influential concept of *umwelt*, or perceptual environment, which was developed by the German theoretical biologist Jakob von Uexküll in the early to mid-twentieth century. Uexküll pointed out that animals with highly divergent sensory capacities can be in the same location, yet observe things so differently that they are in effect in distinctive realms.[15] Thus, for example, a man and a horse will perceive the same field very differently, since the animal, though possessed of enormous tactile sensitivity, is colour-blind. A bee will perceive the field differently from either a horse or a human, since it is sensitive to light in the ultraviolet end of the spectrum. A dog will navigate by scent rather than by sight, and many bats, as we have only learned in the last few decades, navigate by echolocation. If each has a very different *umwelt*, it is possible for animals of different species to live alongside one another and yet hardly perceive one another, a bit like the Elementals and human beings.

Near the end of his life, Paracelsus published a book entitled *Liber de nymphis, sylphis, pygmaeis et salamandris et de caeteris spiritibus* ('The Book of Nymphs, Sylphs, Pygmies, Salamanders and Other Spirits'), a guide to the creatures of the spirit world. The four fundamental types of spirit corresponded to the four elements: nymphs to water, sylphs to air, pygmies or gnomes to earth, and salamanders to fire. These beings were all similar to people in form, though not in proportion. They had reason and speech, but they were still animals, since they lacked immortal souls.

Paracelsus was, of course, building on a tradition perhaps first articulated by Empedocles in the Western world, which held that earth, fire, air and

water were the four basic elements out of which all things were made. The gnomes, also known as 'pygmies', were creatures of earth, who could walk through soil and stone in much the way people walk through air, for that was their element, and no object could block their sight. They were said to know the past, present and future, to guard the metals and to often be found in mines. The salamanders, creatures of fire, live in a world where everything is the opposite of what we know. Their summer is our winter, while their day is our night. They usually have little commerce with human beings but they have often been found among witches, with whom they sometimes mate. At times, the Devil will possess them and use them as messengers. Of the sylphs, or creatures of air, Paracelsus has little to say but that, to compensate for their ethereal substance, their bodies are cruder, coarser and stronger than those of people.

The nymphs, or creatures of water, are most like us, according to Paracelsus. They watch people from riverbanks and at times take on human form to establish friendships or do business with human beings, only to vanish afterwards into the water. Other spirits can also marry human beings, but marriage between a female nymph and a man is most common. The spirit will then receive an immortal soul, just as, to use a comparison of Paracelsus, a heathen receives a soul at baptism. But the husband of a nymph must never show anger towards her near water, or she will vanish into the waves forever. And should the husband be unfaithful, he, like the legendary Count Peter von Stauffenberg, who wedded a water fairy but deserted her, he will shortly die.

All of these creatures, like human beings, can give birth to 'monsters', or prodigies, of many forms. The sylphs occasionally give birth to giants, who included St Christopher, as well as to great warriors such as Siegfried, Hildebrand and Dietrich of Bern. The creatures of the earth and mountains give birth to dwarves, those of fire, will-o'-the wisps. The nymphs give birth to sirens, which may be either bird-women or mermaids.[16] The worlds of the Elementals contained buildings and landscapes, and perhaps an almost endless variety of other beings.

Alchemy was made largely anachronistic less by new discoveries than by specialization, as the 'science of everything' broke down into various academic studies and specialties. The study of physical interactions, begun by alchemists, evolved into metallurgy and chemistry. The idea that the world and everything in it was subject to alteration prepared people for the geology of Charles Lyell, the evolutionary theory of Charles Darwin, the quantum mechanics of Max Planck and the physics of Albert Einstein, all of which centre on massive transformations. Through the work of psychologists such as Carl Jung, alchemy became a symbolic means of describing the human psyche. In the visual arts it has influenced symbolists such as William Blake, Surrealists such as Salvador Dalí, and many others. The novel, the dominant literary form of the nineteenth and early twentieth centuries, is based on the alchemical idea that a

J. J. Grandville, 'A Volvok Epidemic Strikes', 1866. In a world that seemed to offer increasingly little room for enchantment or romance, Grandville sometimes found fantastic adventures among creatures in the grass or even beneath the microscope.

human being is a microcosm, since it endeavours to understand the world by exploring virtually endless perceptual and psychological nuances. Paracelsus had perhaps as much influence on fiction as on medicine.

Imaginary creatures can be overwhelming in their multiplicity; how can one divide them into groups? How do you classify those beings which, by their very nature, seem designed to elude every category? Because it refers so vividly to the forces of nature – which, at least until the industrial era, ruled the daily lives of human beings – the taxonomy of Paracelsus may be the most intuitive that we have.

The Canning Jewel, Italian, *c.* 1580. During the Age of Exploration, jewellers would often build an entire sculpture around images suggested by the form of a particular pearl. This legendary piece was reportedly crafted by the Florentine goldsmith Benvenuto Cellini and then given to a Moghul emperor by the Medici family. It was named after Charles John Canning, the British Governor of India during the mid-19th century.

EIGHT
CREATURES OF WATER

*A river seems a magic thing. A magic, moving,
living part of the very earth itself.*
Laura Gilpin, *The Rio Grande*

IN CREATION MYTHS from Egypt, Mesopotamia, Greece and northwest Africa, water is the original element out of which the world emerges. Writing in the sixth century BCE, Thales of Miletus, whom some consider the world's first philosopher, proclaimed that all things were composed of water. This idea may have been inspired by observation of floods in the Nile Delta, which left new land and abundant life as they withdrew. Water changes dust into mud, which is capable of holding shape, and the Bible tells us that the first man was made of clay. More recently, the seas and oceans may be said to be the major metaphor in psychoanalytical theories for the unconscious mind, with its apparently placid surface that hides abundant activity.

About 80 per cent of the world's biomass is under water. Life in the sea is not only plentiful and exuberant but also far more diverse than life on land. The terrestrial sphere is largely the realm of vertebrates. Among the great profusion of forms and colours of creatures below the surface of the sea are oysters, anemones, octopuses, squid, starfish and countless other creatures, which bear little apparent resemblance to anything on land or even to one another. Beneath the waves, it is not always easy to tell animal from plant, or even the living from the dead.

The surface of water is like a mirror, hence the traditional idea that the sea is an inversion of the world on land. Every terrestrial creature has, according to widespread tradition, an equivalent in the sea, an idea that is preserved today in names such as 'seahorse' and 'sea lion'. But relations within that kingdom are in myth often the opposite of what we are accustomed to. While human society has tended to be patriarchal, it is the mermaids, not mermen, who dominate the waters. In maritime legends they are forever abducting, imprisoning and perhaps even raping hapless sailors.

There has always been a profound ambivalence about water in human culture. It is the ultimate enemy of structure and order, without form and capable of slowly obliterating stones. At the same time, it is a means to cleansing in baptism when sins are 'washed away'. Both these aspects may be seen in legends found in many cultures of a great flood, such as the one survived by Noah, in which the Earth itself is cleansed and a New Covenant is created.

Sea devil, from a newsletter, Seine-et-Oise, France, 16th century. According to tradition, each creature on the earth has a counterpart in the sea, and that applies to mythological ones such as satyrs.

J. B. Coriolan, 'Marine Monster in the form of a Monarch', illustration from Ulisse Aldrovandi, *Monstorum historia* (1642). It is probably the dignified, stately bearing of this creature that moved people to consider it a king of the sea.

J. B. Coriolan, illustration from Ulisse Aldrovandi, *Monstorum historia* (1642). The *camphurch*, also known as 'Aldrovandi's unicorn', was first reported during the sixteenth century, in the waters near the Strait of Malacca. Its forefeet resemble those of a horse, while its hind feet are webbed, and it can move its horn at will.

Tempera on silk painting, dated 31 December 1942. A ship's mate 'crossing the line' (the equator), was traditionally accompanied by an initiation into life at sea, which involved colourful costumes, ceremonies and merrymaking. The young sailors are now part of the Domain of the Golden Dragon, ruler of the 101st meridian.

This ambivalence regarding water has long been, and probably still is, extended to mariners and others who make their living from the sea. They were initiates of a world about which most people might only dream as they watched ships vanish beyond the horizon from the shore. They brought back strange tales from distant lands and were intimate with the wind, waves and weather. At the same time they had a reputation as being unreliable, a bit like the sea itself. They might, perhaps, steal property or leave a young girl pregnant, and then depart by ship, never to be seen again.

Bookplate of Elizabeth Hunter, England, late 19th century. Because books, like ships, can take us to distant lands, mermaids have been a favourite motif on bookplates. The woman in this picture is so intent on reading that she does not hear the mermaids, perhaps her former companions, calling to her.

From the Time Before Time

The pre-literate period of humankind is more profoundly mysterious than either our biological evolution or the further development of civilization. Scientists at least know how to study the evolution of the human mind and body, but they are far less sure how to even approach that of human culture. When the fields we know as myth and folklore began to emerge in the eighteenth and nineteenth centuries, scholars were often perplexed by the way very similar stories seemed to have developed in cultures that had experienced little or no contact with one another over millennia. Nearly 1,000 versions of the tale 'Cinderella' have been recorded, from ancient Egypt to medieval China and from Scotland to the Native American Zuni people. Scholars with a psychoanalytic orientation, especially followers of Jung, believed this was because certain archetypal figures and events are imprinted on the human mind. Folklorists of the Historic-Geographic School, led by Stith Thompson, believed these parallels to be due to cultural diffusion, along routes that might eventually be reconstructed. Sociobiologists have recently tried to combine these approaches by positing a Darwinian selection of tales and motifs, but whatever the potential of that approach, its findings remain tentative.[1]

Monsters, most specifically water monsters which cause storms at sea and even shake the earth, are nearly universal in human cultures. The ancient Egyptians believed that the sun was the bark of the god Ra, which sailed across the sky each day and then made a perilous underworld journey every night. As it passed beneath the ground, the giant serpent Apep would try to swallow it. The Vikings believed in a similar serpent, Midgarðsormr, or Jörmungandr, whose coils ran around the earth. At the end of time, Midgarðsormr will rise from the sea and battle the thunder-god Thor, who will crush the monster's head with his hammer but be killed by its venom. For Aboriginal Australians, the rainbow is a glimpse of the enormous snake which usually remains coiled in streams and pools beneath the earth, but sometimes emerges to cause storms. For the Australian Gagudju people, the rainbow snake is female and the greatest of all deities. She created the earth back in Dreamtime, the time before time, and continues to renew it with rain. Among the Dahomey in northeast Africa, the rainbow snake is Aido Hwedo, who supports the world with its coils. There is no way to tell if such divinities are all derived from a single primeval mythology, which later fragmented, or whether they developed autonomously. However it occurred, snakes, due in part to the absolute simplicity of their form and their rhythmic method of locomotion, seem to connect us with our origins in a primeval past.

The Loch Ness monster and similar creatures reported in various lakes are generally pictured as plesiosaurs, aquatic reptiles that lived alongside dinosaurs and became extinct about 65 million years ago. They have even inspired occasional

Giant octopus attacking a vessel, from Pierre Denys De Montfort, *Histoire Naturelle de Mollusces* (1802). The colour, variety and mystery of life beneath the sea give it a special grandeur, so reports of sea creatures often greatly exaggerate their size.

speculations in the press that perhaps plesiosaurs could be alive today, an idea that is firmly rejected by zoologists. Creationist textbooks used in private religious schools in Louisiana cite the Loch Ness monster as evidence that the theory of evolution is a hoax.[2] Rumours of the animal show the continuity in visual imagination between medieval mariners, modern palaeontologists and contemporary tourists, all of whom try to envisage monstrous creatures on the basis of a few enticing clues.

Tiamat

In contrast to ancient Egypt, the Mesopotamian deities usually have human form. A partial exception is Ishtar (Sumerian Inanna), who is at times portrayed as a woman with wings and an eagle's claws for feet. Various demons and demigods, by contrast, blend features of several animals. They are recorded in poems and sculptures, but above all in the many thousands of carved cylinder seals, which were rolled over wax to produce reliefs of mythological scenes.

Like Egypt, Mesopotamia produced images of imaginary animals going back to the start of civilization and earlier. These images increase in number and importance at about the same time as they do in Egypt – around the middle of the second millennium BCE. In Mesopotamia, this era comprises the Middle Babylonian (1651–1157 BCE), Mitannian (1500–1350 BCE) and Middle Assyrian periods (1350–1000 BCE), generally an era of turmoil and instability. In subsequent art, the fantastic hybrid creatures are increasingly demonized.[3]

There is a mythological account of the origin of imaginary animals in the Babylonian epic of creation known as Enuma Elish. There are several theories about its date of composition, and we can only say with confidence that it was written down some time during the second millennium BCE. The goddess-demon Tiamat is the salt waters, while her consort Apsu is fresh water, and their union is the source of life. After having given birth to the deities, Tiamat is disturbed by their noise and decides to annihilate them. On learning of this plan, the gods ambush and kill Apsu. To help her defeat them, Tiamat gives birth to eleven monsters, including a scorpion man, a bull man, a fish man, a lion demon, a horned serpent and a dragon. In addition she creates the monster Kingu, who becomes her new consort. Tiamat is finally defeated in battle by her grandson Marduk, the god of light, who then becomes the supreme deity. Marduk splits his grandmother's skull with a mace and breaks her open as one might a dried fish. One half of her becomes the sky while the other becomes the earth. Marduk makes Tiamat's breasts into mountains, and the Tigris and Euphrates rivers flow from her eyes. He also kills Kingu, and makes human beings from his blood.

The Babylonian understanding of time was not linear, so the event could not be simply consigned to an obliterated past. The conflict between Marduk and Tiamat is an eternal one between order and chaos and was re-enacted in festivities that marked

Androgynous image of the goddess Tiamat, after a relief in an Assyrian temple, early 7th century BCE.

the Babylonian New Year. That earth and humankind are made of the bodies of Tiamat and Kingu respectively is a sort of original sin, suggesting that we all carry within us the potential for chaos and, perhaps, our own destruction.[4]

Though he was usually depicted as a normal human being, Marduk is described in Enuma Elish as a monster himself. He has four eyes and four enormous ears, and fire blazes from his lips.[5] As for Tiamat, she represents primal chaos, and there is no description of her in the creation myth, but she has been depicted as an androgynous beast with a lion's head and forepaws, an eagle's wings and feet, and a pair of horns. Both belong to the beginning of the cosmos, a period in which, according to most traditions, the physical forms of creatures were more fluid than they are today. In the end, Mesopotamia has bequeathed to us many of the most popular fantastic creatures such as centaurs, merpeople and griffins. But perhaps the greatest legacy of Mesopotamian myth is Tiamat herself, who personifies the primal chaos out of which order and life first emerged.

The Mother of All Monsters

It may well be that in even more remote times, Tiamat was a positive figure. From a feminist point of view, her defeat by Marduk is the establishment of patriarchy. At any rate, the conflict between Marduk and Tiamat provides images which seem to reverberate endlessly in subsequent myths and legends. One figure that resembles Tiamat is Lilith, who is also mentioned in Sumerian tablets that are far older than even Enuma Elish. There are two biblical accounts of the creation of the world. In the first, Adam and his wife are created simultaneously in the image of God, while in the second Adam is created first. The first woman is created afterwards by Yahweh from his rib, in order to provide a fitting companion for him. The image suggests a sort of gender reversal in which the man gives birth, since Yahweh takes the woman out of Adam's side.

Most commentators have been content to skip over the contradictions between the two accounts, like so many others in the Bible, but a few have

tried to reconcile them by distinguishing between Adam's first wife, Lilith, and his second wife, Eve. According to Hebrew legend, Lilith refused to submit to Adam but fled to the desert where, like Tiamat, she gave birth to innumerable monsters and demons. She is called a 'screech owl' in Isaiah (34:14) and is sometimes depicted with avian features. But according to legends of the late Middle Ages in Europe, Eve had mated with the serpent in Eden, and monstrous creatures or people were her progeny.

In Greek mythology, as recounted in Hesiod's *Theogony*, Gaia, or Earth, is also the primal mother of both deities and monsters. She is the first being to emerge out of the original chaos. She creates mountains and seas but also bears Uranus, Heaven, who becomes her consort. They, like Tiamat and Kingu, give birth to the original gods and goddesses, the Titans, as well as to Cyclops and other terrifying creatures:

> And again there were born of Earth and Heaven three more sons, mighty and stern, not to be spoken of, Kottos, Briareos, and Gyges, overbearing children, and their father loathed them from the beginning. A hundred arms sprang from their shoulders – unshapen hulks – and 50 heads grew from the shoulders of each of them upon their stalwart bodies. And strength boundless and powerful was in their mighty form. For all those that were born of Earth and Heaven were the most fearsome of children, and their own father loathed them from the beginning. As soon as each of them was born, he hid them away in a cavern of Earth, and would not let them into the light.[6]

At the request of Gaia, her son Cronos ambushes his father Uranus and castrates his sire with a golden sickle. Uranus disappears into the heavens but his sperm falls into the sea, from which emerges Aphrodite, the goddess of love. Grass grows around her feet and spreads with her every step. This story is one of many from the ancient world that seems to intuitively anticipate the view of scientists that the sea is the original source of life.

Later, when another generation of deities, led by Zeus, makes war on the Titans, Gaia gives birth to her final son, Typhon:

> Out of his shoulders came a hundred fearsome snake-heads with black tongues flickering, and the eyes in his strange heads flashed fire under the brows; and there were voices in all his fearsome heads, giving out every kind of indescribable sound. Sometimes they uttered as if for the gods' understanding, sometimes again the sound of a bellowing bull whose might is uncontainable and whose voice is proud, sometimes again of a lion, who knows no restraint, sometimes again a pack of hounds, astonishing to hear; sometimes again he hissed; and the long mountain echoes beneath.[7]

The entire cosmos trembles as the battle erupts, but Zeus defeats Typhon and Gaia, and then places Tyhpon underneath Mount Etna; volcanic eruptions may still be seen as he struggles to free himself. Like Marduk, Zeus is the deity that vanquishes freaks and prodigies to impose a cosmic order.

Another creature, also in Hesiod's *Theogony*, who is perhaps even closer to the archetype represented by Tiamat, is Echidna. She is the daughter of Phorcys, known as the 'Old Man of the Sea', and the aquatic creature Ceto, from whom our word 'cetaccan' comes. Echidna is a beautiful nymph from the waist up, and an enormous serpent below it. Mating with Typhon, she gives birth to monstrous children including the Hydra, an aquatic serpent with seven or more heads; Cerberus, the dog with 50 heads (three according to later authors) that guards the underworld; and the Chimera, with three heads – of a lion, a goat and a serpent.[8]

One more figure that may go back to Tiamat is the Whore of Babylon in the Book of Revelation, 'who rules enthroned beside abundant waters'. The narrator sees a vision of her riding the Beast of the Apocalypse, which has seven heads and ten horns. She is dressed in robes of purple and scarlet, ornamented with gold, jewels and pearls, and carries a gold wine cup, which is filled with filth. On her forehead is written 'Babylon the Great, the mother of all prostitutes and all the filthy practices of the earth' (17:1–7). In the next vision, an angel appears and announces loudly:

Babylon has fallen, Babylon the Great has fallen, and has become a haunt of devils and lodging for every foul spirit and dirty, loathsome bird. All the nations have been intoxicated by the wine of her prostitution; every king on earth has committed fornication with her, and every merchant grown rich through her debauchery. (18:2–3)

Has the prostitute, like Tiamat, given birth to all of the strange devils and spirits that fill the Book of Revelation for her battle with the hosts of Heaven? At the least, she seems to have summoned them to her side.

The basic story of the Babylonian creation myth is retold constantly up through the Middle Ages and afterwards. In the Old English epic *Beowulf*, one might compare the monster Grendel to Apsu or Kingu, and his mother to Tiamat, while Beowulf, the hero who slays them, is like Marduk, slaying monsters to bring order to a wilderness. The symbolism here has remained largely unchanged since antiquity, but, in late medieval times, human sympathies begin to shift more towards the primal mother and her deformed progeny. (See the discussion of Melusine in chapter Six.)

Sedna

The final, and most enigmatic, archetypal mother of fantastic creatures that we will look at is Sedna, the Inuit goddess of the sea. There are many variants of her story in the vast body of Inuit oral literature,

but the basic outline is pretty consistent. Sedna is a lovely young woman, who is raised by her father Anguta. A handsome young man induces her to leave home in his kayak, promising that she will have fine furs and plenty of food. It turns out that he is really a fulmar, an arctic bird related to the petrel, and his home is a desolate, windy promontory by the sea. Sedna's father comes to rescue her, and she jumps into his kayak and the two of them hurry away. Her husband, together with other sea birds, assumes human form, and they all set out in kayaks of their own to pursue Sedna. Her husband asks her to return with him and, when she refuses, he spreads his arms, which again become wings. But before the fulmar can take flight, Anguta kills him with a spear. The fulmar's followers continue to pursue Sedna and the winds become more furious until Anguta, seeking to lighten the boat, tosses Sedna out into the sea. She grabs the sides of the kayak with her hands, but Anguta cuts off her fingers. These become walruses, seals and whales, while countless other creatures are created from her blood. Sedna sinks into the sea, to become ruler of the depths. Still angry at the way she has been treated, she grants good weather and success in hunting to those who honour her, but expresses her fury in storms.[9]

Sedna is usually depicted much like a mermaid, though with important differences. A mermaid is usually shown as a woman down to the waist, and one that conforms to rather stereotypical ideas of feminine beauty, often with blue eyes and long blonde hair. Below, she has the rather stylized body

Sea creature with the face of a woman, probably Sedna, after an Esquimaux soap stone carving, Cape Dorset, Canada. Sedna has a relationship in folklore to the European mermaid, but seems far closer to the undersea world, and has none of the coyness of her Old World counterpart.

of a fish, with a sharply divided tail that suggests feet. It is not very hard for women who perform synchronized swimming routines to mimic mermaids simply by holding their legs together. Sedna, by contrast, is pervaded by the mystery of the sea in every part of her body and her face: her arms resemble crooked fins and her body is curved like a seal's. Her face appears weathered and at times rather old, and there is nothing flirtatious in her gaze, for her humanity is only a distant memory.

Sedna's fertility does not lie primarily in having many offspring, though in some versions of her story she had many children with a dog, which became the various peoples of the world. It lies, rather, in being able to engender myriad creatures from her blood and body. Like Tiamat, she is a primal mother from the sea, and a bringer of cataclysmic violence. It may be that both Sedna and Tiamat go back to some primeval goddess of very early times, or their legends may have evolved independently.

According to some scholars, the legend of Sedna, despite its great popularity among the Inuit, is of historically recent origin and developed alongside the whaling industry.[10] In that case, one might look for similarities in occidental folklore and religion, but analogies remain – a bit like the creatures of the sea themselves – plentiful yet elusive.

The archetypal mother of monsters shows not simply 'fertility', at least not in the restricted sense in which we usually use the term. It is a primal creativity, the ability to generate not only new life but new forms, new concepts and new possibilities. In a more intellectual context, the equivalent of Tiamat or Melusine might be the visionary, who is not necessarily very adept at managing familiar routines but can envisage radically new agendas. The mythologies that we have looked at show that this sort of imagination has been feared since very early times. Apsu in Babylonian myth, and Uranus in Greek myth, were both terrified of their children, who seemed so strange and so powerful, and both feared being displaced by their progeny.

Heroes and Leviathans

Marduk anticipates not only Zeus but even Yahweh/Elohim: God divides the earth from the sky as Marduk split the body of the defeated Tiamat in two. God continues to organize the primal chaos, separating the waters from the land and then organizing them into rivers and seas, and separated the darkness from the light (Genesis 1:1–10), much as Marduk does in the Enuma Elish.[11] At one point, the similarities may have been greater still. There are many passages in the Old Testament that seem to allude to a battle between Yahweh and a primeval sea monster representing chaos, similar to Marduk's battle with Tiamat. Psalm 74, for example, addresses Yahweh, saying 'You crushed Leviathan's heads, leaving him for wild animals to eat' (14). In Job, Leviathan is a fearsome monster, yet a testimony to the power and wisdom of God (41:2–26). The story behind such references, if indeed there is one, has been lost.

Yahweh/Elohim of the Bible is far from being the God of theologians. Though possessed of awesome powers, he generally seems to be neither omniscient nor omnipotent. He is subject to passions such as anger and jealousy, and can be goaded by Satan into killing the innocent family of Job (Job 1:1–19). He can also regret things, as he does after creating humankind (Genesis 6:5–8). He can even be ashamed before a human being (Genesis 18:18–19) and can bargain, as he does with Abraham before destroying Sodom and Gomorrah (Genesis 18:22–33). He may not allow the people of Israel to have any gods before him (Exodus 20:3), but there often seem to be other divine beings among the heavenly host. What makes it relatively easy to love Yahweh is his vulnerability, which at times seems almost as great as his power. For all his majesty, Yahweh is terribly hurt whenever his people begin to turn away from him. Archaeologists have discovered that Yahweh once had a consort named Asherah, and he seems lonely without her.

Gustave Doré, 'Yahweh Kills Leviathan', c. 1855. 'That day, Yahweh will punish, with his hard sword, massive and strong, Leviathan the fleeing serpent, Leviathan the twisting serpent: he will kill the sea dragon' (Isaiah 27:1).

This loneliness helps explain Yahweh's complex and apparently contradictory relationship with Leviathan, which veers between conquest, celebration and companionship. At the end of the Book of Job, Yahweh's voice speaks to Job from the whirlwind, telling of Leviathan:

Any hope you might have would be futile, the mere sight of him would overwhelm you.

When roused, he grows ferocious, who could ever stand up to him?

Who has ever attacked him with impunity? No one beneath all Heaven!

Albert Pinkham Ryder, *Jonah and the Whale*, 1885. The artist lived in the coastal city of New Bedford, Massachusetts, at time when whaling was a major, though declining, industry. His intimate knowledge of whaling and the sea enabled him to reinterpret the tale of Jonah, with its themes of death and resurrection, in the context of the modern world.

Next I will talk of his limbs and describe his matchless strength –

Who can undo the front of his tunic or pierce the double armour of his breastplate?

Who dare open the gates of his mouth? Terror reigns round his teeth!

His back is like rows of shields, sealed with a stone seal,

Touching each other so close that no breath could pass between,

Sticking to one another making an impervious whole.

His sneezes radiate light, his eyes are like the eyelashes of the dawn.

From his mouth come fiery torches, sparks of fire fly out of it.

His nostrils belch smoke like a cauldron boiling on the fire.

His breath could kindle coals, flame issues from his mouth.

His strength resides in his neck, violence leaps before him as he goes.

The strips of his flesh are jointed together, firmly set in and immovable.

His heart is as hard as rock unyielding as the lower millstone.

When he stands up, the waves take fright and the billows of the sea retreat.

Sword may strike but will not stick in him, no more will spear, javelin or lance.

Iron means no more to him than straw, nor bronze than rotten wood.

No arrow can make him flee, a sling-stone tickles him like hay.

Club seems to him like straw, he laughs at the whirring javelin.

He has sharp potsherds underneath, and moves across the slime like a harrow.

He makes the depths seethe like a cauldron, he makes the sea fume like a scent burner.

Behind him he leaves a glittering wake – a white fleece seems to float on the deeps.

He has no equal on earth, being created without fear.

He looks the haughtiest in the eye; of all the lordly beasts he is king. (41:1–25)

These words recall the hymns of praise to Yahweh himself in the Psalms and elsewhere. Leviathan not only seems to exemplify the might of Yahweh but almost to stand in for him. Just as there is one God, so there is only a single Leviathan.

Several sea monsters are named in the Old Testament, including the great fish that swallows Jonah, but tradition assimilates them all to Leviathan. The lord of the sea is even identified with the serpent of Eden. He seems to represent the primal reality before light was separated from darkness or good from evil. He is, like Tiamat, an embodiment of the original chaos.

The scattered references to Leviathan in the Bible have been elaborated in Jewish legends. One popular one, which may possibly echo the combat between Marduk and Tiamat, tells that at the beginning of the world God creates two leviathans, a male and a female. They grow so large and powerful that Yahweh becomes worried that, should they reproduce, they would destroy the world. He kills the female but, so that the remaining leviathan will not be lonely, Yahweh plays with it at the close of every day. At the end of time he will kill the remaining leviathan, and the just will eat its flesh in an enormous tent made of its skin.[12]

There is a virtually endless number of tales in Western culture where warriors battle dragons, though hardly any in the Orient. The heroes that vanquish monstrous serpents include Baal, Vishnu, Heracles, Apollo, Jason, Cadmus, Sigurd, Siegfried and Perseus in the ancient world. In the Christian world, these include St Michael, St Patrick, Beowulf, St Martha and St Margaret, but the most popular of all is St George, who became the patron saint of Russia and England. All of the tales of heroes or saints defeating dragons contain an echo of the conflict between Yahweh and

Leviathan, as well as, even more distantly, Marduk and Tiamat.

The culture of mariners cuts across national and ethnic boundaries. There are numerous marine creatures reported by sailors throughout the world that also bear at least some resemblance to Leviathan and are intermittently identified with him. Among these was a monster encountered by the Irish St Brendan, who some believe sailed to the Americas in a boat made of hide stretched over timber long before Leif Erickson or Christopher Columbus. According to an account from the ninth century, Brendan and the monks who accompanied him landed on an island, celebrated Mass and lit a fire to cook their food. The island began to move and the monks panicked, but Brendan calmly explained that the land was actually an enormous fish named Jasconius.[13]

In the sixteenth century the Swedish bishop Olaus Magnus (1490–1557) and the French surgeon Ambroise Paré (1510–1590) produced many descriptions of aquatic monsters, together with maps with illustrations that seem fanciful to us today. By far the most celebrated was the great sea

Gustave Doré, 'Roger saving Angelica', illustration to *Orlando Furioso* by Ludovico Arisoto (1877). *Orlando Furioso* was a mock-medieval romance, first published in 1532, which exaggerated every convention of knightly epics by including the most complex romantic entanglements, extravagant magic and fantastic creatures. Doré, caught up in medieval revival, presents these without the original sense of irony.

serpent which Olaus describes as being over 200 feet long and 20 feet thick, covered with scales, and black except for flaming eyes. It emerges from the coast of Norway on clear nights and devours calves, lambs and hogs. At times the serpent will raise its head far above the sea and snatch up men in its jaws, a sign that a vast change in the kingdom is imminent. Paré depicted creatures such as the monk-fish and the bishop-fish which, apart from skin covered with scales, resembled human counterparts in ecclesiastical attire. Early modern European maps of the oceans were filled with these and other strange beings reported by mariners.[14] Most of these had the tails of fish combined with upper bodies that consisted of features drawn from various land animals. Some, for example, were said to have the heads of horses, the ears of wolves, the snouts of pigs, the manes of lions or the paws of bears, and it is hard to tell metaphor from fantasy, or hyperbole from fabrication, in descriptions of them.

But later sightings of sea monsters are in many ways far more puzzling. Paradoxically, as the scepticism about the reported sea monsters became gradually more widespread, the sightings of them also increased in frequency, reaching their highest point in the nineteenth century. Then, there were hundreds of sightings of great sea serpents, many by people who were considered fully reliable, and in accord with the scientific culture of the day, their reports were often very precisely detailed. They generally described a monster of immense length, which moved with a rapid undulating motion, was covered with scales and had a fierce look in its eyes. This testimony is by Captain Woodward and the crew of his ship the *Adamant*, sailing between Britain and America, from the newspaper *The London Aegis* of 7 August 1818:

> I had one of my guns loaded with a cannon-ball and musket-bullets; I fired it at the head

'The Serpent in the Sea of Darkness', illustration to Olaus Magnus, *Historia de Gentibus Septentrionalis* (1555). The monster here could perhaps be an embodiment of a tsunami or hurricane.

Depiction of the god Apollo, French, 15th century. The Graeco-Roman god Apollo is depicted as an idealized medieval king. The women on the left eclectically blend features of the three graces, the Pythia, and the priestesses at Dodona. Note especially the monster at the feet of the god, which seems to be a version of Cerberus, but with many features of reptiles.

of the monster; my crew and myself distinctly heard the balls and bullets strike against his body, from which they rebounded as if they had struck against a rock. The serpent shook his head and his tail in an extraordinary manner, and advanced towards the ship with open jaws. He almost touched the vessel, and had I not tacked [that is, turned the vessel towards the wind] as I did, he would certainly have come on board. He dived, but in a moment we saw him appear again, with his head on one side of the vessel and his tail on the other, as if he were going to lift us up and to upset us. However, we did not feel any shock. He remained five hours near us, only going backward and forward . . . I estimate that his length is at least twice that of my schooner, that is to say a hundred and thirty feet; his head is full twelve or fourteen; the diameter of his body. He is of brackish

'News of 1739 about the Sea-Freak Caught in Spain', a mid-18th-century Russian popular print. This is one of many mermaids or mermen that were reportedly taken from the sea in the early modern period. It may look fantastic, but the description accompanying the picture was very detailed and precise.

Sea serpent, from Bishop Hans Egede, *The New Survey of Old Greenland*, 1734. This drawing was widely disseminated in newspapers and books, until it became perhaps the most familiar image of a water monster during the 18th and early 19th centuries.

colour; his ear holes are about twelve feet from the extremity of his head. In short, the whole has a terrible look. When he coils himself up he places his tail in such a manner that it aids him in darting forward with great force; he moves in all directions with the greatest facility, and astonishing rapidity.[15]

The innumerable testimonials from people who claimed to have seen the great sea serpent would be very powerful evidence for its existence, but they are not very consistent in the smaller details, and they gradually become rarer in the twentieth century. Furthermore, no reliable photographs of the monster have ever been taken, and no body or skeleton of it has ever been found.[16]

To sum up, it is almost as hard to doubt the existence of the great sea serpent as to believe in it. Many sightings might be inspired by whales, seaweed, schools of fish or the play of light upon the water. They could be distorted by the solitude of the sea, the boredom of long voyages, expectations inspired by old books or the intake of alcohol. They could in some cases be deliberate deceptions, undertaken in the knowledge that nobody could disprove reports from the high seas. On the other hand, they could be sightings of creatures that, like so many others in the last few centuries, have become extinct or rare, perhaps with only relatively minor embellishments. The depths of the sea remain barely explored even today, and we cannot predict what novelties they may contain.

The Mermaid and Her Sisters

Until the late Middle Ages, Leviathan and his relations ruled the depths of the seas, but that beast was dethroned by the mermaid. A woman with the tail of a fish instead of legs, the mermaid had a lineage as old as the sea monster's. Dagon, a

Philistine god of fertility, was also depicted with a human torso and face but the tail of a fish, as was Ea or Enki, the Mesopotamian god of wisdom. So was the Syrian goddess Atargatis, as well as numerous local spirits of streams and rivers. But the mermaid, who does not emerge in the culture of mariners until about the fifteenth century, obtained a very distinct identity from the maritime culture that produced her. With the expansion of trade at the end of the Middle Ages, seamanship became a more popular profession. Apart from the nearly complete exclusion of women, it was uniquely cosmopolitan, since it drew adventurers from every corner of the globe.

Why a mermaid rather than a merman? The mermaid was a male fantasy, if a rather complex one. Deprived of female companionship on their journeys, men on board ships often portrayed the mermaid in ways that, in contrast to pictures of related figures such as Atargatis or Sedna, bordered on the pornographic. She would be shown emerging from the waves showing her bare breasts and smiling enticingly. She represented the seduction of the sea, to which these sailors had already at least partially succumbed. The mermaid evoked a desire that could never be consummated. The life of a sailor was difficult, dangerous, unstable and poorly paid; nevertheless many young men felt irresistibly drawn to it, as they would watch ships sailing away from shore. In search of adventure, they would sign up, hardly knowing what to expect, and then live precariously from one voyage to the next. The

'Morgan of the Black Rock', a mermaid sighted near Liverpool, from an 18th-century chapbook. According to tradition, a mermaid was depicted with a comb in her right hand to symbolize feminine vanity. She often has a mirror in her left hand, but this time she holds a flower, perhaps to lure sailors by reminding them of life on land.

mermaid embodied their love–hate relationship with the sea.

The crews may have been masculine, but they felt themselves surrounded by feminine powers. The ships, the weather and the sea itself were felt to be female, in part because they were unpredictable, mysterious and difficult to understand. The sea was where all human laws and expectations ceased to count, but it was also a mirror image, an image in reverse, of life on land. One could not quite

call it 'matriarchal', for the mermaids were seldom viewed as mothers; they were themselves more like children, born not of parents but of the elements, and they had a dangerous sort of innocence.

Mermaids watched the mariners with childlike wonder, not so different from that they themselves elicited. But these women of the sea were extremely powerful and, if offended, could destroy ships on a whim. In the thirteenth century, Bartholomaeus Anglicus wrote that,

> With sweetness of song this beast maketh midshipmen to sleep, and when she seeth that they are asleep, she goeth into the ship, and ravisheth which she may take with her, and bringeth him to a dry place, and maketh him first lie by her, and if he will not or may not, then she slayeth him and eateth his flesh.[17]

As the international maritime culture absorbed elements from throughout the world, many local and regional water spirits were identified with the figure of the mermaid – for example the Slavic rusalka and the Japanese ningyo. Perhaps the best example of this blending of regional with nautical culture is the goddess Ogbuide of Oguta Lake in Nigeria, who is intimately associated with the cycle of birth, death and reincarnation. In the religion of the Igbo people, the soul must cross a body of water in each of these transitions, and Ogbuide guides it on its journey. She is generally accompanied by sacred pythons, who serve as her messengers

The Mermaid of Amboina, woodcut from *Poissons, ecrivisses et crabes de diverse couleurs* by Louis Renard, 1754. Reportedly captured off the coast of Borneo in the early eighteenth century, this creature was kept in a vat filled with water. It uttered plaintive cries like those of a mouse, refused all food and died after four days.

and sometimes as avengers. Around the end of the nineteenth century, Ogbuide became conflated with other African deities of lakes and streams, as well as with the mermaid of European folklore, to become Mami Wata, whose image decorates many West African taverns and other establishments. Mami Wata takes her massive body of flowing hair and the python around her neck from Ogbuide.[18] Like a European mermaid, she has the upper body of a woman and the tail of a fish, and at times she is even depicted with a mirror and comb.

The mermaid soon acquired a significance that went beyond the confines of ships and ports. She was not only the ruler of the waves but also the goddess of an emerging commercial culture. Her smile was the enticement that manufacturers of all sorts placed in service of their wares. Pictures of mermaids adorned boats, pubs, guest houses, souvenirs and products of every sort. A mermaid with two tails, a 'Melusine', is the logo of Starbucks Coffee, and an animated, singing mermaid advertises Chicken of the Sea canned tuna.

In Europe from the late Middle Ages through the Victorian period, several mermaids were allegedly captured and displayed. The emerging scientific culture even provided markets for mermaid memorabilia of all sorts, exhibited in cabinets of curiosities and travelling shows throughout Europe and North America. In the middle of the nineteenth century, P. T. Barnum, whose name is now almost synonymous with hucksterism, displayed his famous 'Feejee mermaid', which was actually the tail of a fish sewn on to the torso of a dead monkey, originally made by a Japanese fisherman for a Shinto ceremony.

This creature, known as the 'Feejee Mermaid', was first exhibited by P. T. Barnum in London during 1822. It was advertised as a mermaid but was actually a monkey's upper body sewn to a fish's tail, originally made for a Shinto ceremony.

John Keats's poem 'Lines on the Mermaid Tavern' (1818) may be the only advertising jingle ever to enter the literary cannon. Like the mermaid herself, it lies on the border between myth and commerce:

Souls of Poets dead and gone,
What Elysium have ye known,
Happy field or mossy cavern,
Choicer than the Mermaid Tavern?
Have ye tippled drink more fine
Than mine host's Canary wine?
Or are fruits of Paradise
Sweeter than those dainty pies
Of venison? O generous food!
Drest as though bold Robin Hood
Would, with his maid Marian,
Sup and bowse from horn and can.

I have heard that on a day
Mine host's sign-board flew away,
Nobody knew whither, till
An astrologer's old quill
To a sheepskin gave the story,
Said he saw you in your glory,
Underneath a new old sign
Sipping beverage divine,
And pledging with contented smack
The Mermaid in the Zodiac.[19]

In summary, the mermaid is truly a modern myth, arguably the major mythic figure of the past few centuries. She is a figure that rose to prominence alongside the scientific revolutions and the expansion of commerce, and was in fact often nourished by these events.

Despite convincing arguments by anthropologists such as Mary Douglas and Claude Lévi-Strauss since at least the 1950s that, contrary to what the Victorians believed, so-called 'primitive' people are not especially credulous, contemporary people have not yet relinquished their sense of superiority. When indigenous peoples such as Native Americans talked to animals and plants in the wood, it was, until the last few decades at least, taken as evidence of a primitive mentality. But if that is the case, how does one explain the fact that today many owners talk to their animal companions, houseplants and cars?

The mermaid was, for all her commercialization, an authentic figure of folklore. There were hundreds, probably thousands, of mermaid sightings in the Age of Exploration, including on the ships of Columbus, John Smith and Hendrik Hudson. These were reported not as miracles but in a more casual way, which shows how thoroughly the existence of the mermaid was accepted by sailors.

William Blake, *Jacob's Ladder*, 1800. The angels appear like flames, the rays of light like logs and the stars like embers in a hearth.

NINE

Creatures of Fire and Air

> Now in the falling of the gloom
> The red fire paints the empty room:
> And warmly on the roof it looks,
> And flickers on the back of books.
>
> Armies march by tower and spire
> Of cities blazing, in the fire;–
> Till as I gaze with staring eyes,
> The armies fall, the lustre dies.
>
> Robert Louis Stevenson, 'Armies in the Fire'

THE HEARTH OR CAMPFIRE has been the traditional place for storytelling because of not only the warmth it provides but the way it stimulates imagination. Traditional storytellers in Ireland, shanachies or *seanchaithe*, would find inspiration for their tales in both the embers and the changing shadows cast by flames on the walls of cottages. Flames assume curvilinear, organic forms, and they move as unpredictably as animals or people.

The English Romantic poet and visual artist William Blake used to gaze at the embers in his hearth in search of inspiration. He watched as the flames suddenly rose, flickered and died, while branches crumbled and logs turned gradually to ash. In the changing tones of yellow, red, black, blue and grey, he saw figures enacting epic dramas, tales of heroes taking place in vast forests or cities. He might later illustrate these dramas and, in acknowledgement of their origins, place thin lines of flame around the bodies of the men and women.

As a student of the occult, Blake could well have been influenced in this by the alchemist and physician Paracelsus, who called beings of fire 'salamandri'. In his treatise on the spirit world, Paracelsus explained that fire creatures, like flames themselves, are tall and slender, and often run and jump through one another. They seldom appear to human beings, and when they do it is often an omen of coming disaster. Their monstrous children, the will-o'-the-wisps, glide upon the water and have many shapes.[1]

Creatures of the air, as described by Paracelsus, share the dynamic but elusive quality of the wind and clouds. He usually referred to them as 'sylphs', but sometimes as 'forest people' or 'sylvestres', and thought they were essentially composed of air. His ideas about them were probably inspired by the Green Men so often found drawn in the margins of medieval manuscripts. He believed that sylphs, like wild men of the woods, were big and tough, but ate only vegetation.[2] Today the word conjures an image that is the opposite of what Paracelsus envisioned. 'Sylph' is at times used to refer to a slender girl, as well as to the fairies of European folklore and the figures that people 'see' in clouds. Nevertheless, Paracelsus's Elementals of fire and air are still 'imaginary' in the sense of having a special ontological status, of occupying a sort of intermediate zone between being and non-being, between material existence and nothingness.

William Blake, *Beatrice Addressing Dante*, 1827. In this illustration of Canto 29 of Dante's *Paradiso*, a griffin draws the triumphal chariot of Beatrice, together with allegorical figures. The rising and swirling forms in red and blue suggest flames, and the figures are accompanied by clouds of smoke.

Finally, as we turn from learned alchemists to the language of our everyday life, we find that 'creatures of air' usually refers to birds, and at times to insects such as butterflies and bees. 'Creatures of fire', if the phrase is used at all, suggests supernatural beings.

The Sun

In the early to mid-nineteenth century, the British folklorist Max Müller proclaimed a grand theory: that all myth was originally derived from observation of heavenly events in a remote age called the 'mythopoeic' period, before humanity was separated into different peoples. The names of deities all originally designated occurrences and objects in the sky, for example clouds, stars and storms. As language became more direct and less poetic, grammar made simple observations into elaborate myths:

> The idea of a young hero . . . [such as Baldr, Sigurd or Achilles] dying in the fullness of youth, a story so frequently told, localized, and individualized, was first suggested by the sun, dying in all its youthful vigor, either at the end of the day, conquered by the powers of darkness, or at the end of the sunny season, stung by the thorn of Winter.[3]

In other words, the primeval accounts of celestial changes once had an absolute simplicity, but then grammatical evolution forced people to organize

events according to time, place, motive, and so on, thus distorting the original statements and producing myths. Confusion created by the development of language, according to Müller, also gave rise to tales of fantastic creatures such as gorgons and chimeras.

This theory now seems not only anachronistic but also terribly Victorian. For one thing, there is the extreme intellectual boldness with which a few events are made to stand for all the rest, reflecting the self-assurance of an empire that seemed destined to endure forever. Also very Victorian in spirit was the pedantic side of Müller's theory, in which such audacious conceptions were supported by fine points of etymology. There was also the combination of scorn and nostalgia with which the Victorians viewed distant times and exotic peoples. Finally, he adapted stories by authors such as Hesiod to Victorian sensibilities by reducing their acts of extreme violence and unbridled sexuality into allegories for everyday events, such as the approach of dawn. The bold interpretations of myths from across the globe by Müller and his followers in terms of the weather or astronomy now seem far more poetic than scientific. Today, Müller's grand conception of a mythopoeic period seems less a theory than itself a sort of myth. It rather resembles the Garden of Eden in Abrahamic religions, and his hypothesis about the creation of myths describes a sort of fall from grace.

But Müller is remembered as a founder of comparative mythology, as well as for translations of Sanskrit literature that are still read today. And if enthusiasm and brashness led him to greatly overstate the importance of the sun and other heavenly bodies in mythology, he still deserves some credit for identifying it. No, all things in myth and legend cannot be traced back to celestial phenomena, but there are some that can.

We may stylize the sun as a simple yellow ball, and perhaps draw a smiling face on it, but we experience it as far more. On a clear summer day, when the sun is at its height, we cannot look directly at it, especially not in tropical climates, for that would burn our eyes. We see the sun indirectly, often as reflected in rivers, ponds and lakes. Sunlight produces a dazzling range of colours when reflected on clouds and, when the air is especially moist, these form rainbows. The sun may look white in winter, orange in autumn and black during an eclipse. The Egyptians conceived of the sun as the boat of the god Ra, sailing across the sky. The Greeks and Romans saw it as the chariot of Apollo. But the splendour of evening clouds and rainbows brings to mind, above all, the plumage of a multicoloured bird.

And the sun is represented by many such birds, especially across the northern hemisphere: the Egyptian phoenix, the Mesopotamian bird Anzu, the Central Asian griffin, the Russian firebird, the Persian huma, the Jewish Milcham, the Turkish kerkes, the Arabian roc, the Near Eastern simurg, the Chinese fenghuang and the Japanese ho-o, to name only a few. In addition there are many 'birds of paradise', reported over the centuries by travellers, chiefly in the forests of Asia. These

creatures tend to have enormous size, immense strength and brilliant, flowing plumes, and present us with the sort of parallels that so entice and frustrate folklorists.

The stories of these birds could have arisen largely independently, occasionally borrowing motifs from one another as they were retold. We cannot trace the folkloric evolution of these mythical birds in very great detail, but those of the Old World seem to intuitively fall into two broad categories: the phoenix and the griffin. Both are incarnations of the sun, but in different aspects. The phoenix, with its flowing plumes, brilliant colours and exuberant flight, represents the sun at dawn and in late evening. The griffin, with its immense power, primeval simplicity and majestic stillness, stands for the sun at midday.

The Phoenix

The phoenix is a Hellenized version of Bennu, a bird closely associated with the Egyptian sun-god Ra, whose major shrine was at Heliopolis. Bennu is usually depicted in hieroglyphs as a heron, at times perched on top of a pyramid to symbolize its role as a bearer of eternal life. In a version of the Egyptian *Book of the Dead*, a guide for souls in the underworld dating from around the middle of the second millennium BCE, Bennu is described as 'keeper of the volume of the book of things which are and of things which shall be'.[4]

There are a few passing references to the phoenix in Greek literature going back to Hesiod, but the first detailed one, which established the importance of the bird in Western culture, is that of the fifth-century BCE historian Herodotus. He described it as having feathers of gold and red, and as formed rather like an eagle. The bird lives in Arabia, and lives for 500 years. Herodotus' story of the phoenix sounds rather garbled, and even the writer himself, who often seemed boundless in his credulity, says he finds it difficult to believe. According to him, the phoenix appears only once in a half-millennium, when an old phoenix dies. The son of the old phoenix makes an enormous ball of myrrh, and places its father inside. It then carries the ball to Egypt and deposits it in the temple of the sun.[5]

Does a new phoenix hatch from the ball? Almost all of Herodotus' readers have assumed this, but he actually does not say it. And, if one phoenix can carry his dead father in a ball, does it have a mother? Or does the phoenix never reproduce, because it never dies? And what will happen to the younger phoenix, when his 500 years are up? Does that phoenix also have a son, who will take it to Heliopolis? If so, why is a phoenix seen there only once, rather than twice or many times, in 500 years?

But it is likely that the eminent historian's confusion helped to build the myth of the phoenix, since it forced later writers to fill in gaps and simplify the tale. The egg of myrrh described by Herodotus suggests the cocoon created by a caterpillar, from which a butterfly emerges – probably the oldest and most universal symbol of resurrection. Later retellings of the story brought out this implicit theme of rebirth more clearly. For successors of

Herodotus, there is only one phoenix, combining father, son and mother. At the end of its long lifespan the phoenix creates not an egg but a pyre, on which it immolates itself and is reborn from the ashes.

The phoenix was mentioned increasingly frequently by Roman and Greek authors of late antiquity, as it gradually became more stylized and allegorical. As a symbol of resurrection, variants of the phoenix entered Jewish, Christian and Islamic culture. Milcham, or the Jewish phoenix, was the only animal that heeded God's commandment not to eat of the Tree of Life, for which it was rewarded with immortality. The simurg, or Arabian phoenix, lives for about two millennia and nests peacefully in the Tree of Knowledge. The kerkes, or Turkish phoenix, lives for 1,000 years, then consumes itself with fire and is rejuvenated, as it will continue to do until the end of time. Each time the kerkes is reborn, new leaves and branches grow on the Ababel, the tree of wisdom in the Quran. The firebird, or Russian phoenix, guards the golden apples of eternal life. The fenghuang, or Chinese phoenix, emerged from the sun and nourishes itself not on food but only on solar rays. The ho-o, or Japanese phoenix, only appears at the start of a new era. For alchemists, the phoenix represented the element sulphur, a major ingredient in gunpowder, which corresponded to the sun. The Western phoenix is a symbol of Christ, who also rose from the dead; one bestiary from the late thirteenth century said of St Paul, 'he entered into his chrysalis like a true phoenix, filling it with the odour of his martyrdom.'[6]

In the poem 'Of Mere Being' by Wallace Stevens, a bird sings in a palm tree that is growing in a place so remote that it is almost beyond reach of thought. The poet concludes:

The wind moves slowly in the branches.
The bird's fire-fangled feathers dangle down.[7]

With its brilliantly coloured plumage, the bird is clearly the phoenix, but so spiritualized as to cast away even its name.

The Griffin

Since both the phoenix and the griffin take myriad forms, one cannot always distinguish anatomically between the two. And yet, given a picture of a mythical bird, it is usually easy to tell intuitively which one is depicted. The phoenix is generally shown with wings outspread in flight, with its body in an elegant curve and the feathers of its long tail trailing luxuriously behind. The griffin, by contrast, is usually shown standing motionless or, at most, walking at a stately pace. When, occasionally, it is flying, it is in a pose that emphasizes power rather than grace.

Essentially, the griffin is a combination of a lion and an eagle, both of which are themselves solar animals. The lion is associated with the sun because of its power, its nearly golden colour and the way that its mane extends around its face like the rays of the sun. The eagle is as well, because of its large size, the intensity of its gaze and the power of its

Katsushika Hokusai, *Phoenix*, 1844. The ho-o or 'Japanese phoenix' is, like its Chinese counterpart, a composite of many animals, with features of a bird, snake, giraffe, deer, tortoise and fish. Its appearance is rare and signals the start of a new era.

Kate Nielson, illustration to Grimms' fairy tale *The Juniper Tree*, 1913. After his sister has ritually disposed of his bones, a little boy is reborn from a cloud of fire in a juniper tree in the form of a bird much like the phoenix.

Illumination of a griffin from a late 12th-century bestiary. The accompanying description places griffins in the Hyperborean Mountains (in the far north, possibly Scotland and Ireland) and emphasizes their fierceness, stating that they will tear apart men and horses.

flight. The sun appears to rule heavenly bodies, and as such the lion is called 'king of beasts' while the eagle is 'king of birds'. Most frequently, a griffin is depicted with the wings, head and front legs of an eagle, and the torso and hindquarters of a lion, but there are innumerable variations. It sometimes has rays coming from its face, a sort of halo, like beams of sunlight.

The griffin is among the most ancient of all imaginary animals, and there are many early representations of similar creatures throughout Egypt and the Near East. Perhaps the oldest of all is the Sumerian Imdugud, called Anzu in Assyro-Babylonian culture. It is a lion with tail feathers and huge wings, which cause whirlwinds when they are flapped. It steals the tablets of destiny from the gods but is finally killed by the deity Ninurta. Like later griffins, its representation was more visual than narrative, and it decorates many ancient buildings.

The more familiar images of the griffin come mostly from classical Greece. Herodotus told of griffins in the far north that guard gold, which Arimaspians, a people with a single eye in the middle of their brow, constantly try to steal from them.[8] Tradition generally locates them in the Gobi Desert, which does indeed contain gold, as well as dinosaur bones that could have inspired the myths. The sphinx, which originated in Egypt, is also a solar animal, and the Greek variant resembles a griffin, having the wings of an eagle, the body of a lion and the face of a woman.

The romances of Alexander the Great, which were popular in the High Middle Ages, tell how the Greek conqueror had two enormous white birds

Creatures of Fire and Air

captured, yoked and chained to a basket made of ox hide. He then climbed in and, propelled by their flight, ascended into the heavens, when an angel appeared and warned him, 'O Alexander, you have not yet secured the whole earth, and are you now exploring the heavens? Return to earth as soon as possible, or you will become food for these birds.' The birds are not clearly identified in the tales, but illustrators of the period depicted them as griffins.[9]

The griffin is a popular symbol of royalty and nobility in Western heraldry, and that is probably where we find its greatest profusion of forms. The hippogriff, a variant often found in the iconography of the Italian Renaissance, resembles a traditional griffin except that it has the hindquarters of a horse rather than a lion. Said to be the product of a union between a griffin and a mare, it represents Christ, who was both human and divine. In English heraldry, the griffin often takes the form of an opinicus, with the head of an eagle, the body of a lion and the tail of a camel, either with or without wings. In Canto 29 of Dante's *Paradiso*,

Aquamanile of brass, Nüremburg, *c.* 1400. This griffin is remarkably serene, dignified and stately, as befits its exalted status in heraldry.

a griffin appears in a procession on the summit of the mountain of Purgatory, drawing the chariot of the Church in triumph.

The decline of heraldry from the latter nineteenth century to the present day has given the griffin a new sort of vitality, as it has gradually shifted from the realm of symbolism to that of fiction. In earlier literature, the griffin (in contrast to many animals of legend) would very seldom speak, because it seemed to exist at an exalted distance from humanity. Its symbolic presence was so powerful that any words, except perhaps for cryptic prophesies, would have seemed disappointing. Divested of at least part of its lofty meaning, the griffin has come down to earth. The Gryphon in Lewis Carroll's *Alice's Adventures in Wonderland* is initially gruff, but proves to be an amiable creature who dances gleefully with the Mock Turtle.[10]

Griffin by Hans Burgkmair, early 16th century. Perhaps more than any other fantastic animal, the griffin was adopted, and highly stylized, by the conventions of heraldry.

Master of the Hausbuch, griffin, Germany, late 15th century. As befitting an animal associated with kings, the griffin is generally portrayed striding with a serene majestic gait.

The Roc

Many travellers to Central Asia told of a giant bird, the roc, probably related in folklore to the griffin, which would swoop down from the sky, grasp an elephant in its claws and fly off with it. Ibn Battuta (1304–c. 1377), a Moroccan whose travels across Africa and Asia in the mid-fourteenth century were perhaps more extensive than those of any previous explorer, wrote that once, a mountain which was not on any map suddenly appeared in the sea, and strong winds seemed to be driving his ship straight into it. His sailors were preparing themselves for death when the wind calmed, and the next morning the mountain had risen into the sky and revealed itself as a roc bird. At this, those on board began to take a final farewell to one another, but the wind changed direction, driving their ship away, and the roc failed to notice them.[11]

John Duncan, *Heptu Bidding Farewell to the City of Obb*, 1909. The artist was a Scottish painter in the tradition of the Pre-Raphaelites. This painting may be pure fantasy, and does not illustrate any story. The mount of Heptu is a griffin, but does not conform closely to any heraldic model.

There are several references to roc birds, which feed their young on elephants, in *The Arabian Nights' Entertainments*. Sinbad the Sailor, sailing the South China Sea, comes across an island with a gleaming white dome. His crew breaks open the surface to find a baby roc, which they kill and butcher for food. They take as much of the meat as they can carry and return to their ship, but the mother roc and her mate, each carrying a huge stone, follow them. One roc drops its stone in the water, creating huge waves, and the other drops its stone on the rudder of the ship, throwing everyone into the sea. Sinbad manages to survive by grasping a piece of timber, which carries him to another island and to further adventures.[12]

Edward Julius Detmold, illustration to *The Arabian Nights Entertainments*, 1924. The roc bird here combines the features of an eagle, a hawk and an owl. According to the encyclopedia of A-Qazwini, written in the late 13th century CE, the roc bird can carry off an elephant 'as easily as the kite carries off a mouse'.

William Harvey, 'The Roc Bird Carrying off Elephants', illustration to Edward William Lane's translation of *The Arabian Nights Entertainments* (1834). This depiction of the roc, with long, flowing plumes is probably influenced by pictures of the fenghuang or 'Chinese phoenix'.

In the tale of Aladdin, the very last in most European editions of the collection, the hero has won the beautiful princess Badroulbadour in marriage and built a magnificent palace for her with the aid of a supremely powerful jinn, or genie, whom Aladdin summons by rubbing a magic lamp. One day the princess asks Aladdin for a roc egg to suspend from the middle of the domed ceiling of the palace's great hall. Thinking that a mere trifle, Aladdin rubs the lamp and demands it of the spirit, at which

Arthur Rackham, illustration to the tale of Aladdin, from *The Arthur Rackham Fairy Book* (1933). Here, the terrifying jinn has been given not only wings of a bird but also a somewhat avian posture, perhaps because of its association with the roc.

the jinn uttered such a terrible cry that the room shook and Aladdin staggered and nearly fell down the stairs. 'What, you miserable wretch!' cried the jinn in a voice which would have made the most confident of men tremble. 'Isn't it enough that I and my companions have done everything for you, but you ask me, with ingratitude that beggars belief, to bring you my master and hang him from the middle of this dome?'

The jinn does not destroy Aladdin, for it knows that the suggestion originally came not from him or his wife but from an evil magician, but it leaves and never returns.[13] Aladdin kills the magician, who is disguised as a holy woman, and he and Badroulbadour continue to thrive, but there are no more magical events. This leaves the roc as the final, and probably the greatest, mystery in this most mysterious of books.

The Thunderbird

There is enough similarity between them to suggest that many giant birds of folklore have an origin in a single myth, dating back to very remote times. There could even be – though this is speculative – a remote folkloric link between these avians and the thunderbird, which is found in the mythologies of most Native American tribes of the Great Plains. In 1675 Jacques Marquette discovered a huge painting on a rock near the banks of the Mississippi in Illinois, which represented a variant of the thunderbird. Local native people described the creature to him as

> large as a calf; they have horns on their heads like those of a deer, a horrible look, red eyes, a beard like a tiger's, a face somewhat like a man's, a body covered with scales, and so long a tail that it winds all around the body, passing above the head and going between the legs.[14]

The thunderbird of legend lifts whales, in much the way the roc bird of Arabia picks up elephants. It creates storms by flapping its wings and sheet lightning by blinking its eyes; it carries snakes in its claws, which when dropped, become lightning forks.

The deer horns and the winding, scaly body of the thunderbird also suggest the Chinese dragon, which is similarly intimately associated with

A monstrous bird with the horns of a deer, from a prehistoric petroglyph near the Pisa River in Illinois. This proto-thunderbird has a strong resemblance to the one described to the explorer Jacques Marquette by Native Americans.

Creatures of Fire and Air

Thunderbird, drawing by Caren Caraway after an image on a Kwakiutl ceremonial curtain from Albert Bay, attributed to Arthur Shaughnessy, 1920s. Representation of the thunderbird varies greatly from one tribe to the next, but it is always an embodiment of storms.

Woodblock print of Eagle Man, the war god of the Zuni, 19th century. Many Native American tribes have versions of the figure of Eagle Man, who can be either a monster or a deity.

storms. But the closest Old World equivalent of the thunderbird is the Eagle of Zeus, which may have been an early form of the god of thunder. This eagle was sometimes shown on Roman coins carrying bolts of lightning and, like its North American cousin, was closely associated with storms.

Oni

Japan is among the places most vulnerable to natural catastrophes such as earthquakes, hurricanes and tsunamis, and yet the Japanese view of nature, reflected in many artistic media from woodblock prints to haiku, is overwhelmingly bucolic. The main reason for this paradox is that such disasters are attributed more to supernatural intervention than to the natural world. The folklore of Japan is extraordinarily rich in demons, ogres, imps and other

spirits that are, in the words of one scholar of myth, 'unsurpassed' in 'range, diversity, and oddity'.[15]

Perhaps the most feared spirits of all are the oni, which are largely human in form but usually have horns protruding from their scalps and large mouths with prominent fangs. Their skin may be of any colour, but black, red, blue and yellow are most common. Some have a third eye in the centre of their foreheads. They wear loincloths made of tiger skin, and their bodies are gnarled and rough. The oni generally live in remote, mountainous regions that are virtually uninhabitable for human beings, but they are said to enter cities and kidnap people, especially young girls, whom they then torture and eat. The role of the oni has changed over the centuries, and in the modern era, as life in Japan became more prosperous and secure, oni have sometimes received sympathy as symbols of alienation in a very homogeneous society. But scholars believe that oni originated as embodiments of the elements at their most destructive, particularly of lightning and thunder.[16]

The association with these phenomena is shown by the way oni appear, vanish and change with the suddenness of a thunderbolt. One famous vanquisher of oni is the samurai Watanabe no Tsuna (953–1025). In one traditional tale, Watanabe meets a young woman by a bridge near Kyoto, who claims to be lost and asks him to take her home. He agrees and, as he helps her on to his horse, she suddenly reverts to her true form – a female oni

Kawanabe Kyōsai, monsters, 1870s or 1880s. Kyōsai might be called the 'Hieronymus Bosch of Japan'. He was a political rebel, who used fantasy to satirize the increasing regimentation and bureaucratization of modern Japanese society.

Katsushiku Hokusai, *Sarayshiki*, 1830. This is the ghost of the servant girl Okiku, who, according to legend, was killed thrown into a well for refusing the sexual advances of her master. In the 19th century, Japanese culture featured a vast range of mostly terrifying ghosts, spirits and demons, but she was generally benign.

Kawanabe Kyōsai, detail from *Ghosts*, 1881. Kyosai's fantastic illustrations continue to influence graphic novels and cartoons. Here, the red creature in the centre seems to be gazing out at us with its one huge eye.

named Ibaraki. Ibaraki grabs Watanabe's topknot and rises into the air with him, intending to abduct the hero to a distant mountain. Watanabe grabs his sword and, with a single blow, severs one of Ibaraki's arms. She flies away with a terrible cry, leaving him with the trophy. Later, Watanabe's foster mother comes to his house and requests to see the severed arm. He agrees, and takes her to the box where it is kept. Instantly the old woman turns into Ibaraki, who now has only a single arm. Unwilling to tangle with Watanabe once again, she grabs her severed arm and flies away.[17]

The Fire Salamander

Fire has many aspects, which is why the Greeks had several fire deities: Hephaestus, god of the forge; Prometheus, who brought flame to humankind; Hestia, goddess of the hearth; Helios and Apollo, gods of the sun, and numerous fire demons.

Shibata Zeshin, *The Demon Ibaraki*, c. 1890. By taking the form of his aunt, the female oni Ibaraki tricked the samurai Wanatabe no Tsuna, who once severed her arm in a fight, into showing her the trophy. This pen and ink sketch shows her after she has just grabbed her severed arm and started to flee.

According to Greek tradition, after Zeus defeated the serpent Typhon, he placed the monster underneath Mount Etna; the fire erupting from the mountaintop was its breath. The idea of fire-breathing dragons in Western culture was probably inspired in part by volcanos. It was also doubtless influenced by the red, forked tongues of many reptiles, which flicker in and out of their mouths like flames.

Some legends of dragons may also have been stimulated by the European fire salamander (*Salamandra salamandra*), which has a black body with irregular yellow stripes that suggest flames. It hibernates in dead logs, and in consequence is often found awakening in hearths. Glands behind the eyes of a fire salamander release a milky fluid, which can at times provide enough protection to enable it to walk through flames to safety. These qualities make the salamander into a sort of quintessential dragon. Different as they are in many respects, both the Western and East Asian dragons are intimately associated with flames. Several Occidental dragons, such as the one that kills the hero Beowulf, breathe fire, while Chinese dragons breathe clouds (which may contain fire in the form of lightning), and flames rise from their limbs.

Like many other writers of the Renaissance, Edward Topsell applied relatively modern methods of taxonomy to creatures from medieval legends. He wrote,

There be some dragons which have wings and no feet, some again with feet and no wings, and some neither feet nor wings, but are only distinguished from the common sort of serpents by the comb growing upon their heads, and the beard under their cheeks.[18]

He offered very detailed descriptions of most of these dragons but, uncharacteristically, said nothing about the anatomy of the fire drake. This was a creature of Anglo-Saxon folklore, which reportedly lived in mountain caverns and flew with bat's wings. Topsell only observes that this dragon looks like a meteor from a distance, and that its breath is a line of flame.[19] The fire drake, in other words, is a comet – perhaps Topsell believed, with astrologers and alchemists, that planets and other heavenly bodies are alive.

Before the advent of aircraft or space travel, people knew the realm of the sky only by looking upwards, and a bird would appear as little more than a silhouette. Comparative size was very hard to judge, and distance was even harder. Patterns of light reflected off clouds and refracted through

Fire salamander, from the *Secretorum Chymicum*, 1687. Leonardo da Vinci wrote in a notebook that the salamander 'has no digestive organs, and gets no food but from the fire, in which it constantly renews its scaly skin'.

Creatures of Fire and Air

Arms with the crowned salamander, symbol of Francois I of France (r. 1515–47), who chose as his motto *Nutrisco et extinguo* (nurture and extinguish) in reference to how fire both purifies and consumes.

the moist air could easily suggest the tail feathers of a phoenix or the scales of a dragon. But did people really believe in these creatures? I think that human beings experienced these fantastic animals with an immediacy that transcends both belief and scepticism. Put simply, they seldom asked if what they saw was 'real'.

Sandro Botticelli, *Birth of Venus*, c. 1485. This illustrates Hesiod's tale that Aphrodite/Venus was born when sperm from the castrated Uranus fell into the sea. The violent tale is spiritualized by Renaissance Neoplatonism. As Zephrys, the west wind, blows the goddess to shore, a nymph hurries to cover her nakedness, and flowers begin to take root where her feet will touch the ground.

TEN
CREATURES OF EARTH

> I have found it useful to imagine the Earth as an animal . . .
> Until recently no specific animal came to my mind, but always
> something large, like an elephant or a whale. Recently, on
> becoming aware of global heating, I thought of Earth more
> as a camel.
>
> James Lovelock, *The Revenge of Gaia*

HESIOD'S CREATION MYTH, as detailed in chapter Eight, seems strangely contemporary, in that it shows the earth as constantly in flux, creating mountains, earthquakes and continents as it shifts. This is closer to modern science than the Bible's account of Creation, according to which God made the world in a single day. It would not be until the work of the Scottish geologist James Hutton in the latter eighteenth century that the dynamic quality of the earth would be so clearly recognized in the modern world. Inspired by Hesiod's account, the twentieth-century scientist James Lovelock has formulated what he calls the 'Gaia hypothesis': Earth regulates its temperature like a living organism, and all life is part of a dynamic equilibrium created by it.[1]

What is Earth?

The English word 'human' comes via Old French from the Latin *humanus*, which is closely related to the word *humus*, meaning 'earth'. It is also related to the word 'humble', which is not far from its original sense – that we human beings are of the earth and, therefore, perishable, in contrast to the immortal gods. Yet another, now only slightly anachronistic, word for humankind is 'mortals'. The biblical account of the Creation and many other mythologies, including those of the Blackfoot, Yoruba, Dyak, Egyptians, Chinese and Polynesians, tell us that human beings and animals were originally made from earth or clay.[2] Black earth, rich in organic material, is the model for the *prima materia*, the primordial substance from which, according to alchemists, the cosmos was created, and perhaps it is a metaphoric foundation for the 'cold, dark matter' postulated by physicists today.

We are forever trying to purge ourselves of dirt, yet it perpetually accumulates on our faces and hands. It is a product of decaying organisms, and may contain a faint stench of rotting vegetation, flesh or even excrement. The word 'dirt' can mean malicious gossip, and the adjective 'dirty' usually means corrupt. And yet, from time immemorial, people have recognized dirt, or 'earth', as the source of life. In the words of Paracelsus,

> When spring comes and then summer, all the hues sprout forth, and no one would

suspect their presence in the earth . . . Just as the noblest and most delicate colours arise from this black, foul earth, so various creatures sprang forth from the primordial substance that was only formless filth in the beginning.³

The topsoil in a forest or field is full of life, even in winter. This includes burrowing mammals such as groundhogs, foxes, moles and a wide variety of rodents. Still more numerous are worms, snakes and centipedes. Then there are insects, especially beetles and ants, as well as spiders and other arachnids. Many species leave eggs or larvae in the soil, which are not always easy to distinguish from decaying matter. For pre-modern observers, this life appeared to be generated by the decay of organic matter, and in a more extended sense, it really is.

'Cthonic' creatures are those associated with the realms beneath the surface of the earth. These include not only 'creepy-crawly' things, but also bats and other cave-dwelling creatures. All animals that are nocturnal, black or eaters of carrion can appear chthonic – crows, bats, owls – these are associated with darkness, and therefore with death and decaying corpses. The variety of strange creatures burrowing in and nibbling at a corpse provided a model for images of demons accompanying lost souls in Hell. Yet the soil nourishes crops and, full of organic matter, often seems to be almost alive itself.

Spider Woman

The historian of religion Mircea Eliade identified a myth that he thought was found across the world, in which a hero, guided by spirits in the form of animals, undertakes a shamanic journey below the surface of the earth in search of healing powers, secret wisdom or even to bring back the dead. In Western traditions, he saw variants of this in such figures as Gilgamesh, Odysseus, Orpheus, Aeneas, Christ and Dante.⁴ But an even better example is the culture hero Tiyo, variants of whose tale are told by the Hopi and several other tribes of the American southwest.

Hoping to bring rain to a parched land, Tiyo follows a stream from the Colorado River underground, and comes to the subterranean home of Spider Woman, who greets and befriends him in human form. With her, in the form of a tiny spider whispering directions in his ear, he explores the spirit world. In the Land of Snakes, he marries the snake maiden Tcuamana. He returns with a vast store of magical practices, including a ceremony to bring rain, which he shares with his people, and founds the Snake and Antelope clans. The children of Tiyo and Tcuamana bite the offspring of other members of the clan, killing them with their venom. When the people of these clans move away, Tiyo, Tcuamana and their children return to the underworld. Tiyo wants to be reunited with his people, who entreat him to do something about the death god Masauwuh, who has been ravaging the

land in the form of a monster. Tiyo overcomes Masauwuh and makes peace with him, who then assumes the benevolent form of a young man. After this, Tcuamana and Tiyo have more children, who are not venomous, and snake priests of his clan continue to honour the couple in dances to the present day.[5]

Spider Woman remains the deity to whom the Hopi and Navaho turn first in times of crisis. According to tradition, she taught the women of the tribes to weave, using a loom made of the coordinates of the sky, and with sun rays, sheet lightning, rock crystal and white shell among the threads. Her home is said to be a sandstone monolith known as Spider Rock, on the Navaho Reservation in Canyon de Chelly National Park in Arizona. In being divine yet compassionate and approachable, she is roughly comparable to Mary in Christian, or Guanyin in Buddhist, traditions.

And how should we imagine Spider Woman? In Western tradition, we think of species as being mutually exclusive, so a dual identity suggests a composite form. A centaur is human to the waist and equine below. Arachne, the woman who, because she could weave better than the goddess Minerva, was turned into a spider in Graeco-Roman mythology, is usually portrayed as a spider with a human face and arms. Spider Woman of Native American myth, however, is not a hybrid. Rather, she is both fully human and fully spider. Native Americans depict her simply as either woman or spider, assuming that both dimensions of her identity are exemplified in either form.

What is a 'human being'? What is an 'animal'? And what is a 'plant'? The technical definitions of contemporary biologists have little relevance here, since they cannot explain the cultural importance of this distinction over millennia. The most easily apparent difference is that plants, with a few exceptions, are directly connected to the earth, perhaps a bit like infants joined to their mother by an umbilical cord.

At least since the time of Aristotle, most people in Western culture have assumed that animals have some sort of incipient consciousness, while plants do not. Nevertheless, the motions of plants as viewed with time-lapse photography often seem every bit as purposeful as those of animals or human beings. They tentatively explore new territory, wrestle with competitors and manoeuvre around barriers to gain access to the sun, with an apparent deliberation that rivals that of any mammal. And, in the words of David Attenborough,

> Plants recruit animals as carriers [of seeds] in several different ways – by bribery, deceit, self-sacrifice, and straightforward coercion. You have only to walk through thick undergrowth in almost any part of the world to discover that you yourself have been exploited. Your trousers, skirts, socks, jerseys, are quite likely to be carrying seeds . . .[6]

The dodder plant, a weed related to the morning glory, can quickly detect the proximity of a

Frederic Leighton, *Perseus and Andromeda*, 1891. Leighton, influenced by the Pre-Raphaelites, has stylized Perseus and his winged horse, Pegasus, to represent the sun. The dragon, blocking the light with its wing, represents earth. The maiden, Andromeda, is unconscious, and the hero seems to be literally bringing her back from the dead.

tomato or other plant that is capable of hosting insect pests, and make a preemptive strike by sending out shoots to strangle the other vegetable. Plants seem to differ from animals in that they respond to stimuli far more slowly, but recent research places even that difference in question. Leaves and stems may immediately emit poisons or even alter their chemistry when insects lay eggs on their leaves. No wonder most people with houseplants talk to them![7] Plants seem to mediate between the earth and its animals, and in consequence, between life and death. There are many legends of people living on in a flower, vine or tree that grows from their grave. The Pythagoreans of ancient Greece and Rome would not eat beans, believing that they could contain a human soul, perhaps because the appearance of a bean suggests an embryo.

The affinity between plants and animals seems relatively apparent to those raised in indigenous cultures, but it is less so to those raised in the West, especially in the modern era. The reason, I suspect, can be best explained not in terms of abstract philosophy, but rather by the increasingly rapid, and elaborately scheduled, pace of contemporary life. Living at a different tempo, people in the past would have been more attuned to the very gradual changes which could be observed in the life of vegetation. This was especially true for the overwhelming number of people who lived by farming, and watched for subtle alterations to tell them when the time for harvesting or planting had come.

When it is not based on regular, geometric forms such as straight lines and circles, the foundations of abstract designs throughout the world are the sort of curvilinear patterns found in vegetation, in leaves, roots, stems and so on. Such designs are found in odd corners, unappropriated spaces where our eyes seek diversion – the capitals of Corinthian columns, rims of Greek vases, pommels of swords, Native American blankets, Chinese porcelain and in the margins of medieval manuscripts. They are also found in reliefs – on houses, palaces and places of worship all over the world.

Characteristically, these patterns verge on being completely abstract, yet their meandering lines often form grotesques. They feature rhythmic patterns of foliage from which animals and human beings emerge. The bodies of serpents, dragons and birds are intertwined in intricate knotwork. Heads of people and animals grow like berries out of stems. Horses, monkeys and dolphins sprout like flowers from branches.[8] Animals and plants are less clearly differentiated where the mind, not strictly bound by religious and social conventions, is at play.

It is in the Islamic world, where realistic art has been inhibited by the religious injunction against graven images, that floral pattern design reached its apogee. The curves of vines and the roundness of fruit seemed particularly luxurious in the deserts of the Near East. Meandering lines formed images of plants and animals while still remaining sufficiently abstract to avoid offending religious sensibilities. There are several oriental legends that

might originally have been inspired by floral designs – of vines and trees bearing living heads, like fruit, usually human heads but at times those of animals as well. The fascination with vegetal forms quickly spread west to medieval Europe and east to India and China.[9]

The folkloric creatures that blur the boundaries between the animal and vegetable realms often seem to be the most otherworldly of all imaginary creatures, the sort that most confound human attempts at classification. One important legend was inspired by the barnacle, a small sea creature that attaches itself to a solid surface such as the plank of a ship, the flank of a shark or the shell of a mollusc. It then grows a protective shell on all sides except the one facing outward, and lives by pushing nutrients into its mouth using an organ, often called a 'foot'. Biologists now classify the barnacle as a crustacean, related to crabs and lobsters, but in appearance it does not bear a clear resemblance to any other creature at all.

In the Middle Ages, barnacles on the trunks and branches of trees that had fallen into the water inspired belief in 'barnacle geese'. The barnacles on wood were taken for buds on trees, which then grow, ripen and gradually take on an avian shape. Eventually, according to legend, they develop into fully formed geese, which hang from branches only by their beaks, then fall to the ground, find water, and swim away. To put it simply, they are geese that grow on trees, rather in the manner of peaches or cherries. The story enabled Catholics to classify geese as fish, thereby exempting their flesh from the ban against eating meat on Friday. It was described in great detail by such a sophisticated observer as John Gerard, superintendent of gardens under Queen Elizabeth I, in his *Great Herball* of 1597.[10]

And if even geese could grow on trees, then what else might also? Sir John Mandeville, or the author who wrote under that name, reported in the fourteenth century that when the men of Tartary told them of lambs that grow on trees, he had no trouble believing their account. It did not impress him as a great marvel, for he thought of the barnacle goose. With this animal, he could answer the heathens who laid claim to wonders, by telling of one from his native country that was at least as great.[11]

Trees that Speak

Trees, from the start of civilization, were both partners and rivals of human beings. As they covered greater areas, men and women began to cut them down, creating settlements, first temporary and later increasingly permanent, in the woods. They used wood, on a growing scale, for fuel and for a variety of tools. We generally think of the forest as in a primeval state. This may be because, in most regions, forests are so persistent in returning whenever land is neglected.

In a sense, however, the forest is no more primeval than desert, tundra or grassland. The forests of the northern latitudes may be old, yet they have not been there forever. Their story, in fact, is closely linked with that of human beings. With the end

of the last ice age, about 12,000 years ago, both forests and human beings began to greatly expand their range. Trees spread across vast areas that had previously been tundra or covered with ice. In consequence hunting became more difficult, since game was not readily visible. Human beings gradually began to develop agriculture and to domesticate animals.

Of the realm of vegetation, people have always identified most closely with trees. Like people, trees stand upright and, while some live vastly longer than people, they often have comparable lifespans – of about 60 to 100 years. Like people, trees at least appear to dominate their region, in their case the forest. Their thrusting upwards suggests a longing for transcendence, which many take to be the most intimate and distinctive aspect of humankind. Closely linked with trees, in fact as well as in symbolism, is fire, which often represents the soul. A traditional way to start a fire, already used by prehistoric men and women, is to rub pieces of wood together. The flame seems to be continually waiting within the wood, like the soul in a body. But, like human aspirations, the spark may quickly become out of control, consuming the trees that nourished it.

From the time of the earliest civilizations in Egypt and Mesopotamia, illustrations of figures combining arboreal and human features, often together with horns of animals, have been common. At times a human torso, or else simply a face or arm and hand, grows out of a tree trunk. Conversely, branches and leaves may be growing from

Jost Amman, 'Tree of Knowledge', illustration to *De conceptu et generatione hominis* by Jacob Rueff, 1587. The tree here is anthropomorphized, with the skeleton as wood, the leaves and apples as flesh, and the snake as the soul.

a human body. Such images are often associated with gods and goddesses of fertility, and they have never lost their popularity.[12]

In the first biblical Creation story, God makes Eve out of Adam's rib, but painters of the European Middle Ages and Renaissance often depicted Adam lying on the ground while, at a gesture from God, Eve emerges from his body, like a tree growing out of the earth. Paracelsus wrote, 'Woman is like the earth . . . She is the tree which grows from the earth, and the child is the fruit that is born of the tree.'[13]

Michelangelo Buonarotti, *The Creation of Eve*, from the Sistine Chapel, 1510–11. Note how the figure of Eve repeats the curve of the branch under which Adam is sleeping. She seems to grow out of his side, almost like a tree herself.

Many religious traditions have some concept of a world tree that spans the cosmos. In Norse mythology, that tree is Yggdrasil, and the squirrel Ratatoskr scampers among its branches, spreading gossip among the gods, dwarves, giants and other divine beings. In the Islamic world, there are many legends of a tree that bears the sun and moon; according to a tale found in many romances, Alexander comes upon it on the boundary of India. First, the sun speaks to him in Greek, saluting him as a great conqueror. Then the moon speaks to him in Hindi, predicting his imminent death in Babylon.[14] Both heavenly bodies have usually been depicted with solemn faces, as though in recognition that even the mightiest of kings are subject to fate in the end.

Persian and Arab literature also contains several references to the Waq Waq Tree, located on

Creatures of Earth

J. Augustus Knapp, *The Tree Yggdrasil*, early 20th century. In Norse mythology all parts of the cosmos are joined by this immense ash tree.

a remote island, which has branches from which living heads sprout like fruit. In some stories the heads are those of women, while in others they are the heads of animals such as elephants and rams.[15] In *The Arabian Nights Entertainments*, the tree grows on one of the seven islands of Waq in the China Seas, which mark the furthest limit of the world and are inhabited by tribes of jinn, water spirits and devils. The human heads on the tree, male and female, call 'Waq! Waq!' in praise of God every time the sun rises or sets.[16]

Legends going back to Roman times, which became increasingly widespread in the High Middle Ages, tell of the plant known as the mandragora,

Drawings of the mandrake or 'mandragora', Germany, 18th century. The humanized plant appears serene as it rests in the earth, but will let out a terrifying scream when pulled out.

or mandrake, said to have a spirit like that of a human being. In some tales it grows only under a gallows, since it is generated by the semen, sweat and blood of executed criminals. It has often been drawn in the form of a small man or woman with appendages shaped like roots. The mandrake reportedly has many medicinal and magical properties, but if pulled out of the earth it lets out a terrible cry that can paralyse or even kill a man. Legend has it that to procure the root, a herbalist must go to the gallows where it grows, after midnight on a moonless night, and plug his ears with beeswax. He must then tie the mandrake to the tail of a dog, walk away, and then call the dog with a trumpet. As the dog runs away, it will pull up the mandrake and die immediately, but the man can then harvest the plant in safety. In illustrations from the medieval period onwards, the mandrake is shown as a root with furrows that form a face and body, like that of a little man or woman.[17]

During the Renaissance, a favourite motif was the Greek myth of the nymph Daphne, shown in the process of becoming a laurel tree. According to Ovid, Daphne prayed to her father, a river spirit, to escape the amorous advances of the god Apollo, and was then transformed into a laurel tree.[18] The image of her with outstretched hands, sprouting branches from which leaves emerge, became so familiar and iconic that it seemed less a metamorphosis than a fantastic composite of human being and tree.

Robert Kirk, a minister in Aberfoyle, Scotland, reported towards the end of the seventeenth century that in a realm beneath the earth, plants were sentient beings that received individual names and communicated with fairies. Of his alleged visit to a fairy dance, he wrote, 'I saw there beings that seemed more like trees than humankind, yet who danced just as lightly; while others were short and

squat of form, with gnarled and weathered faces, whose steps, though firmer than those of their companions, were no less elegant for all that.'[19] The account by Kirk may well have been, directly or not, part of the inspiration behind the Ents, the tree-beings in J.R.R. Tolkien's *The Lord of the Rings*. In Tolkein's books, these are beings created by deities eons ago to serve as shepherds for trees and protect them from dwarves. They are sturdy but graceful figures that almost seamlessly blend arboreal and human features; their skin resembles bark and their beards are like clusters of twigs. Their bond with humanity, however, is shown by the slow intensity of their gaze. Experience going back to remote times has made them patient, cautious and wise.[20]

Maria Sibylla Merian, illustration from *Ercarum Ortus Alimentam et Paradoxa Metamorphosis* (1718). The metamorphosis of a caterpillar to a chrysalis and ultimately a butterfly is the model for perhaps most shape-changers in legend and literature. For Merian, who devoted her life to studying these insects, and many of her contemporaries, they seemed amazing as anything in Ovid.

ELEVEN
SHAPE-SHIFTERS

> It is very easy to depict a human face that resembles
> a lion ... but it is much more difficult to depict a
> lion that does not resemble a person.
> Charles Le Brun

TALES OF SHAPE-SHIFTING, found in the folk literature of virtually all cultures, are ultimately based on events in the natural world. Insects and amphibians, especially, undergo a radical change in appearance in the transition from a larval to an adult state. A tadpole looks rather like a fish, and nothing like the frog it will eventually become. Snakes shed their skins repeatedly, and insects cast off their exoskeletons; most plants emerge from seeds, while birds and many reptiles hatch from eggs. The most dramatic change of all is that from a caterpillar to a butterfly, and this is the chief model for stories of physical transformation.

The word 'metamorphosis' comes from Greek and can be used to refer to any transformation of a living thing. It literally means 'beyond form', and the concept presupposes an identity that transcends the physical. The older meaning of the term is a 'magical' change of form, such as a witch who becomes an owl to fly about at night. Shamans of many cultures have practised ritualistic metamorphoses, going into trances to assume the nature of birds or other animals. Such practices may be the origin of many tales of metamorphosis from across the globe. Today the word is most frequently used to mean a biologically determined change of structure, as an organism passes from one stage of development to the next. This definition dates from the latter seventeenth century, when naturalists and artists had begun to make more systematic and deliberate observations of living things.

Scholars of myth sometimes distinguish between 'metamorphosis' and 'metempsychosis', the transmigration of souls at death. In metempsychosis, the change tends to be irrevocable, while in myth a metamorphosis is often simply a temporary disguise, as for example when Zeus changes into a bull to abduct the maiden Europa. Nevertheless, both concepts are represented symbolically in much the same way. In a vast range of cultures, from the Hopi to the Greeks and the Japanese, the butterfly is a symbol of the soul, and a butterfly emerging from its chrysalis is a universally understood metaphor for the spirit leaving the body at death. Metempsychosis is found in traditional religions such as Hinduism and Buddhism, as well as in New Age beliefs.

The Other Self

Initiates of powerful secret societies in the chiefdoms of the African savannahs claim the ability to transform themselves into animals such as owls and snakes, but the means and exact natures of these transformations are not revealed to the uninitiated. Among the Wuli of Cameroon, the change is accomplished by transferring a person's vital energy into an animal. Both the sorcerer and the animal remain physically distinct, yet they act with a single will.

The preferred animal for Wuli transformations, and one very closely associated with the chiefs, is the leopard. This is a creature that lacks the size and power of many others such as the lion or hyena, or the speed of the cheetah, yet it manages to prosper by blending into its environment and remaining inconspicuous – in other words, by stealth. At times, the Wuli hunters claim to assume the form of a leopard in order to hunt clandestinely in the territory of another tribe. The Wuli will only kill a leopard if it nears their village in a menacing way, in which case they suspect it is possessed by the spirit of a malevolent sorcerer.[1]

Not only shape-shifters but animal doubles are common in the legends of indigenous peoples, especially in Africa and Latin America. The Tzeltal Maya in the Mexican province of Chiapas believe that a person has not just one or two but at least four souls, at times over a dozen. One of these souls has a human form and exists simultaneously in a divine mountain. The other souls may take on any number of forms, from lightning bolts to Catholic priests, but they are most commonly in the form of animals, and these also have a parallel existence. Most of the Tzeltal claim not to know which animals are their souls, but there are exceptions. One elderly man took pride in having a jaguar for a soul, and he would meet with it every year. The man would then feed the jaguar some turkey, play with it and warn it about human hunters.

The Tzeltal associate each part of a human body with a corresponding part of an animal body, even that of an insect. Any blow or wound to an animal

Modern Ibibio mask topped with leopard, Nigeria. The leopard's silence and stealth are proverbial. Here, it provides quite a contrast with the bold, comical features of the face below it, which seems designed to attract attention.

soul will also appear on the corresponding part of a human being. In one tale, a man on an errand encounters some friends and starts to drink with them, becoming so inebriated that he fails to come home until the following day. He wife is so angry at him that she refuses to prepare his food. When the man goes out to chop wood, he comes across a huge puma sitting on a rock and recognizes it as his wife. The puma appears to him whenever he goes to a place where liquor is plentiful, and he becomes convinced that his wife is trying to frighten him away from drink. One day, a rancher shoots a puma, and the man's wife dies at the same time as the animal. A large hole, like that made by a bullet, is visible in her back, at the same place where the puma had been shot.[2]

Animal doubles are very rare, though not unknown, in Western stories, where shape-shifters predominate. Pliny the Elder reported that the soul of a man named Aristaeus could be seen flying out of his mouth in the form of a raven as he slept.[3] The idea of an animal double is, in its most fundamental form, directly based on a nearly universal experience – of close personal identification with an individual of another species. It is very possible that most, or even all, the shape-shifters of legend are descended from animal doubles inspired by real relationships between humans and animals. As the predominant conception of the self became narrower, and people stopped thinking of themselves as existing simultaneously in different bodies, the metamorphosis replaced the animal double as the more common motif in myth and legend.

Therianthropy

Many legends of shape-shifting may go back to cases of reported therianthropy (the metamorphosis of humans into animals), in which individuals believe themselves to have been transformed into wolves or other creatures, and behaves accordingly. Today this would usually be considered a mental illness, but that has not always been the case. In many cultures warriors might transform themselves into dangerous animals such as wolves, bears, leopards or jaguars in order to fight more fiercely. Shamans might undertake a spiritual transformation into another animal in order to gain esoteric knowledge for purposes such as healing. Today, in Haitian voodoo and related religions, believers enter trances in which they are possessed by spirits, sometimes those of animals. There is an extensive, if somewhat secretive, international subculture of people known as 'furry fans', or 'furries', who believe they are actually animals such as wolves and bears that are trapped in a human form, and take on animal identities through such means as dress, tattoos and behaviour.

But, even in the ancient world, therianthropy often came to be regarded as frightening, comic or just plain odd. This is expressed in 'The Cat Woman', one of the ancient Greek fables traditionally attributed to the sage Aesop. Several versions have come down to us, and here is an elegant one from a retelling of Aesop by the nineteenth-century folklorist Joseph Jacobs:

IMAGINARY ANIMALS

Toyohara Chikanobu, *Kiyohime and the Moon*, c. 1895. When the maiden sees her lover desert her in a boat, rage and sorrow begin to transform her into a serpent. In that form, she will follow him in the water and obtain revenge.

The gods were once disputing whether it was possible for a living being to change its nature. Jupiter said, 'Yes', but Venus said, 'No'. So, to try the question, Jupiter turned a cat into a maiden, and gave her to a young man for his wife. The wedding was duly performed and the young couple sat down to the wedding-feast. 'See', said Jupiter to Venus, 'how becomingly she behaves. Who could tell that yesterday she was but a Cat? Surely her nature is changed?'

'Wait a minute', replied Venus, and let a mouse into the room. No sooner did the bride see this than she jumped up from her seat and tried to pounce upon the mouse.[4]

Shape-shifting in Greece and Rome

In Graeco-Roman mythology, metamorphoses are very common, and they had a special fascination for writers, perhaps because shape-shifting was a fantastical motif in a relatively rationalistic culture. In the *Odyssey*, for example, the enchantress Circe transforms the companions of Odysseus into pigs. Shape-shifting passes from myth into philosophy in the fifth century CE through the influence of the Pythagoreans, who believed in the transmigration of souls. Socrates, in Plato's dialogue 'Phaedo', suggests that people may become wolves in the next life if they were rapacious, donkeys if they were foolish, or bees if they were good citizens.[5]

The Roman poet Ovid recounted traditional tales of transformations in his work *Metamorphoses*, published in 8 CE, to dramatize his conception of a universe in constant flux. Ovid's stories of metamorphoses took place in a world that was highly structured, where there was little ambiguity in the distinctions between gods, men, women, plants and animals. The transformations were similarly abrupt and unequivocal, and they signalled a temporary suspension of the cosmic order, which was quickly followed by a return to normality.

For Ovid, as for many intellectually sophisticated Romans and Greeks, metamorphoses are almost always a response to situations that are somehow extreme, whether it is in the love, grief, anger, fear, suffering or boldness they inspire. Such situations were believed to challenge a cosmic balance, and a metamorphosis was a way in which they might be controlled. Thus the maiden Arachne exceeds the limitations of the human condition both through her ability at weaving and her pride, so the goddess Minerva changes her into a spider.[6] A metamorphosis here is a means to realign the material and spiritual dimensions of reality when they are no longer in harmony.

The change in form may occasionally be a romantic apotheosis, as when Alcyone and her drowned lover Ceyx are reunited as birds in Ovid's tale.[7] Far more often, however, the metamorphosis is a deliberate violation of a person's bodily integrity. In many of Ovid's stories a human is transformed into an animal as a punishment for challenging a deity or sorcerer. The hunter Actaeon is transformed into a stag for intruding on the goddess Diana in her bath.[8] The gods who perform transformations are a bit like managers in a firm, who promote, demote and transfer employees so that operations can continue efficiently.

Kitsune

In Japan and China tales of the transformation of foxes into people are particularly frequent. Fox women often try to charm men out of either malice or playfulness, but at times fall genuinely in love with them. In a Chinese story recorded by Shen Chi-chi in the late seventh century, a soldier marries a lovely lady named Jenshih, who later confesses to him that she is actually a fox, but promises to remain in human form out of love

Dosso Dossi, *Circe and her Lovers*, 1511–12. The figure of the witch Circe may have have been modelled after Lucrezia Borgia. Because of both her legendary beauty and the power of her family, Lucrezia found herself, willingly or not, drawn into court intrigues, where people often lost their 'humanity'.

for him. Fox maidens, however, can be recognized by other animals, and one day in the marketplace some dogs catch the scent of a fox and begin to pursue Jenshih. She immediately changes back into a vixen but is soon caught and torn to pieces.[9]

In East Asian stories, foxes possess the means to attain the things that human beings regard as wealth – gold, silver, fine silks, prestige and so on. But these baubles are really not of much use to fox spirits, which often place great value on things that people take for granted, such as a simple hole in the ground where they can live undisturbed. In one Chinese tale from the mid-sixteenth century, the wife of a man in the province of Dezhou becomes friends with a fox, and the two make an agreement: the fox will steal for the woman anything she wants,

and in return she will persuade her husband to pile up two haystacks behind their house for the fox to live in. The couple become very wealthy, until their grandson decides it is time to tear down the haystacks and build new houses. The fox tells him angrily, 'I have made your family enjoy wealth and happiness for generations. If you kick me out perfidiously, don't you believe that I can send you back to poverty?' The young man is so terrified that instead of tearing down the haystacks, he starts to pile on more straw every year until they become like mountains, and his family becomes the richest in the region.[10]

Foxes, in East Asian folklore, may appear in their natural form or as human beings, but their state of mind does not seem to change greatly with their appearance. This is because foxes seem to have a social order that rather closely parallels that of human beings. Like men and women, foxes live in family groups and are notable for their ingenuity. In East Asia they have long lived in close proximity to humans and are often found living in abandoned buildings or underneath houses.

In Japan, it is said that on reaching the age of 100, ordinary foxes become kitsune and obtain the ability to assume a human form. At times this will be of that a child or an elderly man, but most frequently it is of a beautiful young woman. If a man sees a girl alone in a forest, he should assume there is a good chance that she is a kitsune. If that is the case, the

Ando Hiroshige, *Sketch of a Kitsune*, c. 1840. A kitsune is a fox that assumes the form of a human being, but it cannot change its reflection in a mirror.

Kawanabe Kyosei, *Foxes*, c. 1864. Kitsune perform the popular 'lion dance', in an imitation of Japanese festivals.

wisest thing for him to do is to hurry away, since he does not know her intentions – although some kitsune make loving, faithful companions. Kitsune are messengers of the deity Inari, who is usually depicted in the form of a fox, and may be either male or female. As the Shinto goddess of rice, Inari has numerous shrines throughout Japan, usually near cultivated fields, and offerings of food are made to her, especially as harvest time approaches.

For all their magical abilities and their cleverness, kitsune are not generally said to be intimidating. They are fascinated by people, much as human beings are intrigued by them. They are also vulnerable like human beings, not only physically but also psychologically. They are capable of knowing love, pity, anger, triumph, resentment and humiliation. In Japanese folktales, kitsune are constantly negotiating, having conflicts and

entering into relationships with people, and the two parties are usually about evenly matched: these are contests of human weaponry and technology against vulpine magic, and cleverness is often the deciding factor.

According to one tale from the late twelfth century, a man had met a beautiful woman in Kyoto, and wanted to make love to her. She reluctantly refused, saying that if they were intimate, he would die. When he insisted, she agreed, saying that she would then die in his place, but that he should copy the Lotus Sutra and dedicate it to her. At dawn, after a night of making love, she got up, took the man's fan and said, 'I meant what I said, you know . . . I'm going to die instead of you. If you want proof, go into the palace ground and look around Butoku Hall. You'll see.' When the man did as directed, he found a fox lying dead and his fan covering her face. The man was overcome with sorrow. He copied the Lotus Sutra and dedicated it to the fox seven times, after which he received a vision of her in Heaven surrounded by celestial beings.[11]

Shape-shifting in the Judaeo-Christian World

Considering how widespread stories of metamorphosis have been in the ancient world, it is remarkable that the Old Testament or Torah contains so few. The serpent in Eden undergoes a sort of metamorphosis after tempting Eve, since it is henceforward compelled to crawl on its belly (Genesis 3:14–15). Metamorphosis also occurs when Moses, in order to demonstrate the power of Yahweh to Pharaoh, turns his staff into a snake (Exodus 7:8–13). The foremost mystery of Christianity is the Eucharist, in which bread and wine become the body and blood of Jesus, an extraordinary event that demonstrates the power of God.

In the Gospels, the physical form of Jesus rises from the dead, but there is no suggestion of a soul apart from the body. That idea enters Christianity from Graeco-Roman culture, through the work of theologians such as St Augustine. Imagery of metamorphosis then becomes very important in Christianity, especially in describing the process of conversion. Like the butterfly emerging from the chrysalis, a person who dedicates his or her life to Christ is said to be 'born again'.

Augustine and other Church fathers had maintained that animals, to say nothing of plants, do not have souls. For much of the Christian era, in consequence, stories of metamorphosis have been largely confined to folk literature. In the *Divine Comedy* by Dante, most of the dead retain their accustomed forms, though there are exceptions. The suicides, for example, are transformed into trees, which, however, begin to bleed and to speak when a branch is broken off. Because they scorned their bodily form in life, they remain deprived of it in death.

The Werewolf

During the Renaissance, witches and warlocks were widely believed to be shape-shifters, roaming by night as creatures such as cats or ravens. Particularly

in the last decades of the sixteenth century and the start of the seventeenth, there was a wave of hysteria about werewolves – people that assumed the form of a wolf by night – in France and Eastern Europe. Numerous tales of werewolves had been told in Norse, Graeco-Roman and many other civilizations, but diabolical associations made werewolves especially frightening in a Christian context. Stories of werewolves and similar creatures are extremely widespread, which suggests that they are very ancient as well. They resonate with all sorts of half-articulate fears and desires that humanity has accumulated over millennia of cultural evolution. 'Lycanthropy', the psychic transformation of a person into a wolf, was possibly common among warriors in the ancient world, and it enabled them to battle with greater courage and ferocity. There are references to this in many Greek and Roman writers' works, including Homer, Herodotus, Pausanias and Pliny.

Ovid tells the story of how Jupiter, the supreme god of the Romans, distressed by reports of human wickedness, assumed the form of a mortal and visited the palace of King Lycaon in Arcadia. When his host served him a meal of human flesh, Jupiter took on his true form and struck the palace with a lightning bolt. Lycaon ran away in terror to a field, and when he tried to speak, a howl left his mouth instead of words: Jupiter had turned him into a wolf, so that he might turn his bloodlust against sheep instead of men.[12]

In the *Satyricon* by the Roman author Petronius, written in the reign of Emperor Nero, a freedman named Niceros relates what has become perhaps the most famous werewolf tale of all. Accompanied by a soldier, Niceros went to visit a widow on the night of a full moon. When they reached a graveyard, his companion stopped, saying he wished to relieve himself. When Niceros, after a short rest, looked around, he saw that the soldier had stripped off all his clothes and was urinating in a circle around them. Then the soldier suddenly turned into a wolf, howled and ran away. Terrified, Niceros made his way to the widow's home, where she told him that a wolf had broken into her barn and killed a sheep, but was wounded in the neck by a spear from one of her slaves. When he returned home, Niceros saw the soldier in bed being treated by a doctor for a wound in his neck, and realized that he was the wolf that killed the sheep.[13]

At the time, few members of the Roman intelligentsia believed in werewolves, and Petronius mixes horror with humour. He is, of course, aware of the martial associations of the werewolf, and the story shows how the image of soldiers had degenerated. Even with supernatural aid, the werewolf only manages to kill a sheep before being seriously wounded by a man who is not even a professional fighter.

Very similar stories were told in werewolf trials of the early modern period, which were especially common in Baltic countries and France. Werewolves were often 'recognized' by a wound or other physical feature that they retained in both lupine and human form. In one such trial, in 1588 in the French village of Auvergne, a ferocious wolf was

Hans Weiditz, 'A witch, transformed into a wolf, attacking travellers', from *Die Emeis* ('The Ants') by Johann Geiler von Kaysersberg, Strassburg (1517). Even in lupine form, this werewolf's expression still betrays perhaps a touch of humanity.

alleged to have assaulted a hunter. According to judicial records, the man managed to cut off his attacker's paw, at which point the wolf ran back into the forest. The hunter put the paw into his sack, but when he later drew it out to show to a friend, he found that it had turned into a woman's hand, on which he recognized his wife's wedding ring. Returning home, he found his wife with one hand cut off, trying to cauterize the wound with a candle. He took her to the village magistrate and she was eventually burned at the stake.[14]

People of the period often believed that werewolves and other shape-shifters retained some bestial features even in human form. Accordingly, a suspect would be carefully examined by a tribunal, and features such as hair in unaccustomed places would be taken as evidence of a transformation. If a person's eyebrows grew together, this was considered proof of a secret life as a werewolf, while a protuberance on their back might suggest a vestigial tail, and a large nose could be a lupine snout.

A legacy of these inquisitions continued in physiognomy, the practice of inferring a person's character from their physical features, which originated in antiquity but was most popular from the sixteenth century and through the later nineteenth. Physiognomists believed that human personality types corresponded to different species of animal, so the inner nature of a person could be determined by identifying the corresponding creature. Accordingly, a bust of Plato had extended nostrils, suggesting a dog, but his high forehead indicated good sense. He most resembled a stag, in which reason overcomes a prop- ensity to lust. People whose faces resembled hares were judged to be libertines; those with noses like the beaks of eagles, ambitious; those whose skulls appeared strong

IMAGINARY ANIMALS

such as J. J. Grandville (1803–1847) in France and Gary Larson (1950–present) in America.

Shape-shifting in the Modern World

In the high culture of the Renaissance, however, transformations became the foundation of alchemy. Metallurgy had provided inspiration for many ideas about shape-shifting since very early times, because heating and pounding can profoundly transform not only the shape but also the texture and colour of metal ore. Many experiments of the

Lucas Cranach the Elder, *Werewolf*, 1512. Usually in the early modern period, a werewolf is a person who fully takes on the form of a wolf, but here it is a man with long, dishevelled hair and a lupine posture. The extra suggestion of cannibalism makes his bloody trail even more horrifying.

enough to support the horns of a bull, wrathful. To illustrate the types, artists such as Giambattista della Porta (1535–1615) and Charles Le Brun (1619–1690) drew human heads superimposed on, or closely juxtaposed with, animal heads, creating composite figures – pig people, wolf people, rat people and so on.[15] These artists developed ways of blending human and animal features, which were then continued, usually without their scientific pretensions, in the technique of caricatures by artists

J. J. Grandville, 'Phreonological Specimens with Unexpected Character Traits', *c.* 1850. The artist used techniques developed by phrenologists, yet satirized their scientific pretensions. Here you have a friendly viper, a cruel lamb and a sensitive wolf.

Charles Le Brun, *Human Face Compared to that of a Pig*, late 17th century. Le Brun, whom Louis XIV considered 'the greatest French painter of all time', believed that the inner character of human beings was revealed through their resemblance to animals.

alchemists involved attempts to create living things, such as insects or even human life, out of dirt and waste. They frequently cited Ovid's *Metamorphoses* and interpreted its stories of transformation as allegories for physical processes.

By accustoming people to the idea that the forms of living things were not immutable, alchemists prepared them for the Darwin-Wallace theory of evolution. In popular culture for over a century after the publication in 1859 of Darwin's *On the Origin of Species*, evolution was portrayed as a metamorphosis, whereby creatures went through a series of fixed stages as they progressed to greater complexity. A fish was depicted stepping out of the sea to become a reptile, a mammal, an ape and finally a human being. In the late nineteenth century the biologist Ernst Haeckel developed a theory, now discredited, that human embryos go through stages analogous to the 'scale of evolution' as they develop from a fertilized egg to a newborn child. This sense of life as a fixed progression could well have contributed to the popular idea that people can become angels at death.

For philosophers such as René Descartes and John Locke, morality was only concerned with a person's relationships with God and with other human beings; it did not encompass animals or the environment. Subsequent discoveries in biology, especially the Darwin-Wallace Theory of Evolution, made it increasingly more difficult to take this human exceptionalism for granted.

When evolution was interpreted as progressive and hierarchal, however, claims to racial superiority could be rationalized by maintaining that certain people were more 'advanced'. Accordingly, in Europe of the nineteenth and early twentieth centuries, victims of prejudice such as Blacks and Irish were often portrayed with simian features. Individuals with unusual traits such as extensive body hair could be stigmatized as 'throwbacks' to

an earlier evolutionary stage.¹⁶ As the boundary between animals and humans came to seem more permeable, dehumanization emerged as a major literary theme of nineteenth- and twentieth century European literature. In Franz Kafka's tale 'The Metamorphosis' (1915), a man wakes up one morning to find he has turned into a cockroach. He gradually comes to terms with his identity, until he is content to simply lie in his room all day looking at the ceiling, but his family tires of caring for him and eventually he dies of neglect.¹⁷ One theme of the story is that human status may be called into question by numbing routines and formalized relationships.

In modern popular culture, shape-shifters have generally been replaced by human–animal composites. The werewolf in popular culture is no longer a person who is transformed into another species, but a hairy man with a lupine face, for example in the movie *The Wolf Man* of 1941. Among the numerous other composites in twentieth-century popular culture is the comic-book hero Spider-Man, a teenager who is bitten by a radioactive spider and becomes able to climb walls and ceilings and swing on webbing. Popular literature and film is filled with ape-men, cat-women, bat-people and so on. Perhaps the monsters most prevalent in contemporary movies, television shows and novels are vampires, who usually appear as ordinary human beings until they open their mouths and reveal their fanged teeth. If one of them sucks a person's blood, the victim becomes a vampire as well. Just as Christianity once spiritualized metamorphoses, the secular culture of the modern world has psychologized them. Not only vampires but Spider-Man and Batman are shown as constantly struggling with their difference and alienation from normal human society.

Beyond the Twenty-first Century

As we progress into the twenty-first century, not only individual identity but also human identity has become increasingly uncertain. People can radically change their appearance through plastic surgery and, if they can afford it, even their gender. Transplants of organs and genetic material from one species to another are starting to become more common.¹⁸ Human genetic material, for example, is sometimes placed in pigs, so they will develop organs that can be transplanted safely into human beings. The pigs, then, become partly human, while the recipients of the organs become partly pig. Researchers sometimes speak of individual plants and animals as if they were simply vessels of genetic material, to be recombined in endless possibilities. On the Internet, people can try out new personalities and even, in multi-user domains or 'MUDs', digital bodies to interact with others in virtual reality. Assuming the physical features of their choice, they can become a fantastic animal, a real animal, or simply a different human being. The virtual self can then decorate a home, buy an island, travel in space, or do almost anything else it may desire.¹⁹

The idea of a shape-shifter presupposes an identity, which is not dependent on physical form. A man

must be able to assume a different shape such as that of a whale or an ant, while, remaining himself. He must, in other words, have some sort of constant essence. The concept of metamorphosis involves a balance between constancy and change. Today, scientists argue that almost nothing is entirely static; not only do living things evolve but continents drift, and the very structure of space and time is warped by gravitation. Even the constancy of physical laws is now open to question. This is flux far more profound than that postulated by Ovid, who seemed, for example, to consider the stars exempt from change. If, as many philosophers maintain, the soul, for human beings as well as animals, is an illusion, a metamorphosis in the more traditional sense, of metempsychosis, cannot take place. Nevertheless, though impossible to either verify or disprove, belief in such transmigration of the soul is still widespread in contemporary culture throughout the world. Reincarnation is one way to account for the way in which animals, from ants to whales, seem to have uncannily 'human' characteristics.

Max Ernst, *Celebes*, 1921. This machine combines elements of an elephant, bull, and snake, animals of enormous power. It is being introduced by a headless mannequin, perhaps a victim of the First World War. The picture may illustrate a modern version of the Greek myth in which Zeus seduces the maiden Europa in the form of a bull.

TWELVE
MECHANICAL ANIMALS

> I hope you are very happy, Little Guy. I'm currently taking care of your son.
> I know he's yours because he looks and acts just like you. I'm really sorry
> I couldn't save you and had you on pause a lot when you were older.
> Thanks a lot for being the best Tamagotchi anyone could've ever owned.
>
> Epitaph of Little Guy, aged 48, who died when his *'battery drained out'*.
> From the Tamagotchi Graveyard

'CHILDREN'S BOOKS' have never been just for children. They are a repository for adults' secret pleasures, things they enjoy but which seem too undignified, too crazy or too revealing to admit to very openly. They are marketed to, and also read, by adults and children alike. But a classification as children's literature provides a cover for the writer and the grown-up readers who seek to preserve a certain gravitas among their friends and professional colleagues. It enables them to say, in effect, 'I may be carrying this book, but it is not really intended for me.'

The adult reader of children's books resembles the academic who writes learned treatises on pornography in order to have an excuse to indulge in forbidden activities; but in one respect, the motivation of these readers is entirely the opposite. Children's books can afford adults the opportunity to secretly enjoy a world almost entirely without sex, in the midst of a society obsessed with it, while not being accused of repression or prudishness. The lack of erotic content in most of these books is not exclusively for the sake of sheltering developing minds.

But the secret enjoyment that I am more concerned with here is neither sex nor its absence. It is the enjoyment of fantastic animals, which have proliferated in books for children as long as these have been written. The tradition may go back to ancient Sumero-Akkadian animal proverbs, which were arguably the first literature for children. It continued with the fables attributed to Aesop and the medieval bestiaries, reaching a culmination in Britain in the late eighteenth and nineteenth centuries, when books for children proliferated.

Harry Potter

The phenomenally successful Harry Potter series by J. K. Rowling introduced many young people to recreational reading in the late 1990s, and continues to do so today.[1] They tell of Harry, a talented young wizard in training, who divides his time between Hogwarts School of Witchcraft and Wizardry, where he defeats cosmic villains, and the world of ordinary people, or 'Muggles'. At Hogwarts, there is little technology that dates from after the Industrial Revolution. Not only are there no computers, typewriters, cameras, televisions or radios, but even fountain pens seem a little too modern, and people write using quills

and inkwells. Letters are not delivered by plane or even by truck, but by using owls as carriers. There seems to be no medicine apart from magical spells, and the only concession to the world of Muggles is the use of running water and flush toilets.

Of course, computers are for Muggles, but the culture of computers is present at Hogwarts after all, since magic spells assume the functions and the ambience of digital creations. The first broomstick used by Harry is called a 'Nimbus 2000', which sounds like a name for a sleek new piece of office equipment. The pictures in the wizardry newspapers contain talking images much like computer graphics, while magical books send messages that resemble email.

Real technological innovations often seem to have been anticipated by folklore, literature and religion: the flying carpets or boats of legend have become the planes and rockets of today. Folklore also envisaged such devices as cash machines (ATMs) and automatic doors centuries, perhaps even millennia, before these became part of everyday life in the latter twentieth century. In the medieval *Arabian Nights Entertainments*, for example, Ali Baba finds a cave full of treasure, and learns that the entrance is opened by the magic words 'Open sesame.' He tells this to his brother Qasim, who enters the cave, but then forgets how to reopen the door. Qasim tries similar formulas like 'Open barley', but they do not work and he is trapped inside the cavern. A reader today, who is used to opening web sites with passwords and secret codes will find Qasim's dilemma very familiar. For us this is a matter of technology, while for Ali Baba and Qasim it is magic, but, no matter what you call it, the experience is just about the same.[2]

The *spiritus familiaris* or familiar, the supernatural magician's helper, has become the computer, which is ready to answer any question and do its master's bidding. Computer programs, with their esoteric symbols, have an uncanny resemblance to magic spells.

It is surprisingly difficult to distinguish between technology and magic. When computers and the Internet are in perpetual tension with the rest of everyday life, they are 'technology'. For those who have grown up with them, however, they can be so much a part of daily life that they hardly seem to have an autonomous existence. At this point, they are no longer 'technology' but 'magic', or at least something close to that. The enchantment that was once safely locked away between the covers of books has stepped outside and begun to walk our streets. At Hogwarts, technology equals magic.

Like the boundaries between human beings and animals, the division between living things and objects, in this case machines, has come to seem more uncertain in recent decades. Nobody can say what 'consciousness' really is. Science fiction writers have long wondered whether computers might have consciousness, or at least whether they might develop it eventually. All of us probably have had that question pass through our minds at one time or another. What J. K. Rowling has recognized is that technology can create an ambience similar to that of the animistic world of folk and

A model head of Dobby the house elf as he appeared in the Harry Potter films. Dobby has large, neotonous eyes that elicit sympathy, and large ears a bit like those of a bat.

fairy tales. In terms of how we experience the world, the computer revolution has returned us to something perhaps closer to the pre-industrial world than to the hierarchically ordered cosmos of the eighteenth and nineteenth centuries.

As new technologies have led to a proliferation of fantasy animals in animated films and video games, scientific techniques of genetic manipulation have raised the possibility that creatures similar to those of myth and legend could be created in the laboratory. A firefly gene has been placed in a tobacco plant to make it glow in the dark. They have even, by growing cells through a mould, produced a mouse with a human ear growing on its back, a creature that looks as though it stepped out of a painting by Hieronymus Bosch.[3]

At the same time, robots are being created to offer companionship to the lonely or to guide blind people. These developments raise difficult questions about the ways we have traditionally classified creatures, as well as about human identity. They also potentially blur commonly accepted distinctions between fantasy and reality. But, while biotechnology and artificial intelligence may respond to our longing for wonder, they still do not generally satisfy it very well. They appeal to our curiosity, our practical needs, and sometimes our emotions, but not to our imaginations.

While mechanical creatures are increasingly prominent in our everyday lives, real ones continue to haunt our dreams. As ever more real animals are driven to the point of extinction, creatures such as the tiger regain many of the numinous qualities that they had in archaic times. They are invoked in figures of speech, tattooed on human bodies and exploited by advertisers. Even should they become extinct, tigers, snow leopards, blue whales and mountain gorillas will continue to evolve in the human imagination, and perhaps take their place alongside the unicorn and the winged horse.

Though technology has little or no reality in the world of Harry Potter, it is used quite unabashedly, and even proudly, in recreating it. The Harry Potter series has spawned a sequence of films just as popular as the books, in which the dragons, centaurs, giant spiders and other creatures are rendered using all the 'magic' of the cinema – computer generation, mechanical devices, elaborate costumes, trickery using lighting, and so on. To summarize, we can say that technology is banned from Hogwarts not because it is inimical to magic,

but because it is so much like magic. To place both alongside one another in a series of stories could create enormous confusion.

The animals in Rowling's series are, almost without exception, not unprecedented creations such as those of Dr Seuss, but borrowed primarily from Graeco-Roman mythology or medieval folklore, as were those in C. S. Lewis's *The Chronicles of Narnia*. Harry's mentor Albus Dumbledore has a pet phoenix named Fawkes, after Guy Fawkes, who tried to blow up the Houses of Parliament in London and is burned in effigy in Britain every year on 5 November. Fawkes the phoenix has crimson feathers, a golden tail and a mighty beak and claws. It has fought alongside its master in many battles and even sacrificed itself for victory, but was reborn. When Dumbledore dies, Fawkes sings a beautiful lament and then vanishes, to live forever in the wild.

An adversary of Fawkes is the basilisk. Just as in medieval lore, basilisks are created by evil magicians who take an egg laid by a rooster and have it incubated by a toad. They are huge lizards with green skin and enormous yellow eyes which can petrify people, and even ghosts, with their gaze. Their teeth contain deadly venom and their bite can only be cured by the tears of a phoenix. The villainous Salazar Slytherin set a basilisk to guard his Chamber of Secrets, where it attacked Harry Potter. Fawkes, however, blinded the basilisk, saving Harry from its eyes.

Yet another imaginary animal in Rowling's books is Aragog, the giant spider who, when still in an egg, was smuggled into Britain from a distant land. He grew to be almost as large as an elephant, and learned human speech. Because he had been befriended by the aspiring wizard Rubeus Hagrid, Aragog restrained his taste for human flesh, but others in the clan of spiders that he ruled were capable of devouring human beings. During a great battle at Hogwarts, Aragog and his clan support Harry against the evil Lord Voldemort. These are just a few of the vast host of imaginary creatures in the Potter series, which also includes manticores (Persian monsters with the bodies of lions, heads of human beings, and teeth of sharks), unicorns, merpeople, centaurs, hippogriffs and many kinds of dragons.

Electronic Animals

J. K. Rowling has perceptively recognized that young people of the present period, at times called 'digital natives', have grown up surrounded by imaginary animals that are created electronically and with ever-increasing vividness – on the screen and in video games. Possibly, though, the creatures of fantasy that are most reminiscent of those in Hogwarts are 'digital pets', which are designed to be quirky and individual. Characteristically, they can accept affection, demand care and come to relative 'maturity', yet, like real animals, they do not always obey their owners.

Human technology has always been created largely in imitation of animals. Prehistoric tools appear to have been modelled after birds' beaks. It

is likely that trapping techniques were originally inspired by watching spiders spread their webs, and dams could have been inspired by beavers. Ploughs could have been initially modelled after the activity of swine, which root up the earth in search of food. Several modern inventions also have a clear prototype among animals, for example alarm clocks, which have taken the place of barking dogs or crowing roosters. Quite a few even took their colloquial names from animals, such as the steam train, which was known initially as the 'iron horse'.

Over the centuries this imitation of animals, far from becoming anachronistic, has only become more sophisticated. The popular Vulcain 'Cricket' watch worn by Dwight Eisenhower and other presidents of the United States contained an alarm mechanism modelled after the calls made by insects, which can fill a field with sound in spite of their diminutive size. Velcro was perfected by observing the ability of flies and geckos to walk on vertical surfaces. Today, aeronautics engineers study the ability of insects such as dragonflies to hover in place or move in any direction with great precision.[4] Mechanical devices have taken over so much of their design from animals that they almost seem to be haunted by creatures of the past.

It is a little tempting, if not quite accurate, to call all of these technologies 'imaginary animals'. By adapting features of animals, they inevitably also take on many bestial associations, and perhaps that is why so many drivers talk to their cars. The giant machines of the Industrial Revolution could even have evoked ancestral memories of megafauna, which may be why they inspired so much fear and awe. This zoomorphic perspective on large machines is most apparent in the work of the Italian Futurists in the early twentieth century; these artists used the power and speed of the emerging industries as the inspiration for their Fascist political agenda. They venerated large machines almost as zoomorphic deities, and saw the dehumanization that took place in factories or in wars as a mystical annihilation of the self. It is also clear in the artwork of the Cubists, who blended organic forms with mechanical ones, and in the work of many Surrealists such as Max Ernst and Salvador Dalí – in fact much European art of the period.

With the gradual decline of heavy industry, machines were generally reduced in size and lost much of their mystique. They began to seem far less like gods, but a great deal more like people. Their motions became far less jerky and violent, their touch became more sensitive. Google has created an automobile equipped with sensors that enable it to negotiate the heavy traffic of Manhattan without a driver. Computer viruses now reproduce and evolve just like the real thing, and they can be almost as hard to eradicate.

Today an increasing number of devices imitate not only the behaviour but also the autonomy and emotions that we expect from animals or human beings. A very simple example is the cash machine, which after a transaction tells the user, 'It is always a pleasure to serve you.' Other devices relate to people in more nuanced ways, as animals,

especially pets, might do. To the best of my knowledge, there has not yet been an electronic/digital pet modelled after Fawkes or Harry Potter's pet owl Hedwig. Even more notably, however, there seem to be hardly any digital cynocephali, centaurs, basilisks or other creatures from the ancient world outside of computer games. The creators of digital pets seem to prefer to take either familiar models such as dogs and cats or else create their own imaginary ones, 'from scratch'.

Digital and robotic creations can be considered 'imaginary animals' to the extent that they are intended not simply to perform practical tasks but, more significantly, to offer companionship to human beings. They must, in other words, relate to people as something fully alive and autonomous. They appear to have emotions, and perhaps even a moral code, which enable them to enter into reciprocal relationships with people.

Among the earliest robots designed to mimic human emotions was Kismet (Turkish for 'fate'), which was created in the late 1990s at the Massachusetts Institute of Technology. Kismet is a mechanical head equipped with visual, auditory and kinaesthetic sensors; its sole purpose is to convincingly mimic the emotional responses of a live creature. Its facial features have been individually chosen for their expressiveness, and they do not correspond very closely to those of any species. Kismet has enormous round eyes, like those of a frog in form yet with a human sort of intensity. Its wide mouth suggests that of a chimpanzee, while its ears are like those of a bat. By shifting these features, the robot 'expresses' a wide range of emotions. It follows people with its eyes to show attention and reacts to sudden changes by tensing up in fear. It can also mimic anger, disgust, boredom, pleasure or surprise. Kismet is designed to respond to the tone of a person's voice; it even responds in kind – with only rudimentary grammar but a wide range of intonations.[5]

Tamagotchis

The Tamagotchi is a hand-held computer in the shape of an egg, brightly coloured and with a screen in the centre, which you can buy for around U.S.$20. A few seconds after the owner, usually a child, starts the device and sets the internal clock, the creature, the Tamagotchi will 'hatch', appearing on the screen. The owner is told the Tamagotchi's gender and invited to name it, usually in five to eight characters. After that the owner is entrusted with the task of raising the Tamagotchi as a pet, digitally feeding it, exercising it, playing with it and even cleaning away its excrement. When the Tamagotchi appears despondent, it usually helps to praise it. No two Tamagotchis are alike, and these digital pets develop an individual 'personality'. If a Tamagotchi is neglected, it can become peevish; if overindulged, it will grow fat. One human day is about the equivalent of a Tamagotchi year, and the creature goes through stages that correspond to infancy, childhood, adolescence, maturity and old age. More technologically sophisticated Tamagotchis can communicate wirelessly with one another, and male

Mechanical Animals

Kismet, a robot made in the 1990s at MIT to simulate the expression of human emotions. One notable thing about this robot is that its creators made almost no attempt to conceal its mechanical nature or to make it appear human.

and female ones can 'mate', producing a new generation. Tamagotchis were created in Japan by the company Bandai and, as of the time of writing, sales since their appearance in 1996 are approaching 100 million.

Like most digital and robotic animals, the Tamagotchi has no single biological equivalent. Since it hatches from an egg, perhaps it is a bird. Like Kismet, a Tamagotchi is almost all head, with huge, neotenous eyes and a wide mouth. Many Tamagotchis have large, protruding ears, a bit like those of mice. Tamagotchis are divided into types, including 'dinosaur', 'chicken', 'monkey' and 'octopus', though their resemblance to these creatures is minimal.

Perhaps the ultimate models for the Tamagotchis, if they have one, are insects such as beetles, which are regarded mostly as pests in Europe and North America but are often beloved pets in Japan.

A mother once told me, 'If you give a child a Tamagotchi, be prepared for big tears.' Even Tamagotchis are mortal. Some 'die' because their owners neglect to feed them, while others perish in accidents, for example being dropped on the pavement. Some die of old age, after about 100 Tamagotchi years. The owner can usually get another simply by pressing the 'reset' button, but the new Tamagotchi will not have the same experiences, and many owners, out of regard for the original, prefer not to do this. Once dead, the creature can be laid to rest online, in a 'Tamagotchi graveyard'. At the virtual entrance of one, a sign proclaims, 'Here lie proud and honored Tamagotchis. Please keep noise to a minimum and respect their rest. If u [sic] are an unfortunate owner and have lost your beloved Tamagotchi, please make your way to our undertaker who will attend to all your needs.'

For every deceased Tamagotchi there is a virtual headstone giving the age, owner, name, type and cause of death, as well as an obituary or inscription. 'Joe' was a Tamagotchi of the dinosaur type who died at the age of eight from 'accidental dropping'. The owner writes, 'My poor Joe. The first born. He had a good life and was taken care of very well. It was unfortunate that his life had to come to such an abrupt end, whilst living in a jeans pocket. We shall all miss him very dearly.' PeeWee was a Tamagotchi of the alien type who 'starved to death' at the age of five. His obituary reads, 'You were pretty cute and you knew it but did you really have to die? You fool. Love you always.' A Tamagotchi of the monkey type died at the age of nine when 'Fire – dropped it, and it made a weird beep sound.' One more creature of the dinosaur type died at eleven years old, of 'accidental resetting', leaving the owner inconsolable: 'My darling Billy Boy. *sob* He was so beautiful. Never a moment's trouble did I have with him. He went with me everywhere and did everything with me. Then came the fateful day of 'The Big Drop' Oh my Billy Boy, what will I do without you? *sob*'. A digital dragon provides an eternal flame by a simple inscription that reads, 'Long live Jimmy'.[6]

Most of the laments are so clearly heartfelt that it is impossible not to be moved by them, yet it seems odd to mourn what is, after all, only an image produced by a machine. Or is it? In the back of one's mind, unsophisticated as the idea sounds, is the suspicion that the Tamagotchi could really be alive. After all, it seems to be, and how can one prove that it is not? On the other hand, even children with Tamagotchis seem aware on some level that they are not sensate in the same way as, say, the family dog. And if we really thought that Tamagotchis were alive, we would jail, or at least fine, people for mistreating them. We might even accuse somebody who accidentally pushed the 'reset' button of manslaughter. Perhaps it is a phase of their lives, or else an aspect of themselves, that the children are really mourning. Is it a loss of innocence?

If we stop to think about it a bit more intensely, the oddest thing about the Tamagotchi graveyard may be that, most of the time, it does not even seem strange. Tamagotchis reflect a flattening of experience, in which numerous polarities begin to fall away: the self and other, reality and fantasy, knowledge and emotion. Relationships among people or between people and animals invite almost endless probing. An animal, whether kept as a pet or in a domestic setting, invites unceasing reflection, with its combination of strangeness and familiarity, just as a portrait by Rembrandt or a farm scene by Millet also does. But with a Tamagotchi, the relationship is simply what you see, and there are no layers of meaning.[7] Owners seldom write or talk about amazing adventures their Tamagotchis may be having in their absence.

This simplicity can seem refreshing, in view of the nearly endless complexity and ambivalence that fills so many interpersonal relationships in the twentieth and twenty-first centuries. People have often sought relief in their relationships with pets, especially dogs, which are widely perceived as being without artifice or ambiguity, and Tamagotchis simply take this one step further.

Other Digital and Robotic Pets

The Tamagotchi is now only one of many alternatives for those who would like a digital pet. Almost as old is the Furby, which was a huge fad in 1998. A Furby is an electronic doll, covered with fur, which has huge eyes and combines the features of an owl and a mouse. Furbies are programmed to start by speaking a sort of gibberish that the makers call 'Furbish', but their owners are instructed to speak to them often, and the toys gradually begin to 'learn' English. Many Furbies are now equipped with visual sensors and voice recognition systems.

There are also digital pets which live in virtual worlds, for which the owner is invited to buy excursions and accessories. Neopets enables one to purchase griffins and other mythological creatures, rather like those in the Harry Potter stories. The pets live in a virtual community called the planet of Neopia, where they can do things like fight pirates or visit prehistoric times. The community has an economy and even a stock market, which is based on the currency of Neopoints. Foo Pets, on the other hand, features mostly virtual cats and dogs. Moshi Monsters, based in the United Kingdom, sells toys of fantastic creatures that are relatively anthropomorphic, with two arms, two legs and comparatively huge heads with enormous eyes. Each comes with an adoption certificate, plus a code to allow the owner to play digital games over the Internet. Each Moshi Monster can laugh and say at least a few sentences. Mind Candy, the company that makes them, also sells a vast array of paraphernalia associated with their animal creations, such as jewellery, boxes and magazines.

Owners usually use digital and robotic pets that are based on actual animals in relatively pragmatic ways. A Paro is a robotic seal designed especially for the elderly and those suffering from dementia. It responds to petting by showing pleasure,

thus calming their owners and helping them avoid disorientation.

Could electronic pets in time take the place of real ones? They are usually cheaper and almost always easier to care for than a real animal can ever be. Cars have now taken the place of horses for transportation, and electronic protection systems have replaced watchdogs. Alarm clocks instead of roosters wake us in the morning. It is now conceivable that animals in our lives could become almost entirely anachronistic, if we nourish our bodies with *in vitro* (synthetic) meat and our emotions with Tamagotchis, though we might pay a price in authenticity.

Far too often, in debates over whether animals or computers are sentient, people glibly equate consciousness with awareness or intelligence. Actually, consciousness is relatively easy to simulate, since digital messages can be sharply focused in a way that suggests clear intention; the unconscious mind, however, is far more difficult to fake. It is precisely the unconscious dimension of thought and emotion that digital pets appear to lack. One might perhaps go even further and say that the unconscious mind is the essence of life, even if only artists and visionaries value it properly. But, then, it could also be argued that the files concealed in the depths of our computers, together with little-used or out-of-date programs, form something like an incipient unconscious mind. Just as our buried memories sometimes cause errors of memory or recognition, so these can occasionally impede a computer's functioning.

Computers are no longer used so much for calculations as for simulations, so even those who program them do not know in advance how they will respond in a given set of circumstances.[8] Interactions with computers are rapidly becoming as unpredictable as those among human beings or animals. We should therefore not think that programming computers necessarily puts us in control of them. Human domination, the cause of so much guilt and pride, is primarily an illusion created by exaggerating human unity, human autonomy and the extent to which changes are the result of our conscious choices, while simultaneously denying all autonomy to other agents.

Some people maintain that we are dominant because we are at 'the top' of the proverbial 'food chain'. Now, it is true that we have done a pretty good job of avoiding being eaten by large predators such as bears and crocodiles, though we have only accomplished that by driving them close to extinction in many areas. We are, however, much less effective in escaping the tinier predators, such as germs and viruses. We have some success in evading them, but it is always only temporary, since they quickly adapt to our medicines and antibiotics; we are perpetually on the defensive. And, no matter how tightly we seal our coffins or what chemicals we place in our veins, they always eat us in the end. Furthermore, in most contexts people do not assume that being 'higher' on a food chain confers superiority. Snakes may eat monkeys, yet people traditionally consider simians more intelligent than reptiles.

J. J. Grandville, 'A Dog Walking His Man', from *Les Animaux* (1842). People usually think they are in charge of their dogs, but the dogs themselves may not necessarily agree.

The English word 'domesticate' comes, like 'dominion' and 'dominate', from the Latin *dominus*, meaning 'master' or 'lord'. But researchers no longer see domestication of animals such as the dog to be the result of unilateral decisions by humankind. Instead, they regard it as a symbiosis that developed without either party being aware of it.[9] Our relations with animals continue to evolve, in ways that are, for the most part, not the result of conscious choices. Nobody ever decided that there should be a great expansion of pet keeping among the European and American middle classes during the nineteenth century or that animal husbandry should be industrialized in the latter twentieth, and it is also very far from clear how such developments serve 'human interests'. Nobody can predict with any confidence how relations between human beings and animals, imaginary or not, will evolve in the centuries to come, except that they are very unlikely to stay the same.

Human dominance is mostly a trick of perspective. The crows in the city of Sendai, Japan, have learned how to use traffic to crack walnuts. They wait until the traffic lights turn red, and then swoop down from a tree, place a walnut in front of the tyre of a car, and then return to their branch to wait. When the light turns green, the car drives over the nut, and the crow can feast on the seed. Quite possibly, these crows believe that cars and trucks exist for the express purpose of crushing shells. To the extent that they may think in such terms, rats may imagine they have commissioned our supermarkets to insure themselves a consistent supply of scraps.

But it is not so much animals as machines that are now exposing the limits of human control, as it becomes increasingly apparent that computers are not merely slaves to human agendas. The family dog receives food, shelter, medical care and much more from people, while offering in return less

tangible gifts such as companionship. But the relationship is sufficiently asymmetrical that it is, if not necessarily appropriate, at least relatively easy to construe it as one of human dominance. With computers, the reciprocity is harder to ignore, since these devices are constantly exchanging information with human beings and are intimately involved in decisions at every level of government and industry. Devices like Tamagotchis expose the more underappreciated aspects of our changing relationship with artificial intelligence, including the compulsive nature of our bond with it.[10] Were an alien from outer space to visit the contemporary developed world, that creature might well think that computers were the dominant form of life, with human beings only present to build and service them, and help them achieve their full potential. And why do people perform these tasks? The alien might think it was because that is how we are programmed.

Conclusion

> The universe is a very big place, but as far as we know it's mainly empty, boring, and cold. If we exterminate the last magnificent scary beasts on planet Earth, as we seem bent on doing, then no matter where we go for the rest of our history as a species – for the rest of time – we may never encounter any others. The only thing more dreadful than arriving on lv-426 and finding a nest of aliens, I suspect, would be to arrive there, and on the next unexplored planet, and on the next after that, and find nothing.
> David Quammen, *Monster of God*

IN THE INITIAL CHAPTERS of this book, I argued against any sharp differentiation between imaginary animals and real ones. Admittedly, this opens me to the charge of relativism. 'After all,' somebody might say, 'isn't this the same thing as claiming there is no difference between truth and falsehood?'

The criticism is unprovable, hard to refute and also almost comically predictable, for similar things are said of nearly any philosophical or religious perspective that is unfamiliar. Christians regularly accuse unbelievers of relativism, and atheists make the same charge against Christians. It has been levelled against existentialists, deconstructionists, structuralists, positivists, fundamentalists and so on.

But I cannot think of even one single thinker, whether contemporary or historical, who has ever explicitly renounced all belief in truth. Relativism is not a philosophic doctrine. Rather, it is a sort of substratum of all thought, perhaps especially in contemporary times. It never seems very far away, and is likely to appear implicit in any philosophical or religious perspective but one's own. Life is lived on the edge of chaos, and truth resides on the boundary of nonsense or of relativism. Truth, by its very nature, is fragile and elusive, so we should treasure it accordingly.

When subjected to intense and persistent scrutiny, all of the moral and intellectual foundations of our culture can start to seem distressingly arbitrary. How do we know that people have rights? How do we know that other people are conscious? What is wrong with causing unnecessary suffering? How can we know that the same laws of physics will apply tomorrow as apply today? Such questions are surprisingly hard to answer. If we try to address them seriously, we are probably as least as likely to augment silent doubts as to convince any sceptics. But to lead a life of order and integrity, we cannot dwell constantly on the fragile and often fleeting nature of our cultural or scientific inheritance. We can pretend to question everything in classes like 'An Introduction to Philosophy' but, on a day-to-day level, we must lay our doubts aside. There is no exact word for this process, yet 'faith' probably comes as close as any.

Many scholars have observed that 'monsters' can help us by giving a tangible form to our secret fears.[1] It is less widely appreciated today that 'wonders'

such as the unicorn legitimize our hopes. But all imaginary animals, and to some degree all animals, are ultimately both monsters and wonders, which assist us by deflecting and absorbing our uncertainties. It is hard to tell 'imaginary' animals from symbolic, exemplary, heraldic, stylized, poetic, literary or stereotypical ones. What is reality? Until we answer that question with confidence, a sharp differentiation between real animals and imaginary ones will remain elusive. There is some yeti in every ape, and a bit of Pegasus in every horse. Men and women are not only part angel and part demon, as the old cliché goes; they are also part centaur, part werewolf, part mandrake and part sphinx.

All animals, no matter whether they exist or in what sense, are products of the same dialectic of reality and imagination. Imagining new animals and telling stories about them, for that reason, is a perpetual philosophical exploration, a sort of divine play. The ontological uncertainty that surrounds imaginary animals is not to be dispelled by new analysis, but lies in their very nature.

It is for this reason that imaginary animals can be disorienting, and even the benign ones are potentially objects of fear. They are the product of an existential insecurity, which in turn seems to be an essential part of the human condition. The human imagination, in fact, is so active that our tales of ghosts and goblins constantly threaten to overwhelm our grasp of reality. At times it breaks the restraints imposed by custom or philosophy, and human beings are inundated by a proliferation of monsters. In 1808, the government of India

J. J. Grandville, 'Fantasy Animal', *c.* 1850. All animals are both monsters and wonders.

found it necessary to forbid the telling of tales about 'flying heads, animal goblins, serpent monsters, fire demons, and suchlike terrors'.[2] At the same time, to the extent that we can even conceive of such a thing, a world without imaginary animals would seem desolate. Through their indefinite social and philosophic status, and their links to ever more new possibilities, they hold out a promise of transcendence.

The English 'transcendence' comes from the Latin *transcendere*, which means to climb over or surpass. The underlying metaphor here is the climbing of a wall, probably originally the wall surrounding a town. The walls of our cities today are no longer made of stone. The barrier may now

be less tangible but it is every bit as real – the divide between the human realm, on the one hand, and the natural or supernatural ones beyond.

All animals are very hard, probably impossible, to accommodate neatly in the categories of human thought. No generalization about them which is not fairly trivial ever seems entirely correct or, for that matter, entirely false. When we speak of animals as having or else not having 'consciousness', a 'sense of self' or 'morality', we are imposing on their lives categories that are not only 'human' but also culturally specific. Do animals have 'morality'? Well, which morality do you have in mind? Is it that of a middle-class American in the twenty-first century? A Mafia don, a Viking warrior or a Confucian scholar?

Do animals have a sense of time? It depends if you mean linear time, which has been the predominant view of Westerners in the modern period, but is probably losing that status today, or cyclic time, which reigned in the ancient world. Do you mean time as an eternal present, or time as conceived by Homer? Or by Buddha, Newton or Einstein? A Depression-era vagrant? An Australian Aborigine? A harried CEO?

What about a sense of self? Is that my self or your self? Is it the self of a Buddhist monk, of a Cro-Magnon hunter, an Esquimaux shaman? Louis XIV of France is reported to have said, 'L'état, c'est moi', 'I am the state'. Do any animals have that sort of self?

And consciousness? That is probably the most elusive concept of all. We usually think we have consciousness, but attempts to define it are generally either so abstract as to be useless or so empirical as to be trivial. And, in any case, whatever consciousness may be, we are frequently trying to get rid of it. Buddhist monks try to lose it through meditation, while practitioners of voodoo and related faiths try to escape it in ecstatic trances. Artists try to lose it in their work, as they let their unconscious minds take over. If animals do lack consciousness, perhaps we should envy them.

And do animals comprehend death? Well, do people? And, if so, which people? The ones who see death as a gateway to Heaven or Hell? The ones who believe it is simply a transition from one form to another – that is, reincarnation? Or those who think of death as a mystical union with all of life? Researchers on animals who ask the initial question probably assume the view of death that prevails among the secular intelligentsia – absolute extinction, or something of the sort. They are certainly entitled to their opinion on the matter, but it should not be regarded as the universal human perspective, much less as the standard against which the understanding possessed by animals should be measured.

In the words of Mark Derr, dogs are so valuable to us because

> they connect us to a world outside ourselves and our categories. Yet ours is not a society that deals well with ambiguity, ambivalence, paradox, and border zones, and so the

tendency is to cleave the dog from its wild side and lament the contradictions we have created. It is enough to drive a dog to ruin.[3]

Much the same thing might be said of all animals, especially those of the imagination.

Most research into whether animals have qualities like consciousness is not only anthropocentric but extremely ethnocentric as well. It not only makes human beings the measure of all creatures, but also secular, Western people of the twenty-first century the measure of all human beings. This is also, in my opinion, true of all of the 'expanding circle' approaches to animal rights, which essentially seek to extend contemporary human laws, institutions and concepts to embrace other forms of life.[4] This approach may give some protection to a very small number of animals – those that we think most closely resemble ourselves. It can also comfort us with the reassurance that our philosophies are not historically contingent but, rather, an expression of absolutes. On a modest scale, it may even help to foster humane practices. When elevated to the status of a universal principle, however, the expanding circle approach in fact diminishes animals by imposing

J. J. Grandville, from *Vie Publique et Privée des Animaux* (1842). Like much of Grandville's work, this picture satirizes anthropocentrism. Here Pistolet, a critic, finds himself the centre of attention, perhaps because he appears more 'human' than anyone else. If you look closely, however, you will see that he is more of an animal than he probably wants to admit.

Conclusion

our concepts, expectations and values on their lives. Finally, by denying their distinctness and autonomy, it lessens the richness of the world we live in.

Rather than trying to bring animals into our world, I believe that we should try to enter theirs. This will require an intensified effort of imagination as we endeavour to envision how objects, including people, appear to other creatures. We will need to learn to accept a good deal of uncertainty, as well as to trust our poetic imaginations. What is it like to be a bat? A squirrel? A frog? A tiger? A horseshoe crab? A butterfly? A dragon? A Tamagotchi? We will never have final answers to these questions but, assisted by a combination of art and science, we can arrive at helpful and interesting ones.

Animals are distinguished, in relation to human beings, by their combination of kinship and strangeness; they are so much like us and yet so profoundly different. Imaginary animals are based on real ones, and to render an animal 'imaginary' is essentially to intensify this paradoxical character. When wings are added to a horse, its alterity is amplified, yet it is simultaneously rendered more human, since it becomes more susceptible to allegorical interpretations. Animals don't pass our mirror test; they are our mirror test. Animals are not only, as Claude Lévi-Strauss so famously remarked, 'good to think', but also good to dream.[5]

Imaginary creatures remind us that, in the words of Hamlet, 'There are more things in Heaven and earth, Horatio, than are dreamt of in your

J. J. Grandville, from *Les Animaux* (1842). Will the insect pass or fail this 'mirror test'?

philosophy' (I, v). In this way, they implicitly warn us against arrogance. In Gothic churches, they are a caution against fanaticism; in palaces, a reminder of the limits of temporal power; in libraries, a check on both pride and cynicism. Fantastic animals direct us to, and then beyond, the limitations of normal

routines, social conventions, religious dogma and perhaps even cosmic law.

Mary Oliver writes of a flock of swans flying above a dune:

> What we love, shapely and pure,
> is not to be held,
> but to be believed in.
> And then they vanished,
> into the unreachable distance.[6]

Much the same thing may be said of the mermaids, griffins, unicorns, cynocephali, dragons and other creatures that we have looked at in this book.

Possibly Kawanbe Kyōsai, kitsune and other magical animals, from a Japanese postcard, late 19th or early 20th century. Note the demon in the lower left corner, which is playing a trick on a fox. Kitsune either have no reflection or else the appearance of a fox in mirrors, but this fox mistakes a picture of a woman for its own reflected image.

REFERENCES

1 The True Unicorn

1 Edward Topsell, *The History of Four-footed Beasts and Serpents and Insects* [1658] (New York, 1967), p. 552. In this and the subsequent quotations from this book, I have somewhat modernized the English.
2 Ibid., vol. I, Dedication.
3 Didymus of Alexandria (attrib.), *Physiologus*, trans. Michael J. Curley (Austin, TX, 1979), pp. 150–200.
4 Topsell, *The History of Four-footed Beasts*, vol. III, p. 889.

2 Animal Encounters

1 Michael Pastoureau, *The Bear: History of a Fallen King*, trans. George Holoch (Cambridge, MA, 2007), pp. 60–85.
2 Harriet Ritvo, *Humans and Humanists (and Scientists)* (2010), National Humanities Center, available at http://onthehuman.org, accessed 22 March 2010.
3 Carol Kaesuk Yoon, *Naming Nature: The Clash between Instinct and Science* (New York, 2009), pp. 119–21.
4 Signe Howell, 'Nature in Culture or Culture in Nature? Chewong Ideas of "Humans" and Other Species', in *Nature and Society: Anthropological Perspectives*, ed. Philippe Descola and Gísli Pálsson (New York, 1996), pp. 152–68.
5 Paul Shepard, *The Others: How Animals Made Us Human* (Washington, DC, 1996).
6 Keith Thomas, *Man and the Natural World: Changing Attitudes in England, 1500–1800* (London, 1983); Harriet Ritvo, *The Animal Estate: The English and Other Creatures in Victorian England* (Cambridge, MA, 1989).
7 Nona C. Flores, 'Effigies Amicitiae . . . Veritas Inimicitiae', in *Animals in the Middle Ages: A Book of Essays*, ed. Nona C. Flores (New York, 1996), pp. 167–95.
8 The television show *Fatal Attractions* (on the Animal Planet channel), which has been running continuously since February 2010, consists of several documentaries on cases in which people have become obsessed with their relationships with dangerous animals. See http://animal.discovery.com, accessed 9 February 2012.
9 Karl A. Menninger, 'Totemic Aspects of Contemporary Attitudes toward Animals', in *Psychoanalysis and Culture*, ed. G. B. Wilbur and W. Muensterberger (New York, 1951), pp. 62–3.
10 Boria Sax, 'Are There Predators in Paradise?', *Terra Nova*, I/2 (1997), p. 63.
11 Thomas, *Man and the Natural World*, p. 29.
12 For a thorough study of the values, rituals, practices and symbolism of the hunt in the European Middle Ages, see John Cummins, *The Hound and the Hawk: The Art of Medieval Hunting* (London, 1988).
13 For further discussion of these stories in their cultural and historical contexts, see Michael Pastoureau, *Les Animaux célèbres* (Paris, 2008), pp. 88–117.
14 Aaron H. Katcher, 'Man and the Living Environment: An Excursion into Cyclical Time', in *New Perspectives on Our Lives with Companion Animals*, ed. Aaron H. Katcher and Alan M. Beck (Philadelphia, 1983), p. 526.

15 Joanna Bourke, *What It Means to Be Human: Historical Reflections from the 1880s to the Present* (Berkeley, CA, 2011), pp. 19–20; Roberto Marchesini, 'Alterità non umane', *Liberazione: Rivista di Critica Antispecista*, 6 (2008); Roberto Marchesini, *Alterity and the Non-Human*, trans. Boria Sax, *Humanimalia* (Spring 2010), available at http://www.depauw.edu/humanimalia, accessed 7 May 2012.

16 Jacques Derrida, *The Animal That Therefore I Am*, trans. David Willis (New York, 2008), p. 9.

17 For a variation on this idea, see Gilles Deleuze and Félix Guattari, *A Thousand Plateaus*, trans. Brian Massumi (Minneapolis, MN, 1987).

18 Donna J. Haraway, *When Species Meet* (Minneapolis, MN, 2008), p. 20.

3 What is an 'Imaginary Animal'?

1 Carol Kaesuk Yoon, *Naming Nature: The Clash between Instinct and Science* (New York, 2009), pp. 7–10, 252–60.

2 Ibid., p. 98.

3 Joe Nigg, *The Book of Gryphons: A History of the Most Majestic of All Mythical Creatures* (Cambridge, MA, 1982), pp. 90–91.

4 Samuel Sadaune, *Le Fantastique au Moyen Âge* (Paris, 2009), p. 7, my translation.

5 Rita Carter, 'The Limits of Imagination', in *Human Nature: Fact and Fiction*, ed. Robin Headlam Wells and Johnjoe McFadden (New York, 2006); Antonio Damasio, *Descartes' Error: Emotion, Reason, and the Human Brain* (New York, 2005), pp. 83–113.

6 Roel Sterckx, *The Animal and the Daemon in Early China* (Albany, NY, 2002), p. 28.

7 Philippe Descola, *Par-delà nature et culture* (Paris, 2005), pp. 21–52.

8 Tim Ingold, 'Rethinking the Animate, Reanimating Thought', *Ethnos*, LXXI/1 (2006), p. 10.

9 Gilbert Ryle, *The Concept of Mind* (Chicago, 2000), pp. 18.

10 Damasio, *Descartes' Error*, pp. 223–52; Susan Blackmore, *Consciousness: A Very Short Introduction* (New York, 2005), pp. 50–98.

11 Descola, *Par-delà nature et culture*, pp. 321–37.

12 Ibid., pp. 183–320; Philippe Descola, 'Constructing Natures: Symboloic Ecology and Social Practice', in *Nature and Society: Anthropological Perspectives*, ed. Philippe Descola and Gísli Pálsson (New York, 1996), pp. 108–20.

13 Edward O. Wilson, 'Biophilia and the Conservation Ethic', in *The Biophilia Hypothesis*, ed. Stephen R. Kellert and Edward O. Wilson (Washington, DC, 1993), p. 31.

14 Roberto Marchesini and Karin Anderson, *Animal Appeal: Uno studio sul teriomorfismo* (Bologna, 2001), pp. 23–55.

15 Joanna Bourke, *What It Means to Be Human: Historical Reflections from the 1880s to the Present* (Berkeley, CA, 2011), pp. 285–330.

16 Louisa May Alcott, *Transcendental Wild Oats* [1873] (Carlisle, MA, 1981), p. 48.

17 For a discussion of some of the intricate taboos regarding meat, especially in contemporary times, see Hal Herzog, *Some We Love, Some We Hate, Some We Eat: Why It's So Hard to Think Straight About Animals* (New York, 2010).

18 Elizabeth Lawrence, 'The Sacred Bee, the Filthy Pig, and the Bat out of Hell: Animal Symbolism as Cognitive Biophilia', in *The Biophilia Hypothesis*, ed. Kellert and Wilson, p. 334.

19 Bettina Bildhauer and Robert Mills, 'Introduction: Conceptualizing the Monstrous', in *The Monstrous Middle Ages*, ed. Bettina Bildhauer and Robert Mills (Toronto, 2003), p. 21.

20 René Girard, *Violence and the Sacred*, trans. Patrick Gregory (Baltimore, MD, 1993), pp. 143–68; Lucian Boia, *Entre l'ange et la bête: Le Mythe de l'homme différent de l'Antiquité à nos jours* (Paris, 1995); Marchesini and Anderson, *Animal Appeal*.

21 Aesop, *Fables of Aesop*, trans. S. A. Handford (London, 1987), fable 17.

22 T. H. White, ed., *The Book of Beasts: Being a*

Translation From a Latin Bestiary of the Twelfth Century [c. 1150] (New York, 1984), pp. 14–15.
23 Farid al-Din Attar, *The Conference of Birds* [1177], trans. Afkham Darbandi and Dick Davis (London, 1984).

4 Every Real Animal is Imaginary

1 No complete work of Empedocles has survived, but we have many fragments recorded by other authors. For a compilation of these, see John Burnet, *Early Greek Philosophy* (London, 1903).
2 Sigmund Freud, *Civilization and Its Discontents*, trans. and ed. James Strachey (New York, 1961).
3 David D. Gilmore, *Monsters: Evil Beings, Mythical Beasts, and All Manner of Imaginary Terrors* (Philadelphia, PA, 2009), pp. 92–5.
4 Stephen Jay Gould, *Wonderful Life: The Burgess Shale and the Nature of History* (New York, 1990).
5 Heinz Mode, *Fabulous Beasts and Demons* (London, 1975), pp. 12–14.
6 Ariane Delacampagne and Christian Delacampagne, *Here Be Dragons: A Fantastic Bestiary* (Princeton, NJ, 2003), pp. 84–5.
7 For a survey of some of the fantastic beasts in the legends of Native Americans, see Gilmore, *Monsters*, pp. 90–114.
8 For a discussion of the possible influence of prehistoric bones on mythology, particularly that of Greece and Rome, see Adrienne Mayor, *The First Fossil Hunters: Paleontology in Greek and Roman Times* (Princeton, NJ, 2000).
9 Stanley Charles Nott, *Voices from the Flowery Kingdom* (New York, 1947), pp. 240–47.
10 Steven Mithen, 'The Hunter-Gatherer Prehistory of Human–Animal Relations', *Anthrozoös*, XII/4 (1999).
11 Delacampagne and Delacampagne, *Here Be Dragons*, p. 71.
12 André Leroi-Gourham, *Treasures of Prehistoric Art*, trans. Norbert Guterman (New York, 1967), pp. 128–9, 447, 512; quotation on p. 121.
13 Ibid., pp. 131–3.
14 Mithen, 'The Hunter-Gatherer Prehistory', p. 200.
15 Mark Derr, *How the Dog Became the Dog* (New York, 2011), pp. 25–8.
16 Leroi-Gourham, *Treasures of Prehistoric Art*, p. 446.
17 Ibid., p. 166.
18 Michael S. Gazzaniga, *Human: The Science Behind What Makes Your Brain Unique* (New York, 2008), pp. 310–12.
19 Mircea Eliade, *History of Religious Ideas*, trans. Willard R. Trask (Chicago, 1998), vol. I, p. 5.
20 Joseph Campbell, *Historical Atlas of World Mythology* (New York, 1988), vol. II, Part 2, pp. 224–5, 34.
21 Jocelyne Porcher, *Vivre avec les animaux: Une Utopie pour le XXe siècle* (Paris, 2011), pp. 32–3, 103–4.
22 Walter Burkert, *Creation of the Sacred: Tracks of Biology in Early Religions* (Cambridge, MA, 1996), pp. 40–47; Paul A. Trout, *Deadly Powers: Animal Predators and the Mythic Imagination* (Amherst, NY, 2011), pp. 206–8.
23 Natalie Angier, 'Quest for Evolutionary Meaning in the Persistence of Suicide', *New York Times* (5 April 1994), pp. C1–C10.
24 Ernest Seton-Thompson, *Wild Animals I have Known* (New York, 1911), p. 12.
25 Temple Grandin and Catherine Johnson, *Animals in Translation: Using the Mysteries of Autism to Decode Animal Behavior* (New York, 2005), pp. 27–68.
26 Ibid., p. 67.
27 What suggests such a possibility to me is that the expressions on the faces in the paintings of Bosch very rarely seem commensurate with the scene. Most of his figures have rather vacant expressions, regardless of whether the scene is the Garden of Earthly Delights, a village or Hell.
28 For a very detailed account of the evolution of grylles, see Jurgis Baltrušaitis, *Le Moyen-Âge fantastique* (Paris, 1993).
29 Leroi-Gourham, *Treasures of Prehistoric Art*, pp. 182–6.
30 Baltrušaitis, *Le Moyen-Âge fantastique*, p. 20.

31 Mode, *Fabulous Beasts and Demons*, p. 11.
32 Janetta Rebold Benton, *The Medieval Menagerie: Animals in the Art of the Middle Ages* (New York, 1992), pp. 109–11.
33 Janetta Rebold Benton, 'Gargoyles: Animal Imagery and Artistic Individuality in Medieval Art', in *Animals in the Middle Ages: A Book of Essays*, ed. Nona C. Flores (New York, 1996), p. 147–63.
34 Michael Pastoureau, *Les Animaux célèbres* (Paris, 2008), pp. 95–7, 166–7.
35 Aelian, *On the Characteristics of Animals* [*c*. 200], trans. A. F. Scholfield (Cambridge, MA, 1971); Michel de Montaigne, 'Apology for Raymond Sebond', trans. Donald M. Frame, in *The Complete Essays of Montaigne* (Stanford, CA, 1959).
36 J. G. Wood, *Man and Beast: Here and Hereafter* (New York, 1875), pp. 41–2.
37 Lynn Barber, *The Heyday of Natural History, 1820–1870* (Garden City, NY, 1980), p. 286.
38 J. G. Wood, *Illustrated Natural History* (New York, 1893).
39 I confirmed this by typing the words 'Bigfoot' and 'Sasquatch' into the Google NGram Viewer, which measures the relative frequency with which words have been used in books since 1800. Both words start to become enormously more frequent in the latter twentieth century. 'Bigfoot' peaked at least temporarily around 2002, while 'Sasquatch' continues to skyrocket. Google Books Ngram Viewer, 2012, at http://books.google.com/ngrams, accessed 24 April 2012.
40 Amanda Petrusich, 'Howling at Nothing: A Hunt for Bigfoot', *New York Times* (22 April 2012), Travel section p. 11. The same organization puts out a television programme called *Finding Bigfoot*, which I watch occasionally.
41 Boria Sax, *City of Ravens: London, its Tower, and its Famous Ravens* (London, 2011–12), pp. 1–89.
42 Harold A. Herzog and Shelley L. Calvin, 'Animals, Archtypes, and Popular Culture: Tales from the Tabloid Press', *Anthrozoös*, V/2 (1992).
43 Jan Harold Brunvand, *The Vanishing Hitchhiker: American Urban Legends and their Meaning* (New York, 1989), pp. 2–19, 24–46, 62–74.

5 Every Imaginary Animal is Real

1 In the 1930s many Canadian and American newspapers reported that Native Americans of British Columbia were living in terror of hairy men called 'Sasquatches', which they believed were members of a Native tribe that had formerly been considered extinct but had lived on in caves, from which they were starting to emerge. United Press, 'Hairy Tribe of Wild Men in Vancouver', *Wisconsin State Journal* (10 June 1934), p. 1.
2 David D. Gilmore, *Monsters: Evil Beings, Mythical Beasts and All Manner of Imaginary Terrors* (Amherst, NY, 2011), pp. 91–116.
3 Anonymous, *The Epic of Gilgamesh*, trans. N. K. Sandars (New York, 1970), p. 61.
4 Ibid., p. 63.
5 Krishna-Dwaipayana Vyasa, *The Mahabharata*, trans. Protap Chandra Roy (Calcutta, 1890), pp. 342–51.
6 Ctesias, 'Indica' [*c*. 400 BCE], trans. J. W. McCrindle, in *The Book of Fabulous Beasts: A Treasury of Writings from Ancient Times to the Present*, ed. Joseph Nigg (New York, 1999), pp. 44–5.
7 H. Stanford London, *The Queen's Beasts* (London, 1953) 50.
8 Michael Pastoureau, *The Bear: History of a Fallen King*, trans. George Holoch (Cambridge, MA, 2007), pp. 1–184.
9 Ibid., p. 146.
10 London, *The Queen's Beasts*, p. 18; Michael Pastoureau, *Les Animaux célèbres* (Paris, 2008), pp. 140–50.
11 Vladimir Propp, 'Folklore and Literature', trans. Adriana Y. Martin and Richard P. Martin, in *The Classic Fairy Tales*, ed. Maria Tatar (New York, 1999), p. 379.
12 Stith Thompson, *Motif-Index of Folk Literature: A Classification of Narrative Elements in Folktales,*

Ballads, Myths, Fables, Mediaeval Romances, Exempla, Fabliaux, Jest-Books and Local Legends, revd edn (Bloomington, IN, 1958).
13 Jorge Luis Borges and Margarita Guerrero, *The Book of Imaginary Beings*, trans. Peter Sis (New York, 2005), pp. 153–6.

6 Monsters

1 Lucian Boia, *Entre l'ange et la bête: Le Mythe de l'homme différent de l'Antiquité à nos jours* (Paris, 1995), pp. 13–25.
2 Rudolf Otto, *The Idea of the Holy*, trans. John W. Harvey (New York, 1958), pp. 1–40.
3 Mary Douglas, *Purity and Danger: An Analysis of the Concepts of Pollution and Taboo* (New York, 2002), pp. 42–58.
4 Stephen T. Asma, *On Monsters: An Unnatural History of Our Worst Fears* (New York, 2009).
5 Paul A. Trout, *Deadly Powers: Animal Predators and the Mythic Imagination* (Amherst, NY, 2011).
6 David Attenborough, *The First Eden: The Mediterranean World and Man* (Boston, MA, 1987), pp. 68–71.
7 Timothy K. Beal, *Religion and Its Monsters* (New York, 2002), p. 79.
8 Jurgis Baltrušaitis, *Le Moyen-Âge fantastique* (Paris, 1993), pp. 154–75.
9 Stefano Zuffi, *Angels and Demons in Art*, trans. Rosanna M. Giammanco Frongia (Los Angeles, 2003), p. 248.
10 Lorenzo Lorenzi, *Devils in Art: Florence from the Middle Ages to the Renaissance*, trans. Mark Roberts (Florence, 2006), pp. 26, 150.
11 For a critical review of some, though by no means all, of the theories about Bosch, see Roger H. Marijnissen and Peter Ruyffelaere, *Hieronymous Bosch: The Complete Works* (Antwep, 1987).
12 Bettina Bildhauer and Robert Mills, 'Introduction: Conceptualizing the Monstrous', in *The Mostrous Middle Ages*, ed. Bildhauer and Mills (Toronto, 2003), pp. 1–27.
13 Joscelyn Godwin, *Arktos: The Polar Myth in Science, Symbolism, and Nazi Survival* (Kempton, IL, 1996), p. 49.
14 For a more detailed summary and discussion of the Melusine legend, see Boria Sax, *The Serpent and the Swan: Animal Brides in Folkore and Literature* (Knoxville, TN, 1998), pp. 81–97, 238–45.
15 Jean D'Arras, *Mélusine: Roman du XIVe siècle* [1394] (Dijon, 1932); for a discussion of the legend, see Sax, *The Serpent and the Swan*, pp. 81–112, 238–45.
16 Jacob Grimm and Wilhelm Grimm, *The Complete Fairy Tales of the Brothers Grimm*, trans. Jack Zipes (New York, 1987), tale 108.
17 Apollodorus, *The Library of Greek Mythology*, trans. Robin Hard (New York, 1997), pp. 97–8, 136–40. There are many other references to the story in Greek and Roman culture, and they are generally in agreement except for a few details. Apollodorus has Theseus kill the Minotaur with his fists instead of, as is more usual, with a sword.
18 Michael Pastoureau, *Les Animaux célèbres* (Paris, 2008), pp. 38–48.
19 Pliny, *Natural History: A Selection*, trans. John F. Healy (New York, 1991), book 8, section 78.
20 Alexander Neckam, *De naturis rerum* [c. 1180], ed. Thomas Wright (London, 1863), chap. 75.
21 Boria Sax, 'The Basilisk and Rattlesnake; or, a European Monster Comes to America', *Society and Animals*, II/1 (1994), p. 7.
22 Ibid., pp. 7–14.
23 For a detailed account of the events in Gévaudan, their cultural context, possible explanations for the killings and the legends they inspired, see Jay M. Smith, *Monsters of the Gévaudan: The Making of a Beast* (Cambridge, MA, 2011).

7 Wonders

1 Walt Whitman, *The Complete Poems*, ed. Francis Murphy (New York, 2005), section 31, l. 669.
2 St Adamnan, 'The Life of St Columba', trans. Alan Orr Anderson and Marjorie Ogilvie Anderson,

in *The Book of Fabulous Beasts: A Treasury of Writings from Ancient Times to the Present*, ed. Joseph Nigg (New York, 1999), pp. 147–8.
3 Helen Waddell, *Beasts and Saints* (New York, 1995), pp. 20–21.
4 Patrick F. Houlihan, *The Animal World of the Pharaohs* (New York, 1996), pp. 1–2.
5 Dorothea Arnold, *An Egyptian Bestiary* (New York, 1995), p. 4.
6 Mary Elizabeth Thurston, *The Lost History of the Canine Race: Our 15,000-Year Love Affair with Dogs* (New York, 1996), pp. 59–65.
7 Rudolf Wittkower, *Allegory and the Migration of Symbols* (New York, 1977), pp. 46–7.
8 Paul B Courtright, *Ganeśa: Lord of Obstacles, Lord of Beginnings* (New York, 1985), p. 3.
9 Wu Chĕng-ên, *Monkey* [c. 1582], trans. Arthur Waley (New York, 1970), Preface.
10 Wu Chĕng-ên, *Journey to the West* [c. 1582], trans. Anthony C. Yu (Chicago, 1977), vol. IV, chap. 49.
11 Roel Sterckx, *The Animal and the Daemon in Early China* (Albany, NY, 2002), p. 110.
12 Harald Gebhardt and Mario Ludwig, *Von Drachen, Yetis und Vampiren: Fabeltier auf der Spur* (Munich, 2005), p. 47.
13 Sterckx, *The Animal and the Daemon*, p. 287.
14 Andrea Aromatico, *Alchemy: The Great Secret*, trans. Jack Hawkes (New York, 2000), pp. 20–36, 98–9.
15 Jakob von Uexküll, *Umwelt und Innenwelt der Tiere* (Berlin, 1909).
16 Paracelsus, 'Liber de nymphis, slyphis, pymaeis et salamandris et de ceteris spiritibus' [c. 1540], in *Theorphrastus von Hohenheim, genannt Paracelsus, Sämptliche Werke*, ed. Karl Sudhoff (Berlin, 1933), vol. XIV, pp. 115–52.

8 Creatures of Water

1 For a discussion of this global homogeneity and attempts to explain it, see Boria Sax, 'The Magic of Animals: European Witch Trials in the Perspective of Folklore', *Anthrozoös*, XXII/4 (2009), pp. 320–22.
2 Rachel Loxton, 'Loch Ness Monster Lessons Get the World Talking', *Herald Scotland* (24 June 2012), p. 1, available at www.heraldscotland.com.
3 Jeremy Black and Anthony Green, *Gods, Demons and Symbols of Ancient Mesopotamia: An Illustrated Dictionary* (Austin, TX, 1992), pp. 63–5.
4 Mircea Eliade, *Myth and Reality* (New York, 1975), p. 48.
5 Stephanie Dalley, ed., *Myths from Mesopotamia* (New York, 1992), pp. 228–77.
6 Hesiod, *Theogony / Works and Days* [750 BCE], trans. M. L. West (New York, 1988), ll. 129–91.
7 Ibid., ll. 804–39.
8 Ibid., ll. 29–331.
9 For a discussion of Sedna and many versions of her legend, see Jacqueline Thursby, 'Sedna: Underwater Goddess of the Artic Sea', in *Goddesses in World Culture*, ed. Patricia Monaghan (Santa Barbara, CA, 2010), vol. III, pp. 193–204.
10 Thursby, 'Sedna: Underwater Goddess of the Arctic Sea', pp. 197–8.
11 Dalley, ed., *Myths from Mesopotamia*, pp. 254–7.
12 Elijah Judah Schochet, *Animal Life in Jewish Tradition* (New York, 1984), pp. 28–9, 84–5.
13 Anonymous, 'The Voyage of St Brendan' (selection), in *The Book of Fabulous Beasts: A Treasury of Writings from Ancient Times to the Present*, ed. Joseph Nigg (New York, 1999), pp. 173–4.
14 Nigg, ed., *The Book of Fabulous Beasts*, pp. 261–9.
15 Anonymous, 'Great Sea Serpent', *The London Aegis* (7 August 1818).
16 For a detailed account of many such sightings of the great sea serpent, see J. P. O'Neil, *The Great New England Sea Serpent: An Account of Unknown Creatures Sighted by Many Respectable Persons between 1638 and the Present Day* (Camden, ME, 1999).
17 Bartholomaeus Anglicus, 'On the Properties of Things' (selection), trans. Robert Steele, in *The Book of Fabulous Beasts*, ed. Nigg, p. 141.

18 Sabine Jell-Bahlsen, 'Ogbuide: The Igbo Lake Goddess', in *Goddesses in World Culture*, ed. Monaghan, vol. I, pp. 249–62.
19 John Keats, 'Lines on the Mermaid Tavern', *Golden Treasury*, ed. Francis Turner Palgrave (London, 1884), p. 114.

9 Creatures of Fire and Air

1 Paracelsus, 'Liber de nymphis, slyphis, pymaeis et salamandris et de ceteris spiritibus' [*c*. 1540], in *Theorphrastus von Hohenheim, genannt Paracelsus, Sämptliche Werke*, ed. Karl Sudhoff (Berlin, 1933), vol. XIV, pp. 127, 35, 38, 49–50.
2 Ibid., pp. 127, 49–50.
3 Max Müller, 'Chips from a German Workshop' [1871], in *Peasant Customs and Savage Myths: Selections from British Folklorists*, ed. Richard M. Dorson (Chicago, IL, 1968), vol. I, pp. 67, 103.
4 Anonymous, *The Egyptian Book of the Dead*, trans. E. Wallis Budge (New York, 1995), p. 367.
5 Herodotus, *History of Herodotus*, trans. G. C. Macaulay, Sony e-book edn (London, 1890/2010), chap. 73.
6 Anonymous, 'Bestiary: Being an English Version of the Bodelian Library, Oxford MS Bodley 64' [*c*. 1250], trans. Richard Barber (Woodbridge, 1999), p. 143.
7 Wallace Stevens, 'Of Mere Being', in *Selected Poems* (New York, 2011), p. 318.
8 Herodotus, *History of Herodotus*, chap. 115.
9 Anonymous, 'The Romance of Alexander' (selection), trans. Richard Stoneman, in *The Book of Fabulous Beasts: A Treasury of Writings from Ancient Times to the Present*, ed. Joseph Nigg (New York, 1999), pp. 171–2.
10 Lewis Carroll, in *The Annotated Alice: The Definitive Edition*, ed. Martin Gardner (New York, 1999), pp. 94–9.
11 Joe Nigg, *The Book of Gryphons: A History of the Most Majestic of All Mythical Creatures* (Cambridge, MA, 1982), p. 194.
12 Anonymous, *The Arabian Nights: Tales of 1,001 Nights*, trans. Malcolm C. Lyons (London, 2011), vol. II, Night 556.
13 Ibid., vol. III, Night 1,001.
14 David D. Gilmore, *Monsters: Evil Beings, Mythical Beasts, and All Manner of Imaginary Terrors* (Philadelphia, PA, 2009), pp. 102–3.
15 Ibid., p. 135.
16 Noriko T. Reider, *Japanese Demon Lore: Oni from Ancient Times to the Present* (Logan, UT, 2010), pp. 23–4, 51.
17 Ibid., p. 17.
18 Edward Topsell, *The History of Four-Footed Beasts and Serpents and Insects* [1658] (New York, 1967), vol. II, p. 705.
19 Ibid., vol. II, pp. 713–14.

10 Creatures of Earth

1 James Lovelock, *The Revenge of Gaia: Earth's Climate Crisis and the Fate of Humanity* (New York, 2006).
2 David Leeming and Margaret Leeming, *A Dictionary of Creation Myths* (Oxford, 1994), p. 60.
3 Paracelsus, *Paracelsus: Selected Writings*, trans. Norbert Guterman (Princeton, NJ, 1979), p. 15.
4 Mircea Eliade, *Shamanism: Archaic Techniques of Ecstasy*, trans. Williard R. Trask (Princeton, NJ, 1974).
5 G. M. Mullett, *Spider Woman Stories: Legends of the Hopi Indians* (Tucson, AZ, 1991), pp. 11–43.
6 David Attenborough, *The Private Life of Plants: A Natural History of Plant Behavior* (Princeton, NJ, 1995), p. 23.
7 Natalie Angier, 'Sorry, Vegans: Brussels Sprouts Like to Live, Too', *New York Times* (21 December 2009).
8 Jurgis Baltrušaitis, *Le Moyen-Âge fantastique* (Paris, 1993), pp. 109–24.
9 Ibid., pp. 109–54.
10 John Gerard, 'Herball', in *The Book of Fabulous Beasts: A Treasury of Writings from Ancient Times to the Present*, ed. Joseph Nigg (New York, 1999), pp. 270–72.

11 John Mandeville, *The Travels of Sir John Mandeville* [*c*. 1366] (London, 1983), chap. 29.
12 Heinz Mode, *Fabulous Beasts and Demons* (London, 1975), pp. 187–8, 97.
13 Paracelsus, *Paracelsus: Selected Writings*, p. 25.
14 Baltrušaitis, *Le Moyen-Âge fantastique*, p. 126.
15 For a detailed history of these legends, which have found their way into manuscripts written in Arabic, Persian and Chinese, as well as Western languages, see Baltrušaitis, *Le Moyen-Âge fantastique*, pp. 124–50.
16 Anonymous, *The Arabian Nights: Tales of 1,001 Nights*, trans. Malcolm C. Lyons (London, 2011), vol. III, Nights 820–39.
17 David Attenborough, *The First Eden: The Mediterranean World and Man* (Boston, MA, 1887), pp. 140–41; Mode, *Fabulous Beasts and Demons*, p. 224.
18 Ovid, *Metamporphoses*, trans. Rolfe Humphries (Bloomington, IN, 1955–7), book 1, ll. 449–591.
19 Robert Kirk, *The Secret Life of Elves and Fairies* [1692], ed. John Matthews (New York, 2004), pp. 18, 80–81.
20 J.R.R. Tolkien, *The Fellowship of the Ring: Being the First Part of Lord of the Rings* (New York, 2005), book 3, chap. 4.

11 Shape-shifters

1 Viviane Baeke, 'Les Hommes et leurs "douleurs animales": Cameroun Occidental (région des Grassfields)', in *Animal*, ed. Christiane Falgayrettes-Leveau (Paris, 2007), pp. 253–69.
2 Pedro Pitarch, *The Jaguar and the Priest: An Ethnolgraphy of Tzeltal Souls* (Austin, TX, 2010), pp. 1–5, 40–43.
3 Pliny, *Natural History: A Selection*, trans. John F. Healy (New York, 1991), book 7, chap. 174.
4 Aesop, in Joseph Jacobs, ed., *The Fables of Aesop, Selected, Told Anew* (London, 1910), pp. 180–81.
5 Plato, *The Last Days of Socrates: Euthyphro, Apology, Crito, Phaedo* [*c*. 399–429 BCE] trans. Hugh Tredennick (New York, 1993), sections 82a–b.

6 Ovid, *Metamorphoses*, trans. Rolfe Humphries (Bloomington, IN, 1955–7), book 6, ll. 1–145.
7 Ibid., book 6, ll. 409–748.
8 Ibid., book 3, ll. 138–250; ibid., book 1, ll. 205–55.
9 Wang Chi-Chen, *Traditional Chinese Tales* (New York, 1944), pp. 24–34.
10 Xiaofei Kang, 'Fox Lore and Worship in Late Imperial China', in *What Are the Animals to Us? Approaches from Science, Religion, Folklore, Literature, and Art*, ed. Dave Aftandilian, Marion W. Copeland and David Scofield Wilson (Knoxville, TN, 2007), p. 22.
11 Royall Tyler, ed., *Japanese Tales* (New York, 1987), tale 81.
12 Ovid, *Metamorphoses*, book 1, ll. 163–245.
13 Petronius, *Satyricon* [*c*. 60 CE], trans. Michael Heseltine (Cambridge, MA, 1987), sections 61–2.
14 Charles Mackay, *Extraordinary Popular Delusions and the Madness of Crowds* [1841] (New York, 2011), pp. 274–5.
15 Elizabeth de Fontenay, *Le Silence des bêtes: La Philosophie à l'épreuve de l'animalité* (Paris, 1998), pp. 684–9.
16 For a discussion of this process, see *Boria Sax, Animals in the Third Reich: Pets, Scapegoats and the Holocaust* (New York, 2000), pp. 47–55.
17 Franz Kafka, *The Metamorphosis*, trans. Willa Muir and Edmund Muir (New York, 1987).
18 Bourke, *What It Means to be Human*, pp. 327–386.
19 For a thorough discussion of virtual reality, see Edward Castronova, *Synthetic Worlds: The Business and Culture of Online Games* (London, 2005).

12 Mechanical Animals

1 J. K. Rowling, *Harry Potter Paperback Box Set, Books 1–7* (New York, 2009).
2 Anonymous, *The Arabian Nights: Tales of 1001 Nights*, trans. Malcolm C. Lyons (London, 2011), Night 294.
3 For a detailed discussion of biotechnological, especially genetic, manipulation, see Emily Anthes,

Frankenstein's Cat: Cuddling Up To Biotech's Brave New Beasts (New York, 2013).
4 For a discussion of these and many other technologies based on imitation of animals, see Agnès Guillot and Jean-Arcady Meyer, *How to Catch a Robot Rat: When Biology Inspires Innovation*, trans. Susan Emanuel (Cambridge, MA, 2010).
5 Guillot and Meyer, *How to Catch a Robot Rat*, pp. 134–6.
6 Tamagotchi Graveyard, 2011, at http://shesdevilish.tripod.com/grave.html, accessed 15 August 2011.
7 For a detailed discussion of simulation in the technology and culture of computers, see Sherry Turkle, *Life on the Screen: Identity in the Age of the Internet* (New York, 1995).
8 For a detailed study of digital pets and related creations, see Sherry Turkle, *Alone Together: Why We Expect More from Technology and Less from Each Other* (New York, 2011).
9 Mark Derr, *How the Dog Became a Dog: From Wolves to Our Best Friends* (New York, 2011).
10 For more on this see Boria Sax, 'What Is This Quintessence of Dust? The Concept of the Human and Its Origins', in *The End of Anthropocentrism*, ed. Rob Boddice (London, 2011), pp. 21–37; Roberto Marchesini, *Post-Human: Verso nuovi modelli di esistenza* (Turin, 2002), esp. pp. 43–104, 510–50.

Conclusion

1 David D. Gilmore, *Monsters: Evil Beings, Mythical Beasts, and All Manner of Imaginary Terrors* (Philadelphia, PA, 2009), pp. 189–94.
2 Paul A. Trout, *Deadly Powers: Animal Predators and the Mythic Imagination* (Amherst, NY, 2011), p. 176.
3 Mark Derr, *How the Dog Became a Dog: From Wolves to Our Best Friends* (New York, 2011), p. 61.
4 This is the approach, for example, of the philosophers Tom Regan and Peter Singer. Roberto Marchesini attributes this, correctly in my opinion, to either the inability to recognize alterity or the reluctance to accord it any significance. Roberto Marchesini, *Post-Human: Verso nuovi modelli di esistenza* (Turin, 2002), p. 512.
5 Claude Lévi-Strauss, *Totemism*, trans. Rodney Needham (Boston, MA, 1962), p. 89.
6 Mary Oliver, 'Swans', *Evidence* (Boston, MA, 2009), pp. 2–3.

FURTHER READING

On Imaginary Animals in General

These are some books that I recommend for further reading on the subject of imaginary animals. The literature on the subject is, of course, almost incomprehensibly vast, and any selection cannot help but be a little idiosyncratic. I have confined myself here to outstanding books of secondary literature published in the last several decades, which are broad in their scope. I am also confining myself to books published in English, even though the scholarship in other languages is comparably rich. These books, of course, will themselves contain many further references, and are intended as a starting point, rather than an end, for the reader who wishes to investigate the subject further.

Asma, Stephen T., *On Monsters: An Unnatural History of Our Worst Fears* (New York, 2009)
A history of horror in folklore, literature and film, as well as the monsters it engendered, emphasizing the relationship of terror to the sublime.

Beal, Timothy K., *Religion and Its Monsters* (New York, 2002)
A study of monstrous creatures primarily from the Bible and the Judaeo-Christian tradition, such as Leviathan and Behemoth.

Borges, Jorge Luis, and Margarita Guerrero, *The Book of Imaginary Beings*, trans. Peter Sis (New York, 2005)
A dictionary of fantastic creatures, described without great detail but with an intense sense of wonder.

Delacampagne, Ariane, and Christian Delacampagne, *Here Be Dragons: A Fantastic Bestiary* (Princeton, NJ, 2003)
A beautifully illustrated exploration of fantastic animals depicted throughout human history, and what they tell us about our unconscious minds.

Gilmore, David D., *Monsters: Evil Beings, Mythical Beasts, and All Manner of Imaginary Terrors* (Philadelphia, PA, 2003)
An anthropological discussion of monsters in myth and legend, especially noteworthy for its discussions of legends from Native American and Pacific cultures.

Mode, Heinz, *Fabulous Beasts and Demons* (London, 1975)
A very scholarly survey, which was regarded as the most definitive work on fabulous beasts for a couple of decades after it was published. Though now dated in ways, it remains a valuable source of information and analysis.

Nigg, Joseph, ed., *The Book of Fabulous Beasts: A Treasury of Writings from Ancient Times to the Present* (New York, 1999)
A comprehensive anthology of primary materials on creatures of myth and legend, from the *Epic of Gilgamesh* to Lewis Carroll's *Alice's Adventures in Wonderland*.

South, Malcolm, ed., *Mythical and Fabulous Creatures: A Sourcebook and Research Guide* (New York, 1988)
A scholarly volume devoted primarily to tracing

the origins and historical development of fabulous creatures such as the griffin and unicorn.

Wittkower, Rudolf, *Allegory and the Migration of Symbols* (New York, 1977)
A beautifully illustrated book, which has become a classic. It traces in considerable detail the transmission of visual motifs, especially of fantastic animals, through different cultures, from the era of Herodotus to the beginning of the nineteenth century.

Zell-Ravenheart, Oberon, and Ash DeKirk, *A Wizard's Bestiary* (Franklin Lakes, NJ, 2007)
Possibly the most detailed and comprehensive of several encyclopaedias of fabulous animals.

On Particular Creatures of Myth and Legend

Well over a score of scholarly books on the unicorn alone have been written in the past few decades, but my purpose here is simply to provide the reader with a starting point for further research. I am, therefore, including only one book for each legendary animal, resisting the impulse to overwhelm the reader with material. I am also confining myself to well-known creatures which have a foundation in myth, though most appear in works of fiction as well.

Courtright, Paul B., *Ganesa: Lord of Obstacles, Lord of Beginnings* (New York, 1985)
A scholarly study of the beloved Hindu deity with a human body and elephant head.

Gotfredsen, Lise, *The Unicorn*, trans. Anne Born (New York, 1999)
Beautifully illustrated, and probably the most comprehensive of the many recent histories of the unicorn in myth, legend and art.

Marigny, Jean, *Vampires: Restless Creatures of the Night*, trans. Lorry Frankl (New York, 1994)
A history and anthology of short writings about vampires, emphasizing the ways in which their combination of horror and eroticism has inspired a unique fascination in popular culture.

Nigg, Joe, *The Book of Gryphons: A History of the Most Majestic of All Mythical Creatures* (Cambridge, MA, 1982)
A history of the griffin from ancient Mesopotamia to the present, with emphasis on its importance as a solar animal.

O'Neil, J. P., *The Great New England Sea Serpent: An Account of Unknown Creatures Sighted by Many Respectable Persons between 1638 and the Present Day* (Camden, ME, 1999)
A detailed study of sightings of aquatic monsters reported primarily by mariners, with a discussion of their credibility.

Turkle, Sherry, *Alone Together: Why We Expect More from Technology and Less from Each Other* (New York, 2011)
An examination of digital pets such as the Tamagotchi, and their impact, on a societal as well as an individual level.

White, David Gordon, *Myths of the Dog-Man* (Chicago, 1991)
A highly scholarly history of cynocephali in legends from China and India to the United States and their symbolism as an embodiment of the primitive or barbarous.

ACKNOWLEDGEMENTS

Throughout the book the names of types of imaginary animals have been set lower-case and in roman text, as distinguished from imaginary animals with proper names, such as Bigfoot and the Minotaur. Many of these names, however, are grammatically ambiguous, since in many cases, such as 'Bigfoot', a species is commonly referred to in the third person singular. In those instances, capitalization depends on judgements that, we must acknowledge, can be variable.

All biblical quotations are from the Jerusalem Bible.

Some of the material in this book has been partially adapted from parts of the following previous publications: Boria Sax, 'Metamorphoses', *Encyclopedia of Human–Animal Relationships*, 4 vols, ed. Marc Bekoff (Westport, CT, 2007), vol. IV, pp. 1056–60; Boria Sax, 'Who Patrols the Human–Animal Divide?', *The Minnesota Review*, 73–4 (2009), pp. 165–70; Boria Sax, 'Storytelling and the Information Overload', *On the Horizon*, XIV/4 (2006), pp. 165–70. Special thanks are due to my wife Linda, who offered useful suggestions, many of which I adopted, and proofread a manuscript of this book. She works as a historic interpreter for Historic Hudson Valley, demonstrating early crafts and tasks, and so her comments reflected not only a fine sense of literary style but also a very intimate sort of insight into the past.

PHOTO ACKNOWLEDGEMENTS

From Ulisse Aldrovandi, *Monstorum historia* (Bologna, 1642): pp. 29 (left), 47, 80, 96, 118, 125, 139, 141 (foot), 143, 153; from *The Arabian Nights: Tales from The Thousand and One Nights* (London, 1924): p. 198 (top); from *The Arthur Rackham Fairy Book . . .* (London, 1933): p. 199; Archives du Royaume, Paris: p. 68 (left); from Ludovico Ariosto, *Roland Furieux* (Paris, 1879): p. 177; from *Der Bapstesel vom Rom* (Wittenberg, 1523): p. 54 (right); from F. J. Bertuch, *Bilderbuch für Kinder* (Weimar, 1801): pp. 6, 52; Bibliothèque Nationale, Paris: pp. 40, 134; British Library, London: pp. 26, 194; British Museum, London: pp. 137, 138, 86, 188; Chateau d'Angers, France: p. 105; Detroit Institute of Arts: p. 129; from Hans Egede, *The New Survey of Old Greenland* (London, 1734): p. 181; Ferens Art Gallery, Hull: p. 94; from Conrad Gesner, *Historia Animalium libri I–IV. Cum iconibus. Lib. I. De quadrupedibus viviparis* (Zürich, 1551): p. 8 (top); from S. G. Goodrich, *Johnson's Natural History . . .* (New York, 1867): p. 103; from Philip Henry Gosse, *The Romance of Natural History* (London, 1860): p. 50; from J. J. Grandville, *Un autre Monde* (Paris, 1844): pp. 30, 71, 160; from J. J. Grandville, *Les Metamorphoses du Jour* (Paris, 1854): pp. 20, 124; from J. J. Grandville, *Scenes de la Vie Privée et Publique des Animaux* (Paris, 1842): pp. 24, 140 (right), 142, 160, 164 (lower left and lower right), 247, 252, 253; Gulbenkian Museum of Oriental Arts, Durham: p. 151; from Joannes Jonstonus, *A Description of the Nature of Four-Footed Beasts . . .* (London, 1678): p. 16 (right); from Johann Geiler von Kaysersberg, *Die Emeis: Dis ist das Buch von der Omeissen . . .* (Strassburg, 1517): p. 231; Kunsthistorisches Museum, Vienna: p. 132; from Edward William Lane, *The Thousand and One Nights: The Arabian Nights' Entertainments* (London, 1834): p. 198 (foot); from Andrew Lang, *The Red Romance Book* (London and New York, 1921): p. 17; from Olaus Magnus, *Historia de Gentibus Septentrionalis* (Rome, 1555): p. 178; from Maria Sibylla Merian, *Erucarum Ortus, Alimentum et Paradoxa Metamorphosis* (Amsterdam, 1718): p. 220; Metropolitan Museum of Art, Flanders: pp. 9, 10, 11, 12; from Konrad von Megenberg, *Buch der Natur* (Augsburg, 1478): p. 54 (left); Metropolitan Museum of Art, New York: pp. 22, 107; from *Monstrum in Oceano Germanica* (Rome, 1537): p. 99; from Pierre Denys De Montfort, *Histoire Naturelle de Mollusces* (Paris, 1802): p. 167; Musée Condé, Chantilly: p. 111; Musée du Louvre, Paris: pp. 13, 109; Museo del Prado, Madrid: pp. 112, 114, 115, 116; National Gallery, London: p. 108; National Gallery of Art, Washington, DC: p. 226; Giovanni Battista Nazari, *Della Tramutatione metallica sogni tre . . .* (Brescia, 1599): p. 156; Österreichische Nationalbibliothek, Vienna (Handschriftensammlung, cod. min. 129, 130): pp. 216, 218; Pierpont Morgan Library & Museum, New York: p. 101; private collections: pp. 130, 141 (top), 197; from J. W. Powell, ed., United States Bureau of Ethnology, *Second Annual Report*, (Washington, DC, 1880–81): p. 82; from *Punch*, 6 March 1901: p. 90; from Louis Renard, *Poissons, ecrivisses et crabes de diverse couleurs* (Amsterdam, 1754): p. 183; Rijksmuseum Kröller-Müller, Otterlo: p. 33; Royal Fine Arts Museum of Belgium, Brussels: p. 133; from Jacob Rueff, *De conceptu et generatione hominis . . .* (Frankfurt, 1587): p. 215; from *La Sainte Bible* (Tours, 1866): p. 174; San Brizio chapel, Orvieto: p. 110; Santa Marina de Carmine, Florence: p. 27; from Paulus Scaliger, *Pauli Principi de la Scala primi tomi miscellaneorum, de rerum caussis & successibus atque secretiori*

methodo ibidem expressa, effigies ac exemplar, nimirum, vaticiniorum & imaginum Joachimi abbatis Florensis Calabriæ explanatio (Cologne, 1570): p. 16 (left); from *Secretorum Chymicum* (Frankfurt am Main, 1687): p. 206; Sistine Chapel, Rome: p. 216; Smithsonian American Art Museum, Washington, DC: p. 175; from Johan Stabius, *De Labyrintho* (Nuremberg, 1510): p. 123; Tate, London: pp. 120, 236 (©ADAGP, Paris and DACS, London, 2013); from John Taylor, *The Devil Turn'd Round-head: or, Pluto become a Brownist . . .* (London, 1642): p. 15 (right); from Edward Topsell, *The History of Four-footed Beasts and Serpents* (London, 1658): pp. 14; Uffizi Gallery, Florence: p. 208; Victoria & Albert Museum, London: p. 162; Walker Art Gallery, Liverpool: p. 212.

INDEX

Aaron (brother of Moses) 133–5, *134*
Abominable Snowman *see* yeti
Abraxas 100
Adam 25, *27*, 34, 59, 75, *114*, 117, *130*, 169–70, 215, 216
Aelian 74
Aesop 48–9, 223, 237
Al-Buraq 44–5, 62
Albus Dumbledore 240
Alcott, Louisa May 45
Aldrovandi, Ulisse 29, *47*, 80, 96, *118*, 125, *139*, *141*, 143, *153*, *164*
Alexander VI, Pope *15*, 18
Ali Baba 238
Alighieri, Dante *see* Dante
almas 79
angels 99, 108, *130*, 131–2, *133*, 157, 186, 233
animism 41–2
ant 7, 74, 113
Anthony, St 25, 113
anthrozoology 25, 36
Anubis 46, 136–7, *137*, 139
Anzu 189, 194
Apis 104, 137
ape 38, 75, 126, 233, 250,
 ape-man 76, 79, 81, 83, 234
 chimpanzee 32, 38, 242
 gorilla *50*
 orang-utan 64, 75, *75*
Arabian Nights Entertainments 198, 217, 238
Arthur, legendary King of Britain 31

ba 97, 137
Baltrušaitis, Jurgis 68
Barnum, P. T. 117, 184
basilisk 13, 121–2, 240
barnacle goose 6, 214
bat 32, 37, 44, 66, 108, 121, 123, 124, 127, 128, 234, 239, 242, 253
Batman 234
bear 27, 38, 48, *70*, 88–9, 105, 128, 131, 163
Beast of the Apocalypse 105–07, *105*, *106*, *107*, 119, 171
bee 158
Beast of Gévaudan 125–7
Bennu *137*, 190
Beowulf 103, 171, 176, 205
Bertuch, F. J. 6, 52
bestiaries 8, 9, 20, 49, 90, 191, *194*, 237, 259
Bigfoot 76, 77, 79, 80–81, 188
biophilia, theory of 44
Blake, William 159, 186–7, *186*, 188
Blavatsky, Helena 117
Boia, Lucian 47, 95
Borges, Jorges Luis 79, 92–3
Bosch, Hieronymous 66, *67*, 72, 95, 109, *112*, 113–14, *114*, *115*, *116*, 202, 239
Bourke, Joanna 32
Browne, Thomas 38
Brendan, St 177
Breughel the Elder, Pieter *133*
Breughel, Jan 72
Buddhism 44, 221
Buffon, Comte de (Georges-Louis Leclerc) 75, 128
butterfly 41, 53, *133*, 149, 190, 220, 221, 229, 253

273

Carroll, Lewis 196
cat 23, 32, 34–5, 43, 44, 59, 127, 136, 138, 156, 223–4, 234
Çatalhöyük 100
cave paintings 61–64, *63*, 67–68, 71, 100, 106, 119
centaur 52, 72, 211, 250
Chauvet cave 63
Chewong 23
chimera 52, 64, *156*, 171
Christ 7–9, 11, 31, 44, 49, 65, 73, 88, 105, 139–40, 156, 191, 195, 210, 229
Christianity 9, 40, 73, 107, 116, 123–4, 135, 229, 234
Christopher, St 46, 97, 139, 159
chupacabra 82
cockatrice *see* basilisk
consciousness 41, 42, 61, 211, 238, 246, 251–2
Copernicus, Nicolaus 37
Coriolan, J. B. *see* Aldrovandi
computers 42, 91, 238–39, 241–2
Confucius 87–88
Cranach, Lucas the Elder *54*, 232
crane man 96
Crockett, Davy 103
crocodile 95, 96, 136, *140*
Cronos 155–6, 170
Cromwell, Oliver 14
cynocephali 38, 39, 46, *47*, 48, 97, 110, 242, 254

Dante 95, *188*, 195, 210, 229
Darwin, Charles 48, 50, 53, 74, 75, 135, 159, 166, 233
deer 43, 66, 67, 85, 114, 149, 157, 192, 200
 see also stag
Della Porta, Giambattista 232
demons 13, 25, 37, 55, 61, 68, 79–81, 99, 107, 108–110, *111*, *112*, 113–14, *113*, 116–17, *116*, *117*, 123, 125–6, *125*, *126*, 127–9, *127*, 131, *133*, 145, 146, 147, *146*, *147*, 168, 170, 201, 203, 204, *205*, 210, 229, *254*
 see also Beast of the Apocalypse, Beast of Gevaudan
Derr, Mark 63, 251, 259, 265
Derrida, Jacques 32–5
Descartes, René 35, 74, 233, 258
Divine Comedy (Dante) *188*, 229

dog 24, 38, 43, 44, 46, 63, 65, 108, 136, 137, 139, 140, 158, 171, 172, 218, 231, 244, 247, *247*, 252, 259, 265, 268
donkey 19, 44, 54
dolphin 36, 64, 155, 213
Douglas, Mary 96–7, 185, 261
Dr Seuss (pseudonym for Theodor Seuss Geisel) 72, 240
dracontopede 22, 26–28, *26*, *27*, 131
Dracula, Count 127, 128
dragon 6, 13, 17, 49, 57, *58*, *59*, *90*, 91, 103, 104, 107–109, *108*, *109*, *150*, 165, 168, 174, 206, 207, *212*, 244, 253
 alchemical dragon 154–7, *154*, 205, 207
 Apocalyptic dragon 104–05, *105*, 107, 108
 Chinese dragon 64, 86, 99, 134, 149, *149*, 151–2, *151*, 205
 see also dracontopede, salamander
Draper, Herbert 94
drolleries *see* grylles
Dürer, Albrecht 106

eagle 9, 55, 73, 81, 105, 140, 144, 148, 149, 155, 190, 191, 194, 195, 198, 201
 see also Eagle Man
Eagle Man 81, *201*
Eden, Garden of 25, *26*, *114*, 117, 170, 176, 189, 229, 261, 204
Egypt 44, 46, 52, 53, 63, 66, 97, 104, 119, 134, 135–42, 153, 155, 156, 163, 166, 168, 189–90, 194, 209, 215
Elementals 157–9, 187
Eliade, Mircea 65, 210, 259, 262
Elizabeth I, Queen of England 86, 214
Empedocles 53, 66, 68, 158, 259
Enkidu 83–85, 90
Enlightenment 123–8
Ent 219
Ernst, Max 236, 241
Eve 22, 25–8, *26*, *27*, 75, 114, 117, 130, 170, 215–16, *216*, 229

Farid al-Din Attar 49
False Prophet *105*, 107
Fawkes *see* phoenix
fenghuang *see* phoenix
Ficino, Marsilio 155

Index

firebird *see* phoenix
fish 25, 37–8, 39, 43, 45, 67, 70, 76, 85, 94, 96, 99, 113, 146, 152, 155, 156, 168, 172, 176, 177, *178*, 181, 182, 184, 192, 214, 221, 233
Fitzgerald, John Anster *141*
Ford, H. J. 17
fox *30*, 70, *70*, 148, 225–229, 255
 see also kitsune
Francis, St 25, 73
Freud, Sigmund 53
Fu Xi, Emperor of China 87
Furby 245
Fuseli, Henry *129*

Gaia 170–71, 209
 see also Gaia hypothesis
Gaia hypothesis 209
Galileo Galilei 37
Ganesh 44, 143–44, *144*, 146
Garuda 144–6, *145*
Girard, René 47
Gilgamesh 83–4, 210, 260, 267
Gonzalez, Antoinetta 80
Gonzalez, Petrus, *see* Gonzalez, Antoinetta
Gosse, Philip Henry 50
Gould, Stephen Jay 53
Goya, Francisco de 124–5, *127*
 Grassman 79
Grail 31
Grandville, J. J. *20*, *24*, *124*, *140*, *142*, *158*, *160*, *232*, 232, *247*, *250*, *252*, *253*
griffin 38, 52, *52*, 57, 110, 188, 190, 191, 194–6, *194*, *195*, *196*, *197*
 see also Anzu, roc
Grimm, Jacob and Wilhelm 118
grylles 52, 66–72, *67*, *58*
Guanyin 148, 211

Hallaj 51
Hanuman 145–6, *146*
Haraway, Donna 34

Harry Potter 237–40, 245
Hans My Hedgehog 118–19
heraldry 27, 48, 70, 71, 89, *89*, 195–6, *196*
Hermanubis 139, *139*
Hermes Tresmagistus *see* Thoth
Herodotus 138, 190–91, 194, 230, 263, 268
Hinduism 44, 142–3, 146, 221
hippopotamus 37–8, 136
Hiroshige, Andō 227
Historic-Geographic School (of folklore) 91–2, 166
Hogarth, William *126*
Hokusai, Katsushika *150*, *192*, *203*
Homer 121, 230, 251
ho-o *see* phoenix
Hubertus, St 28, *29*, 31
huma *see* phoenix

ibis 136
Inari 28
Ingold, Tim 41
India 14, 28, 55, 80, 85, 119, 122, 142–3, 144, 162, 214, 216, 250
Islam 40, 44

jackal 136–7, 139
John the Evangelist, St 71, 106, 140, *140*
Judaism 40, 123
Jung, C. G. 100, 159, 166

Kafka, Franz 234
Kamam people 23
karkadann *see* unicorn
Katcher, Aaron 31
Kaulbach, Wilhelm von *70*
Keats, John 128, 184–5
Kepler, Johannes 37
kerkes *see* phoenix
Kirk, Robert 218–19
Kismet 242
kitsune 225, 227, 228, *228*, 254
Knapp, J. Augustus *100*, *154*, *217*

Kyōsai, Kawanabe *202, 204,* 228

Lakshmi 145
Lang, Andrew 17
Larson, Gary 232
Lawrence, Elizabeth A. 46
Le Brun, Charles 221, 232–3, *233*
leopard 105, 222, *222*
Lewis, C. S. 240
Leviathan 148, 173–7, *174, 175,* 176–7, 181
Levi-Strauss, Claude 185, 253
Lilith 117, 169, 170
Limbourg Brothers 111
'Lines on the Mermaid Tavern' *see* Keats, John
Linnaeus, Carl von 37–8
Loch Ness monster 38, 81, 135, 166, 168
Louis XIV, King of France 237, 251
Lovecock, James 209
Lycaon, King (of Arcadia) 230

Maat 136
Mami Wata 184, 202
 see also mermaid
mandrake 13, 217–18, *218,* 250
Marchesini, Roberto 32, 44, 47
Marco Polo 40, 108
Marduk 168–9, 171, 173, 176–177
Masolino 27
Medusa 55–6, *56*
Melusine 118, 171, 173, 184
Menninger, Karl 28
mermaid 36, 38, 72, 76, 140, 172, 181–5, *182, 184*
Michael, St 108, 131, *132, 133,* 176
Middle Ages 8, 25, 27, 36, 60, 67, 68–9, 88, 94, 95, 99, 107, 117, 118, 121, 131, 140, 147, 170, 171, 181–2, 184, 194, 214, 215, 217
Milcham *see* phoenix
Minos, King of Crete 119–21
Minotaur 119–21, *120*
Mithen, Steven 60–61
Mode, Heinz 55

Mokèle-mbèmbé 81–2
monkey 24, 44, 48, 145, 148, 184, 243, 244
 see also ape, Hanuman
Montaigne, Michel de 74
Moreau, Gustave 22
Moses 133, *134,* 229
Muhammad 45, 63, *63*
Müller, Max 188–9

Neckham, Alexander 121
Newton, Isaac 37, 153, 251
ningyo 183
 see also mermaid

Oedipus 22
Ogbuide 183–4
Old Monkey 44, 128
Oliver, Mary 254
 oni 201–04, *205*
 Otto, Rudolf 95
Ovid 218, 220, 225, 230 235, 264

Paley, William 28
Paolo, Giovanni di 130
panther 30, 49
Paracelsus 157–9, 161, 187, 209, 215
Pastoureau, Michael 73, 257
Paul, St 73, 191
Paul the Octopus 76
Petronius 230
perytion 92–3
phoenix 6, 7, 49, 86, 137, 152, 153, 155, 189–91, *192, 193,* 198, 207, 240
 Bennu (Egyptian) *137,* 190
 Fawkes 240
 fenghuang (Chinese) 152, *152,* 153, 191, 198
 firebird (Russian) 189, 191
 ho-o (Japanese) 189
 huma (Persian) 189
 kerkes (Turkish) 189, 191
 Milcham (Jewish) 189, 191

Index

Picasso, Pablo 121
pig 37, 65, 96, 117, 156, 232, *233*, 234
Pliny the Elder 85, 121, 230
Pope 8, 15, *16*, *18*
 see also Alexander VI
Porta, Giambattista della 232
predators 64–6, 99–102, 129, 148, 246
Pre-Raphaelites 99, 197, 212
Propp, Vladimir 90

qilin *see* unicorn
Quetzalcoatl 55, 56, *57*
Quran 191

Rama 145, 146
Raphael Sanzio, *18*, 109
Redon, Odilon *33*
re'em *see* unicorn
Renaissance 9, 25, 38, 42, 56, 68, 74, 99, 107, 110, 117, 121,
 127, 128, 131, 136, 140, 142, 144, 147, 153, 156, 195,
 205, 208, 215, 218, 229, 232
Revelation, book of 71, 104–07, *105*, *106*, *107*
Richard I, King of Britain 89
Rishyasringa 84–5, 90
Ritvo, Harriet 25
roc 6, 189, 196, 198–200, *198*
Romanticism 127–8
Ross, Andrew 38–39
Rowling, J. K. 237–8, 240
Ryder, Albert Pinkham *177*

Sadaune, Samuel 39
salamander 135, 204, 205, *206*, *207*
Sasquatch 38, 76, 79, 80, 83
 see also Bigfoot
satyr 13, *14*, 38, 52, 68, *78*, *80*
Schongauer, Martin 113, *113*
Shakespeare, Willam 7, 95, 141, 158
Shanachies 187
shape-shifting 47, 221–36
Shinto 184, 228

Shiva 143–4
Smellie, William 28
Socrates 53, 225
 Signorelli, Luca 109, *110*
simurg 49, 51, 189, 191
sirens 36, 48, 52, 94, *95*, *97*, 98, 158, 159
sirins *see* sirens
Spider-Man 234
Spider Woman 210–11
stag 28–9, *29*, 31, 63, 92, 121, 152, 225, 231
 see also deer
Stevens, Wallace 191
Sun Wukong *see* Old Monkey
sylphs 158–9, 187

Tamagotchis 242–5, 248, 253
therianthropy 223
Theseus 119
Thoth 136, *136*, 139, 155
Thomas, Keith 25
Thompson, Stith 166
thunderbird 200–01, *200*
Tiyo 210–11
Tolkien, J.R.R. 219
Tree of Life 199
Trout, Paul A. 99–102
Tsuna, Wanatabe no 202, 204, 205
Typhon 156, 170, 196, 205

Uccello, Paolo 108
Uexküll, Jakob von 158
unicorn 6, 7–21, *8*, *9*, *10*, *11*, *12*, *13*, *16*, *17*, *18*, *19*, *20*, *21*,
 32, 38, 57, *60*, 60, *63*, 63, 64, 83–7, 88–9, *88*, *89*,
 90–92, *114*, 114, 119, 157, *164*, 239, 240, 250, 254
 Aldrovandi's unicorn 164
 karkadann (Persian) 85, 90
 of Lascaux 63, *63*, 64
 qilin (Chinese) 57, 85–7, 90
 re'em 85
 sea unicorn 60, *60*
unicorn of Lascaux *see* unicorn

Unicorn Tapestries 9, *9*, *10*, *12*
Vahara 146, *146*
 see also Vishnu
vampire 127–8, 234, 262
Venus *10*, 208, 224
Victoria I, Queen of Britain 89
Victorians 29, 30, 74, 75, 83, 94, 99, 120, 184, 185, 189
 see also Victoria I
virtual reality 234, 245
Vishnu *145*, 146, *146*, *147*, 176

Waley, Arthur 148
Waq Waq Tree 216–17
wechuge 53
Weiditz, Hans *231*
werewolf 47, 125, 139, 229–30, *231*, 232, 234, 250
whale 37, 38, 65, 76, 172, 175, 181, 200, 209, 235, 239
Whitman, Walt 133
Whore of Babylon 171
wild man *14*, 79, *80*, 83
 see also ape, Bigfoot, Sasquatch
Wilson, Edward O. 44
windigo 79
wolf 23, 29, 38, 45, 63, 65, 82, 125, 139, 153, 230–31, 232, *232*, 234
Wood, J. G. 74–5
Wylie, Grace 27–8

Yahweh 96, 100, *130*, 133, 135, 169, 173, *174*, 176, 229
Yama 148
yeren 79
yeti 37–8, 79, 92, 250
yowie 79

Zeus 155, 170–71, 173, 201, 205, 221, 236
zootropia, theory of 44
Zoroastrianism 123